Graphis Inc. is committed to presenting exceptional work in international Design, Advertising, Illustration & Photography.

Published by Graphis | Publisher & Creative Director: B. Martin Pedersen | Design: Ryan Crispo | Editor: Mark F. Bonner
Editorial Assistant: Christina Brower | Production: Yasmin Mathew | Web Support: Charles Sporn | Intern: Luis Goicochea

Remarks: We extend our heartfelt thanks to contributors throughout the world who have made it possible to publish a wide and international spectrum of the best work in this field. Entry instructions for all Graphis Books may be requested from: Graphis Inc., 114 West 17th Street, Second Floor, New York, New York 10011, or visit our web site at www.graphis.com.

Anmerkungen: Unser Dank gilt den Einsendern aus aller Welt, die es uns ermöglicht haben, ein breites, internationales. Spektrum der besten Arbeiten zu veröffentlichen. Teilnahmebedingungen für die Graphis-Bücher sind erhältlich bei: Graphis, Inc., 114 West 17th Street, Second Floor, New York, New York 10011. Besuchen Sie uns im World Wide Web, www.graphis.com.

Remerciements: Nous remercions les participants du monde entier qui ont rendu possible la publication de cet ouvrage offrant un panorama complet des meilleurs travaux. Les modalités d'inscription peuvent être obtenues auprès de: Graphis, Inc., 114 West 17th Street, Second Floor, New York, New York 10011. Rendez-nous visite sur notre site web: www.graphis.com.

Contents

Previous spread: My Body Clock by Peter Kraemer I *Opposite page:* Corbis 24/7/365 by Kit Hinrichs

InMemoriam

Tapani Aartomaa
Graphic Designer
1934 – 2009
Finland

Alex Andersen
Cartoonist
1920 – 2010
United States

Anna Anni
Costume Designer
1926 – 2011
Italy

Masuteru Aoba
Graphic Designer
1939 – 2011
Japan

Shusaku Arakawa
Conceptual Artist
& Designer
1936 – 2010
Japan

Hans Arnold
Artist
1925 – 2010
Switzerland

Roy Ward Baker
Film Director
1916 – 2010
United Kingdom

Louise Bourgeois
Artist & Sculptor
1911 – 2010
United States

Robert F. Boyle
Production Designer
& Art Director
1909 – 2010
United States

Françoise Cachin
Museum Curator & Director
1936 – 2011
France

Jean-Marie Charpentier
Architect
& Urban Planner
1939 – 2010
France

Art Clokey
Animator
1921 – 2010
United States

Paul Francis Conrad
Cartoonist
1924 – 2010
United States

Leo Cullum
Cartoonist
1942 – 2010
United States

Robert M. Cunningham
Illustrator
1924 – 2010
United States

Robin Day
Furniture Designer
1915 – 2010
United Kingdom

Jeanne-Claude
Denat de Guillebon
Installation Artist
1935 – 2009
Morocco

Blake Edwards
Film Director
1922 – 2010
United States

Fernando Fernández
Comic Book Artist
1940 – 2010
Spain

Marshall Flaum
Television
& Documentary Director
1925 – 2010
United States

Josef Flejsar
Graphic Designer
1922 – 2011
Czechoslovakia

Frank Frazetta
Poster Designer / Illustrator
1928 – 2010
United States

S. Neil Fujita
Graphic Designer
1921 – 2010
United States

Shigeo Fukuda
Poster Designer
1932 – 2009
Japan

Elmo Gideon
Artist & Sculptor
1924 – 2010
United States

Bruce Graham
Architect
1925 – 2010
Colombia

John Graysmark
Production Designer
& Art Director
1935 – 2010
United Kingdom

Pierre Guffroy
Production Designer
& Art Director
1926 – 2010
France

Sylvia Harris
Graphic Designer
1953 – 2011
United States

Raymond Hawkey
Graphic Designer
1930 – 2010
United Kingdom

Norman Hetherington
Cartoonist
1921 – 2010
Australia

Jan Kaplicky
Architect
1937 – 2009
Czechoslovakia

Bill Littlejohn
Animator
1914 – 2010
United States

Raymond Grieg Mason
Sculptor
1922 – 2010
United Kingdom

Grant McCune
Visual Effects Artist
1943 – 2011
United States

Alexander McQueen
Fashion Designer
1969 – 2010
United Kingdom

Mario Monicelli
Film Director
1915 – 2010
Italy

Kenneth Noland
Abstract Painter
1924 – 2010
United States

Harvey Pekar
Comic Book Artist
1939 – 2010
United States

Arthur Penn
Film Director
1922 – 2010
United States

Sigmar Polke
Artist
1941 – 2010
Germany

B. S. Ranga
Film Director
1917 – 2010
India

Fausto Sarli
Fashion Designer
1927 – 2010
Italy

Der Scutt
Modernist Architect
1934 – 2010
United States

Louis Silverstein
Graphic Designer
1919 – 2011
United States

Juan Piquer Simón
Film Director
1935 – 2011
Spain

Dugald Stermer
Illustrator
1936 – 2011
United States

Jaroslav Sura
Graphic Designer
1929 – 2011
Czechoslovakia

Edgar Tafel
Architect
1912 – 2011
United States

Noel Taylor
Costume Designer
1917 – 2010
United States

Kurt Weidemann
Graphic Designer
1922 – 2011
Germany

Bruno K. Wiese
Graphic Designer
1922 – 2011
Germany

Peter Yates
Film Director
1929 – 2011
United Kingdom

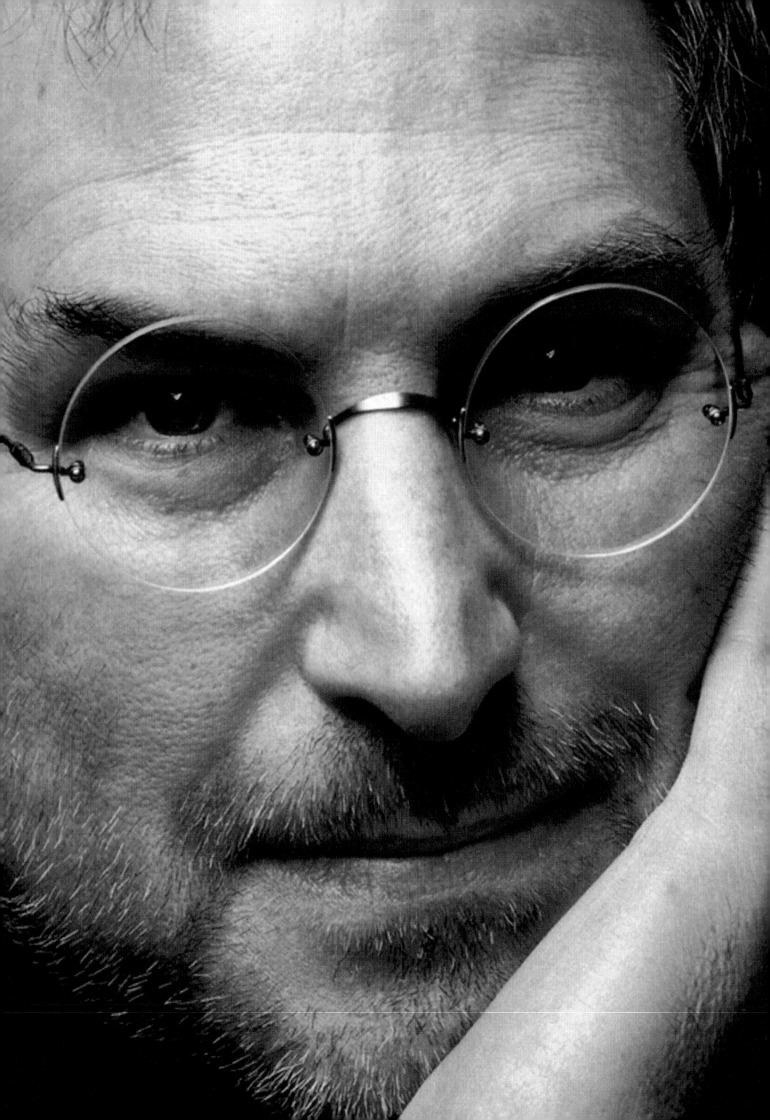

Steve Jobs: InMemoriam (1955-2011)

Here's to the crazy ones. The misfits. The rebels. The troublemakers. The round pegs in the square holes. The ones who see things differently. They're not fond of rules. And they have no respect for the status quo. You can quote them, disagree with them, glorify or vilify them. About the only thing you can't do is ignore them. Because they change things. They push the human race forward. While some may see them as the crazy ones, we see genius. Because the people who are crazy enough to think they can change the world, are the ones who do. Apple, *slogan for 1997's "Think different" campaign.*

Think different.

Fred Woodward's illustrious career in the world of publishing design began rather uncertainly. During his years at Mississippi State and Memphis State, he switched majors three times before finally settling on graphic design. Two semesters into his new major, he got a job at a local design studio, which subsequently led to his appointment as art director of Memphis. *During the early years of his career, he worked for* D Magazine, Westward, Texas Monthly, *and* Regardie's. *In 1987, Woodward was appointed the art director of* Rolling Stone. *The energy and innovation necessary to keeping a magazine fresh through almost 400 issues did not go unnoticed. When Fred was inducted to the Art Directors Hall of Fame in 1996, he was the youngest inductee at the time. In 2001, Woodward became design director at* GQ *magazine. Within a year his elegant redesign of the magazine had earned him the Society of Publication Designers' Magazine of the Year award.*

How do you approach each assignment?
As though we've never done it before. By making a hyperconscious effort not to repeat ourselves. Even though there are a million ways to approach any story, the hope is to get it to a place that feels so right that it looks like it is the only possible solution.

In *GQ*, the department pages are "flexibly formatted," meaning there's a template but we're always working hard to keep things fresh within that frame — familiar, but ever evolving. These pages provide the comfort zone that allows the features to be more freewheeling. We approach each feature as a one-off design that singularly illustrates the content of the piece.

It's important to remember it all begins with the words: the story, the headline, the dek. That's the source. That's the job.

What are the challenges of designing a fast-paced magazine like GQ?
More and more, just keeping up.

GQ is a beast of a magazine. We probably spend about 70 percent of our time designing the more service-oriented, nuts-and-bolts front and middle-of-book sections — that's what they come to us for — and the remaining time on the more glamorous feature well. The cycles of the photo and art departments overlap somewhat. The most intense period of commissioning for the next issue coincides with the most intense period of designing the current one. Add into the equation the digital editions that we're now producing, and it's not only hard to keep up, it's hard to know what month it is.

I've always described *GQ* as a pretty great general-interest magazine in the skin of a pretty great men's fashion magazine. The best thing about working here (besides the semi-annual shoe-and-tie giveaway) is the seemingly unlimited variety of subject matter that we cover. I'm reminded every day just how fortunate we are as designers to be mining such a rich vein.

What inspired you to become a graphic designer?
My earliest typographic memory was looking at that wondrously engraved Koken barbershop-chair footrest while Hobby Bridges was buzzing my hair when I was a small boy. Maybe it was always in me, that deep love of type and design.

A good friend in college, a landscape-architect major, introduced me to Letraset. I had changed my major three times in as many years, lost but still searching. I didn't yet know what graphic design was, but pressing that type onto paper was the first time things felt right.

Who was your greatest professional mentor?
I was a magazine art director before I was out of college, so I was left to figure it out on my own and make my own mistakes. Pretty sure I used more than my quota.

What is the most important lesson(s) you have learned in your career?
Do your homework and then expect good things to happen. Luck favors the prepared. Disaster is your friend. The really brave work almost always happens in crisis mode. On a good day (and with enough caffeine), it's possible to be a conduit of the gods. You have to be able to take a hit. A rejected idea is an opportunity for a better one. It doesn't matter how good the idea is if you can't sell it. If you can't get printed, it doesn't exist. Surround yourself with good people — not just gifted people, but good people.

What is required to achieve great work?
It certainly helps if that's what's truly desired. Everyone involved has to want the work to be great. The editor-in-chief. The editors. The writers. Photo. Fashion. Production. Copy. Research. The interns. Everyone's trying to make something special. Every day.

Designing a big, complex magazine like *GQ* is as collaborative as a movie made with a great ensemble cast. It's no Spalding Gray monologue. I believe in the sanctity and chemistry of the team. Someone may be on fire while someone else is struggling. We help each other along, spark off each other, push, encourage, and lift each other.

I come to work every morning believing that something truly great may happen — yet I'm always a little surprised and overjoyed when it does. That's what keeps me going.

Which designers do you admire most?
Those I work with every day. And all those I have been lucky enough to work with these past (gulp!) 35 years.

And there are, of course, all the greats who came before, on whose big shoulders I try to balance.

How do you keep the process fresh?
Throughout my career, the biggest and most constant source of inspiration comes with the arrival of new photography and illustration for each story. You want to do right by the artists. Honor their efforts. And on some base level, do your best to match their talents.

The very nature of the magazine, all journalism, is to make every effort toward timeliness, which means we're almost always adding a feature (or two or three) very late in the cycle. I have to confess to sometimes seriously stressing over these late additions, but if I'm completely truthful here, the hard fact is I love these adrenalized moments. Some of the work I'm most proud of is born of those times when we've made something from nothing through the sheer force of graphic design.

I take a lot of photographs, just for myself. Nothing makes me happier. It's important to have a creative outlet other than what you do for a living, especially one so pure and simple and solitary that requires only a camera and one good eye.

I know it seems obvious, but you have to keep looking (movies, books, museums, galleries…) for that thing that inspires, that reminds you that you can do better.

What philosophy do you want to impart to others?
There's a cheesy sign in my chiropractor's office that says, "Don't sweat the small stuff. And remember, it's all small stuff." It's tacked to the wall just above a portrait of Albert Einstein, though I'm reasonably sure he never said this, and certainly didn't practice it.

I humbly say, you've got to sweat the small stuff. Every little thing is important. The only difference between a beautifully designed photo caption and a two-page spread is scale.

What do you consider to be your greatest achievement?
Staying relevant over the long haul. Plus, I'm awfully proud of the "family tree" of designers and photo editors that I've worked with over the years and their many achievements — while they were with me and after they left.

Looking towards the future, what do you hope your legacy will be?
I'm far more concerned about the kerning on the big rock.

I come to work every morning believing that something truly great may happen – yet I'm always a little surprised and overjoyed when it does. That's what keeps me going.

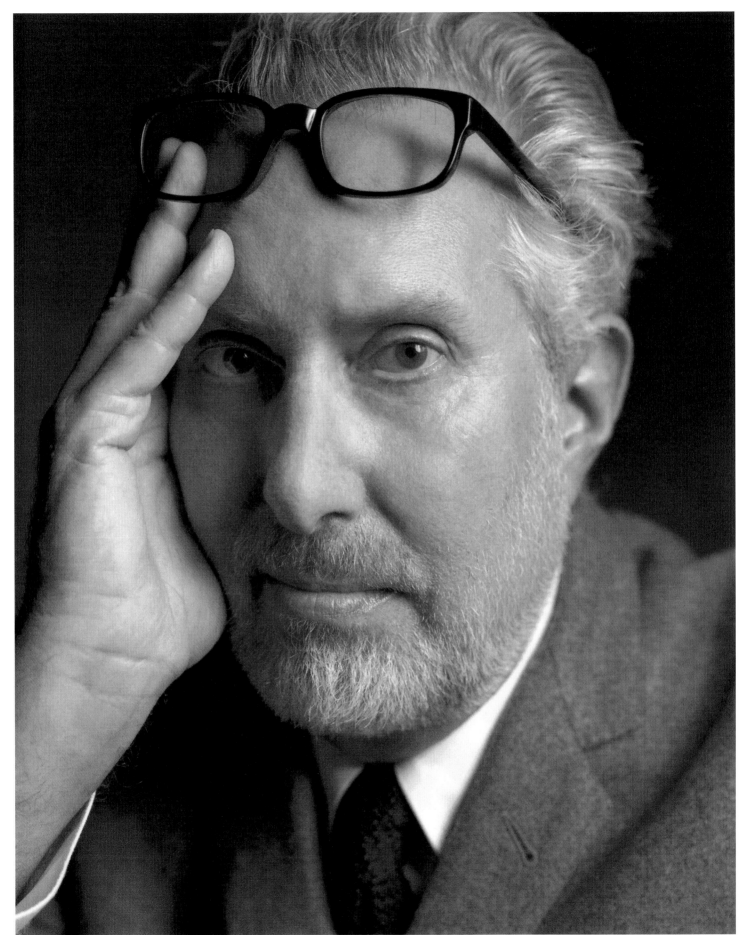

Portrait of Fred Woodward by Mark Seliger

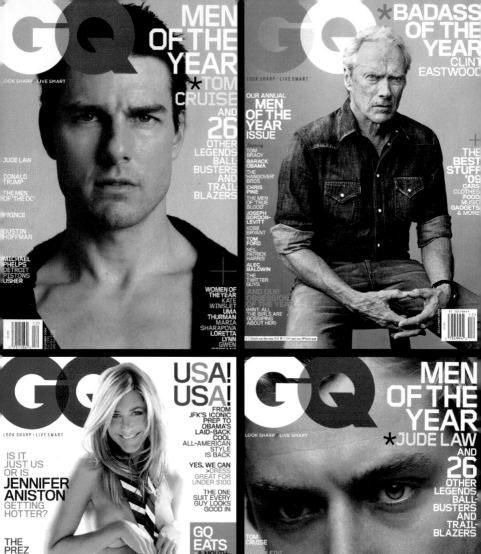

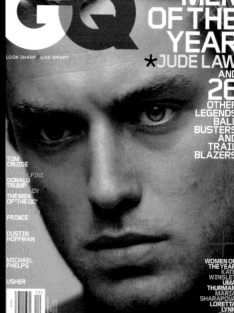

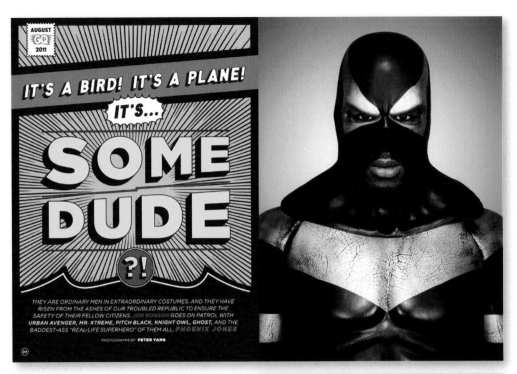

AUGUST
GQ
2011

IT'S A BIRD! IT'S A PLANE!

IT'S...

SOME DUDE

?!

THEY ARE ORDINARY MEN IN EXTRAORDINARY COSTUMES, AND THEY HAVE
RISEN FROM THE ASHES OF OUR TROUBLED REPUBLIC TO ENSURE THE
SAFETY OF THEIR FELLOW CITIZENS. *JON RONSON* GOES ON PATROL WITH
URBAN AVENGER, MR. XTREME, PITCH BLACK, KNIGHT OWL, GHOST, AND THE
BADDEST-ASS "REAL-LIFE SUPERHERO" OF THEM ALL, *PHOENIX JONES*

PHOTOGRAPHS BY **PETER YANG**

PHOTOGRAPHS BY
Christopher Griffith

GQ.COM **151**

→ Think $4 for a gallon of gas is
screwing with your summer? Wait
until you hear about something
called *peak oil*. According to a
growing number of experts—and
we're not just talking about
conspiracy wackos here—we're on
the brink of an economic crisis that
could lead to, well, the end of life as
we know it. **Benjamin Kunkel**
investigates just how scary things
are about to become

World Without Oil. Amen

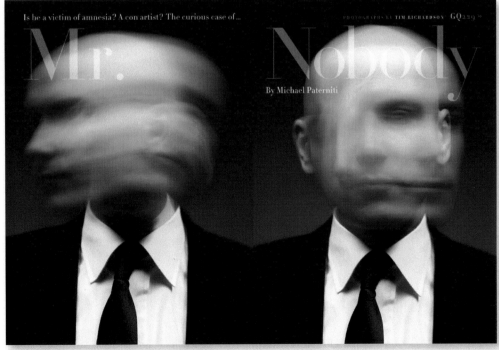

Is he a victim of amnesia? A con artist? The curious case of ...

PHOTOGRAPHS BY **TIM RICHARDSON** GQ229 »

Mr. Nobody

By Michael Paterniti

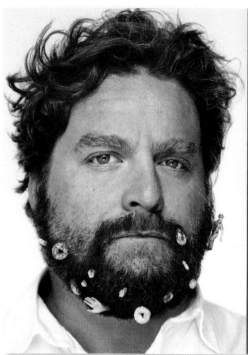

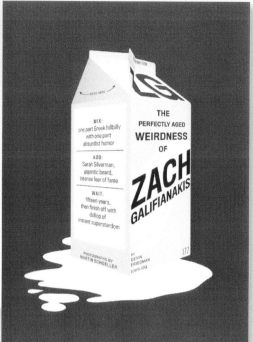

THE PERFECTLY AGED

WEIRDNESS OF

ZACH GALIFIANAKIS

MIX:
one part Greek hillbilly
with one part
absurdist humor

ADD:
Sarah Silverman,
gigantic beard,
intense fear of fame

WAIT:
fifteen years,
then finish off with
dollop of
instant superstardom

PHOTOGRAPHS BY
MARTIN SCHOELLER

BY
DEVIN
FRIEDMAN
100% GQ

177

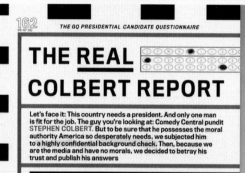

THE **REAL**
COLBERT REPORT

Let's face it: This country needs a president. And only one man is fit for the job. The guy you're looking at: Comedy Central pundit STEPHEN COLBERT. But to be sure that he possesses the moral authority America so desperately needs, we subjected him to a highly confidential background check. Then, because we are the media and have no morals, we decided to betray his trust and publish his answers

SECTION 1: Candidate Information

1. (a) Last Name (b) First Name

COLBERT STEPHEN

2. (a) Office Sought

PRESIDENT OF THE
UNITED STATES

(b) Year of Election 3. Photographs by Mark Seliger

2008

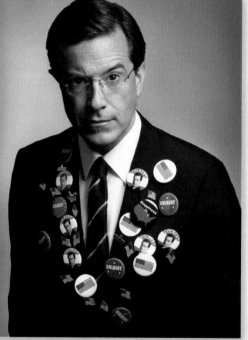

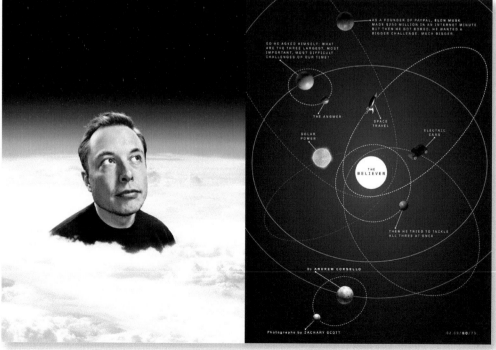

AS A FOUNDER OF PAYPAL, ELON MUSK MADE $250 MILLION IN AN INTERNET MINUTE. BUT THEN HE GOT BORED. HE WANTED A BIGGER CHALLENGE. MUCH BIGGER.

SO HE ASKED HIMSELF: WHAT ARE THE THREE LARGEST, MOST IMPORTANT, MOST DIFFICULT CHALLENGES OF OUR TIME?

THE ANSWER SPACE TRAVEL

SOLAR POWER ELECTRIC CARS

THE BELIEVER

THEN HE TRIED TO TACKLE ALL THREE AT ONCE

BY ANDREW CORSELLO

Photographs by ZACHARY SCOTT

02.09/GQ/75

The Fashionart Magazine

NATASHA OBSESSED

123

SUPER **TROUPER**

PHOTOGRAPHY

SØLVE SUNDSBØ

t-shirt vintage *Chanel*;
necklaces and bracelets
Burberry Prorsum;
trousers *Rue Du Mail by Martine
Sitbon*; trousers hanging
necklace *Erickson Beamon*;
studded jacket and denim shorts
Bess; gloves *LaCrasia*,
necklace worn around
left and right leg *Burberry
Prorsum*; boxing mouth
guard *Usa Ultimate
Sports & Apparel*

FASHION MARIE CHAIX

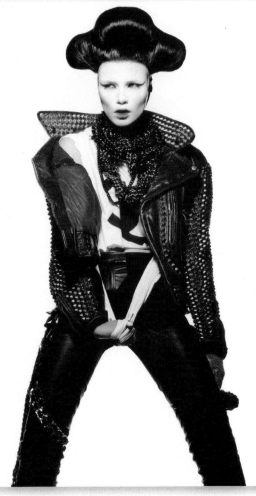

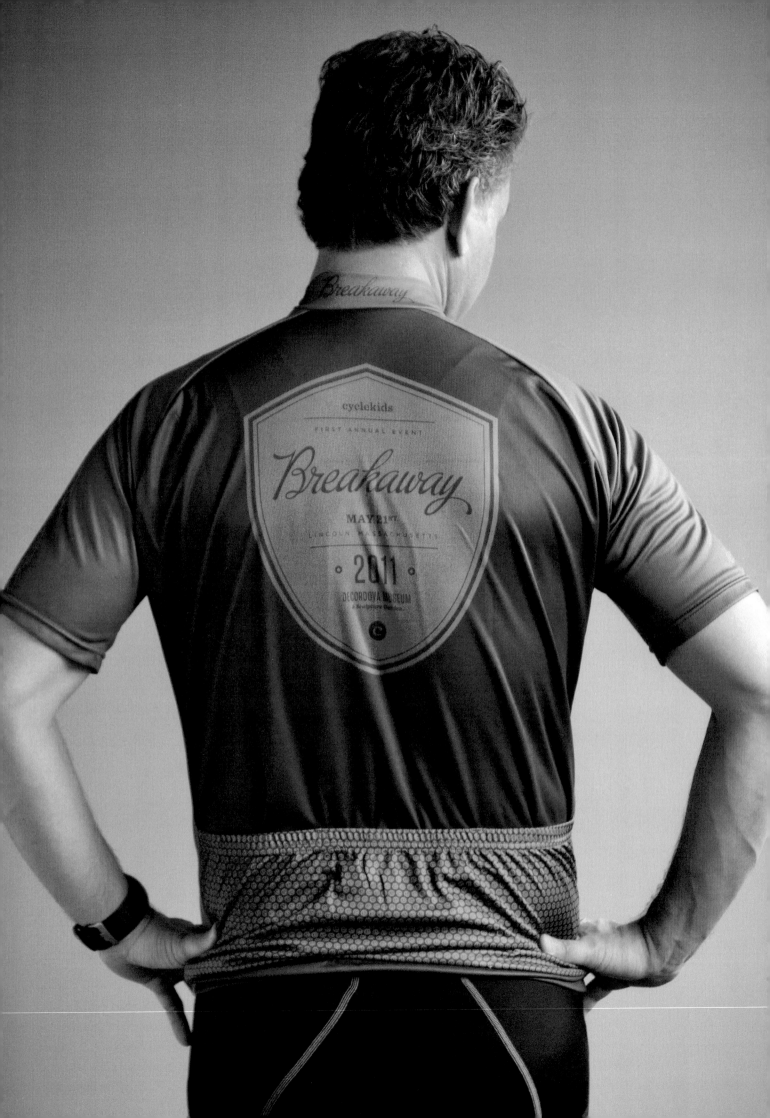

PlatinumWinners

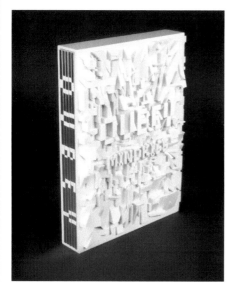

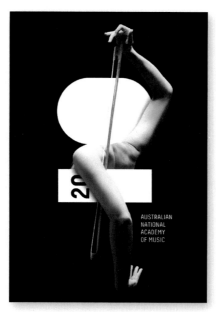

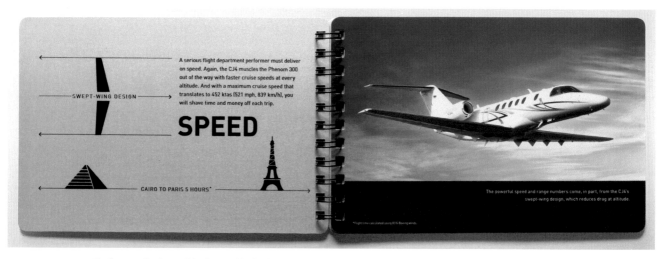

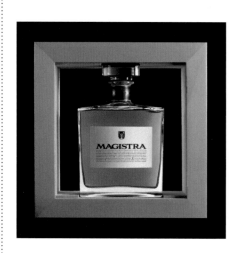

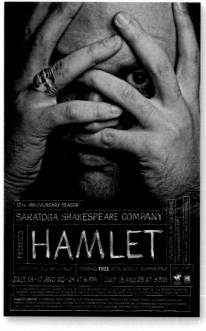

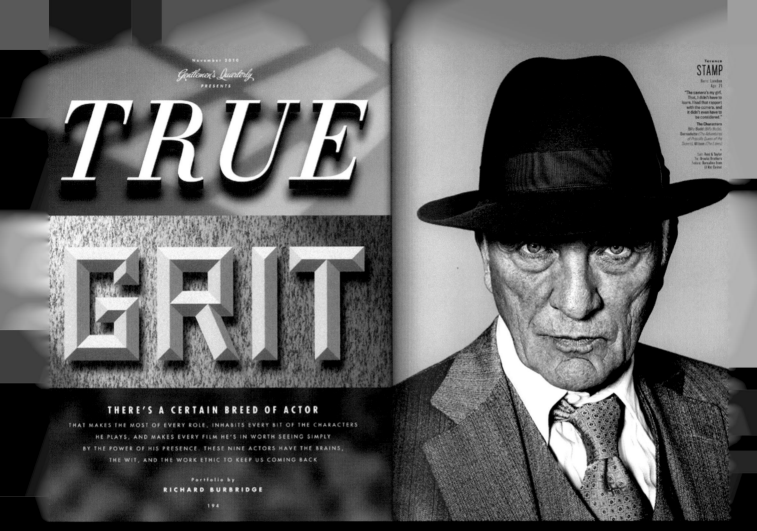

November 2010

Gentlemen's Quarterly

PRESENTS

TRUE
GRIT

THERE'S A CERTAIN BREED OF ACTOR

THAT MAKES THE MOST OF EVERY ROLE, INHABITS EVERY BIT OF THE CHARACTERS
HE PLAYS, AND MAKES EVERY FILM HE'S IN WORTH SEEING SIMPLY
BY THE POWER OF HIS PRESENCE. THESE NINE ACTORS HAVE THE BRAINS,
THE WIT, AND THE WORK ETHIC TO KEEP US COMING BACK

Portfolio by
RICHARD BURBRIDGE

194

Terence
STAMP
Born: London
Age: 71

"The camera's my girl.
That, I didn't have to
learn. I had that rapport
with the camera, and
it didn't even have to
be considered."

The Characters
Billy Budd (*Billy Budd*),
Bernadette (*The Adventures
of Priscilla Queen of the
Desert*), Wilson (*The Limey*)

Suit: Hart & Taylor
Tie: Brooks Brothers
Fedora: Borsalino from
JJ Hat Center

pg 110 Category: Editorial Title: True Grit Designer: Thomas Alberty Design Firm: GQ Magazine Design Director: Fred Woodward Photographer: Richard Burbridge Client: GQ Magazine

THE
LAST
WAILER

EVEN THE NAME IS LEGEND. BUNNY WAILER
He grew up *in the same house as* BOB MARLEY,
and together with PETER TOSH, they created not
just THE WAILERS *but a new template for sound.
But only Bunny remains, and today he lives in his
own private Zion. He is not an easy man to visit.*
John Jeremiah Sullivan *ventured to* KINGSTON,
JAMAICA, *shortly after that city burned last
summer, to find reggae's most righteous survivor*

Assignment: The directors of this global, business-to-business architecture and design firm asked for an annual report that would surprise their clients and reflect their design creativity while still putting across all of their other selling points, such as global reach and breadth of practices.

Approach: We chose a Berliner format, similar to Le Monde. While familiar, it's rarely an annual report. We used newspaper devices like a big headline above the fold and tight columns for news, but avoided direct emulation. It has an oxymoronic quality: it's an annual report, but it's not.

Results: The format was controversial during development, criticized as potentially "looking cheap." That objection went away when it appeared. It went on to "sell out," getting more use than any previous annual report. It's been especially popular with our offices in Asia.

Designers: Mark Coleman, Peiti Chia, Mark Jones, Jen Liao | **Design Firm:** Gensler | **Client:** Gensler

DESIGN WORKS.

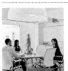
WHEN OUR CLIENTS CONFRONT CHALLENGES, DESIGN OFFERS THEM SOLUTIONS THAT WORK.

Across the global economy, change is in the air. There's a realization that the decisions we make in this new decade will have an impact that will still be felt in 2050. Yet there's an equal need to turn today's challenges into immediate opportunities—to lay the groundwork for strong new growth. As our clients consider what's ahead, design is coming to the fore.

At times like this, everyone is focused on ROI. Reducing costs, boosting performance, or securing a competitive advantage—these goals demand strategy and innovation. "Design thinking" is getting a lot of attention now in the media because design enables organizations of all types to confront their challenges and find robust, game-changing, ROI-conscious solutions. Design is strategy in action, focused on results.

Our clients are contending with a business environment that accentuates geographic, cultural, and other differences. Our strategic and holistic design approach enables them to bridge the diversity and divergence they encounter across their markets. That design works locally and globally is part of its power.

This is why Gensler is positioned to deliver design effectively wherever it's needed. The real world is where the opportunities are. As our clients' global design partner, we've known this for 45 years. In cities around the world, Gensler and our clients are showing how design achieves results that create value for companies and communities and the people they serve. Design works.

This decade is a crucial one. Positioning for the future is the challenge—those who get it right will be the leaders in 2020 and beyond. Design is a powerful means to do this effectively. Gensler is the right choice to harness that power—creating value and achieving the results that will set you apart.

A QUICK GUIDE TO DESIGN THINKING

1 **Question** what conventional wisdom thinks is possible.

2 **Observe** what people actually do—and take it seriously.

3 **Define** the problem in new ways—and connect new dots.

4 **Imagine** the solutions that best leverage this new reality.

The way forward is seldom more of the same. That's rarely been clearer than now. Design offers new ideas and the means of fostering the innovation needed to solve the most challenging problems. By envisioning a better future, design helps the world make progress.

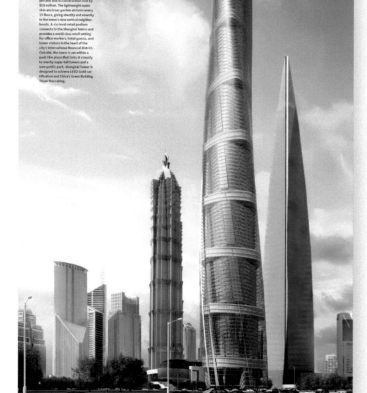

Shanghai Tower
Shanghai, CN

The 2,074-foot-high Shanghai Tower will be China's tallest and the world's second tallest building when it opens in 2014. The breakthrough design cuts wind load by 24 percent, reducing the tower's weight by 32 percent and its construction cost by $58 million. The lightweight outer skin encloses garden atriums every 15 floors, giving identity and amenity to the tower's nine vertical neighborhoods. A six-level retail podium connects to the Shanghai Metro and provides a world-class retail setting for office workers, hotel guests, and tower visitors in the heart of the city's international financial district. Outside, the tower is set within a park-like plaza that links it visually to nearby super-tall towers and a new public park. Shanghai Tower is designed to achieve LEED Gold certification and China's Green Building Three Star rating.

DESIGN WORKS
AT EVERY SCALE.

While megaprojects like Shanghai Tower, CityCenter in Las Vegas, DIFC in Dubai, Tameer Towers in Abu Dhabi, and the L.A. LIVE Tower in Los Angeles attract media attention, the vast majority of our work is modest in scale—but not in quality or innovation! Nor does "big" always mean "tall." Our national and global retail rollout programs add up to "big," even if the increments are small and tailored for their locations. Mass customization enables us to capture economies of scale while shaping the results to these widely different contexts. Even when we design singular projects, they benefit from our vast real-world experience. Design needs to work well at every scale.

"I didn't know you did that!" We often hear this from our clients. Two decades ago, they were surprised that we designed buildings. Now more than a few are amazed to hear that we do interiors! The range of our work is exceptionally broad—that comes with the territory of a global firm with so many valued clients. We believe strongly that our smallest work informs our largest, and vice versa. Behind all of it is our desire to improve performance. Our Workplace Performance Index® (WPI®) measurement and analysis tool for work settings, for example, has influenced the design of work settings large and small.

24,001x

Our Shanghai Tower is 24,001 times larger than our McEvoy Ranch Store in San Francisco. We've done larger and, as our McEvoy Ranch olive oil packaging shows, we've done even smaller.

Sweet Iron
Seattle, Washington, US

The Museum of Bond Vehicles and Espionage
Montreux, Illinois, US

Wenger Swiss Army
Boulder, Colorado, US

McEvoy Ranch Olive Oil
Product packaging

McEvoy Ranch Store
San Francisco, California, US

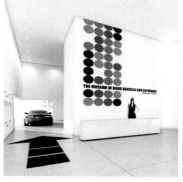

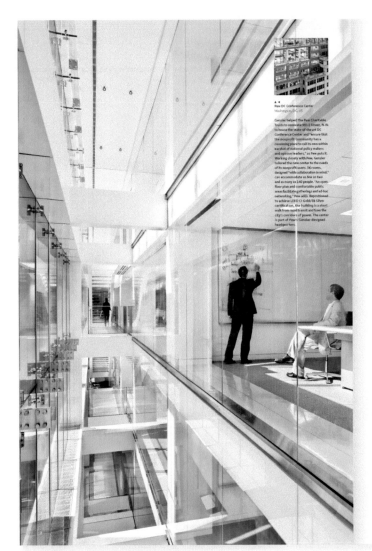

Pew DC Conference Center
Washington, DC, US

Gensler helped The Pew Charitable Trusts to renovate 901 E Street, N.W. to house the state-of-the-art DC Conference Center and "ensure that the nonprofit community has a convening place to call its own within earshot of national policy makers and opinion leaders," as Pew puts it. Working closely with Pew, Gensler tailored the new center to the needs of its nonprofit users. 36 rooms, designed "with collaboration in mind," can accommodate as few as two and as many as 140 people. "An open floor plan and comfortable public areas facilitate gatherings and ad-hoc networking," Pew adds. Repositioned to achieve LEED CI Gold/EB Silver certification, the building is a short walk from rapid transit and from the city's corridors of power. The center is part of Pew's Gensler-designed headquarters.

DESIGN WORKS
TO CREATE VALUE.

Gensler 2010 Annual Report

Creating value is why we design. By giving form to strategy, we make strategy actionable in the real world. By posing new possibilities, we resolve dilemmas and get past obstacles and constraints. Design for us needs to be emotionally intelligent, because people experience it. Their responses to great design go to the heart of the value it provides. There's a clear link between human satisfaction and enjoyment and the spirit with which they engage in the different activities of life. For us, great design is sustainable, too. We aim for high performance and we look beyond each project's intended useful life to ask how it can be renewed, reused, or recycled. What we design is flexible and open-ended, ready for whatever challenges the future throws at it. Design wants to be robust so that its value will endure.

We know how to realize the value of design at every scale—small, medium, or large—and in every location. When we work with our clients, the first step is to understand their expectations—their value proposition for the project or program. Together, we create a scorecard that sets out what value means and how it will be measured. As we explore the project's opportunities through design, new ideas and directions are posed. Our focus is on innovation that adds tangibly to ROI through higher performance.

7.5%

Microsoft Store
Mission Viejo, California, US

Mineta San Jose International Airport
San Jose, California, US

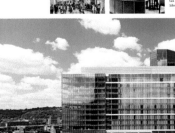

Kimpton Hotel Palomar
Philadelphia, Pennsylvania, US

Gensler transformed the 1920s Architects Building from offices into an award-winning four-star hotel that maximizes the number of guest rooms—and historic preservation tax credits—while achieving LEED Silver certification.

3PNC Plaza
Pittsburgh, Pennsylvania, US

3PNC Plaza sets the stage for Pittsburgh to become a model of smart, sustainable urban growth. The hybrid nature of the 750,000 square-foot, 23-story mixed-use development adds value to the downtown core, feeding energy and commerce into the city. A LEED Gold–registered project, the complex includes a Fairmont Hotel, offices, condominiums, and ground-floor retail. This combination of diverse uses in a single project—strategically placed at the intersection of downtown Pittsburgh's commercial and cultural corridors, close to PNC Park—catalyzes and rejuvenates the city.

DESIGN WORKS
TO FOSTER COMMUNITY.

Gensler 2010 Annual Report

Communities are constantly challenged by events in the world and events on the ground. Design works to stretch their resources, achieving vitally important goals with true economy of means. Design can be the change agent that transforms them, puts them on the map, and gets them from good to great. It works for communities the same way it works for business. The need for strategy, the desire for robust solutions—they're just as strong, every bit as crucial. Gensler engages communities at many different points: emotional touchstones, places of learning and enjoyment, the settings of civic life. Our work for them also exemplifies our shared commitment to sustainability. Communities are in it for the long haul.

Communities rarely go it alone. They look to the private sector to contribute in myriad ways to the quality and vitality of urban life. These partnerships are mutually beneficial and reinforcing. They can be focused on buildings, on infrastructure, or on the lively, amenity-filled settings that activate the cityscape. Design ensures that they contribute directly to the quality and vitality of urban life. It provides the framework for managing growth, sustaining prosperity, and reviving economic conditions. Design works to help communities thrive.

20:1

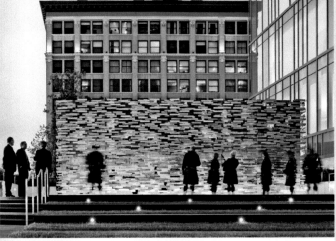

Fourth Presbyterian Church Learning Center
Chicago, Illinois, US

For Fourth Presbyterian Church, serving the community has always been a focus. The five-story learning center makes room for these activities. Its modern design complements the neo-Gothic sanctuary next door.

St. John's University D'Angelo Center
Queens, New York, US

D'Angelo Center gives St. John's a campus gateway where commuting and residential students can mix. Flexible classroom space eliminated the need for a second new building.

Snoqualmie City Hall
Snoqualmie, Washington, US

George Washington University Charles E. Smith Center
Washington, DC, US

New York University Steinhardt Department of Music
New York, New York, US

The James L. Dolan Recording/Teaching Complex gives NYU's music community—faculty and students—state-of-the-art facilities for recording performances by individual artists and ensembles, and teaching how to make those recordings.

Tianjin Eco-City
Tianjin, CN

Houston Ballet Center for Dance
Houston, Texas, US

LAPD Memorial to Fallen Officers
Los Angeles, California, US

This wall of some 2,000 brass plates honors those on the city's police force who have died in the line of duty. The names are water-jet cut through the plates, which reflect and refract daylight to create a shimmering presence across from City Hall.

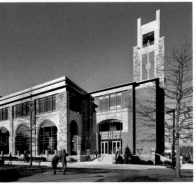

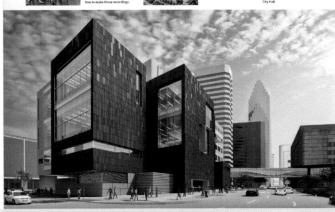

4

Assignment: The Calgary Society for Persons with Disabilities (CSPD) is a non-profit organization that helps people with disabilities enjoy a more independent lifestyle. We were tasked with demonstrating where their money is spent throughout the year and the impact it had on the quality of life for the residents of the CSPD.

Approach: We wanted to communicate that the CSPD was more than a facility designed to care for people. It's place where people become part of a family — an unconventional family but a family nonetheless. For this year's annual report, we projected the CSPD story and financials throughout the homes of residents and photographed the projections for each page of the report. A labor of love for a client we love.

Results: An enthusiastic response and applause from our clients and the board at the annual general meeting.

Designers: James Bull, Monique Gamache | **Design Firm:** WAX | **Creative Directors:** Joe Hospodarec, Monique Gamache
Client: Calgary Society for Persons with Disabilities

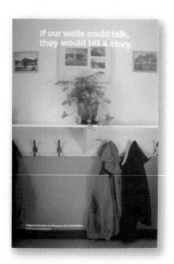

A story about a group of people who came together and created a family. An unconventional family, but a family nonetheless.

A family that always finds a way to make less seem like more.

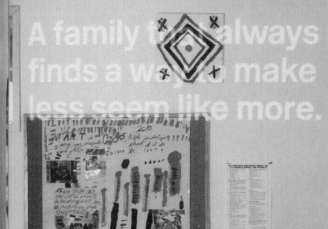

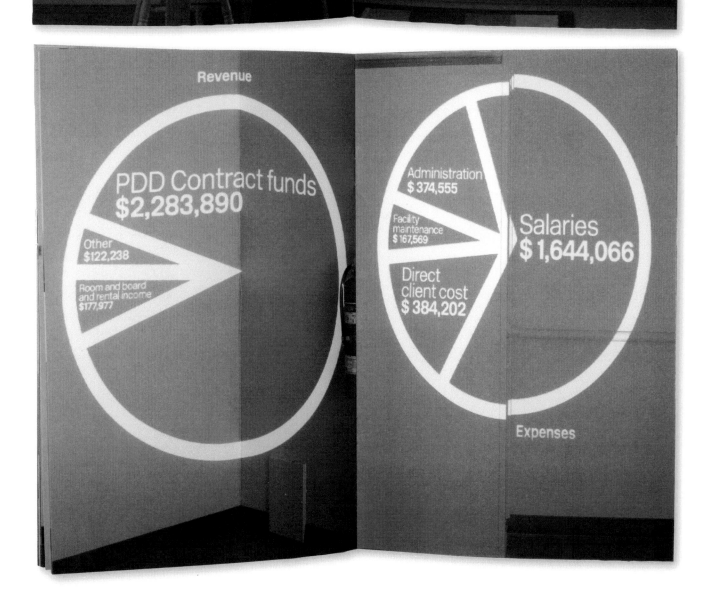

Revenue

PDD Contract funds
$2,283,890

Other
$122,238

Room and board and rental income
$177,977

Administration
$374,555

Facility maintenance
$167,569

Direct client cost
$384,202

Salaries
$1,644,066

Expenses

Assignment: This project gathers a selection of stamps, including the 130 that I have created for the CTT-Correios de Portugal from 1984 until now. During 24 years, I've made several philatelic issues and last year, a Portuguese editor invited me to publish some of these projects in a book. At first, I had to make a careful selection of the issues that I found the best and fit them in a predefined subject. Then, I have had to increase its didactic character, showing the different steps that involves each illustration to be successful.

Approach: This project was developed by myself for myself. My main concern was to join the stamps by subjects and recover all the preparatory sketches, such as studies of detail, color and composition. I also researched among all the options I had found in order to reach the final illustration.

Results: Since at the moment I am both author and client, I have to say I was doubly pleased with this project. Firstly, all the stamps ordered by CTT-Correios de Portugal were approved and achieved. Also, It is my greatest desire to have this book published, and I've had a very positive reaction from readers (especially the philatelic public). I have also received expressions of high regard from all those who enjoy illustration and graphic design.

Art Director, Designer: João Machado | **Design Firm:** João Machado Design, Lda | **Client:** Self-Promotion

JOÃO MACHADO

SELOS
STAMPS

Introdução Introduction
Rene Wanner

calei
dosc
ópio

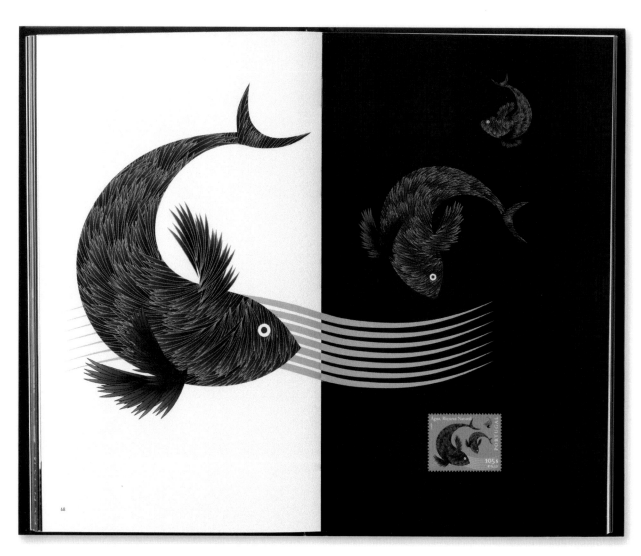

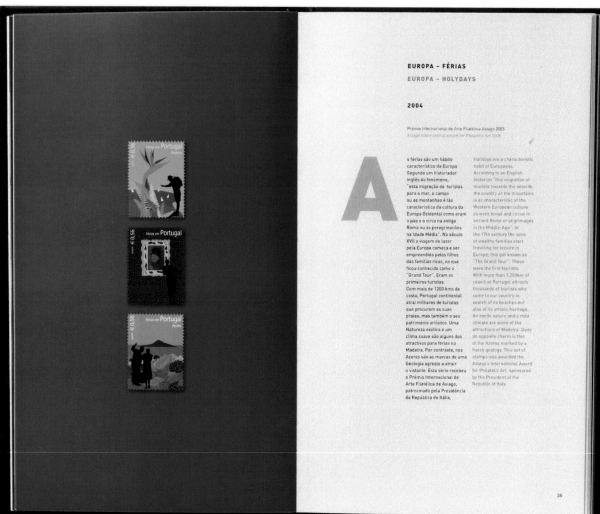

EUROPA – FÉRIAS

EUROPA – HOLYDAYS

2004

Prémio Internacional de Arte Filatélica Asiago 2005
Asiago International Award for Philatelic Art 2005

As férias são um hábito característico da Europa. Segundo um historiador inglês do fenómeno, "esta migração de turistas para o mar, o campo ou as montanhas é tão característica da cultura da Europa Ocidental como eram o pão e o circo na antiga Roma ou as peregrinações na Idade Média". No século XVII a viagem de lazer pela Europa começa a ser empreendida pelos filhos das famílias ricas, no que ficou conhecido como o "Grand Tour". Eram os primeiros turistas. Com mais de 1200 kms de costa, Portugal continental atrai milhares de turistas que procuram as suas praias, mas também o seu património artístico. Uma Natureza exótica e um clima suave são alguns dos atractivos para férias na Madeira. Por contraste, nos Açores são as marcas de uma Geologia agreste a atrair o visitante. Esta série recebeu o Prémio Internacional de Arte Filatélica de Asiago, patrocinada pela Presidência da República de Itália.

Holidays are a characteristic habit of Europeans. According to an English historian "this migration of tourists towards the seaside, the country or the mountains is as characteristic of the Western European culture as were bread and circus in ancient Rome or pilgrimages in the Middle-Age". In the 17th century the sons of wealthy families start traveling for leisure in Europe; this got known as "The Grand Tour". These were the first tourists. With more than 1.200km of coastline Portugal attracts thousands of tourists who come to our country in search of its beaches but also of its artistic heritage. An exotic nature and a mild climate are some of the attractions of Madeira. Quite an opposite charm is this of the Azores marked by a harsh geology. This set of stamps was awarded the Asiago's International Award for Philatelic Art, sponsored by the President of the Republic of Italy.

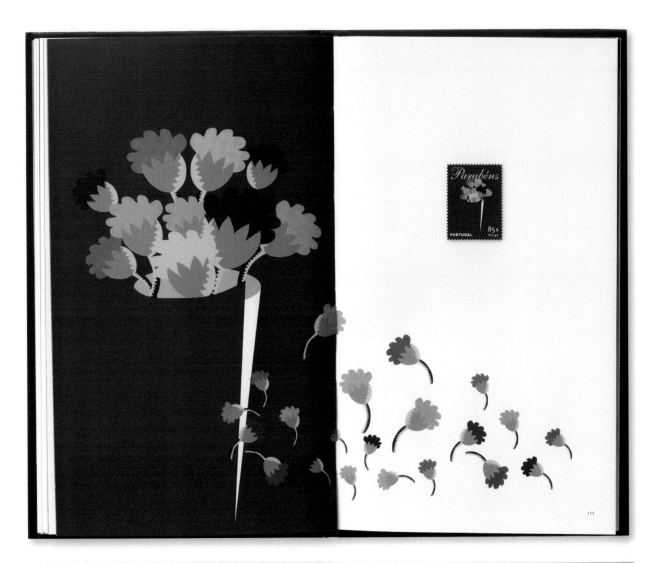

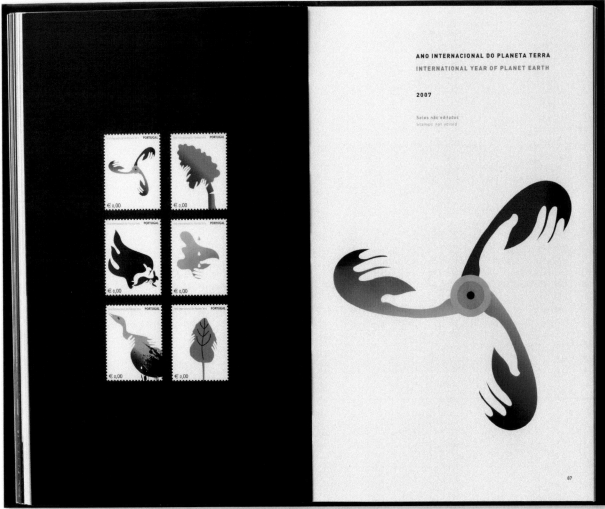

ANO INTERNACIONAL DO PLANETA TERRA

INTERNATIONAL YEAR OF PLANET EARTH

2007

Selos não editados
Stamps not edited

Assignment: This collection of platinum prints of classical subject matter, signals a departure for portrait photographer Mark Seliger.

Approach: We approached 'Listen' as though it were a book for Alfred Steiglitz and therefore opted for understated typography and traditional methods of book making such as the tipped-on cover plate, foiled type on cloth and custom patterned end pages.

Designers: Fred Woodward, Chelsea Cardinal | **Photographer:** Mark Seliger | **Client:** Rizzoli

SELIGER

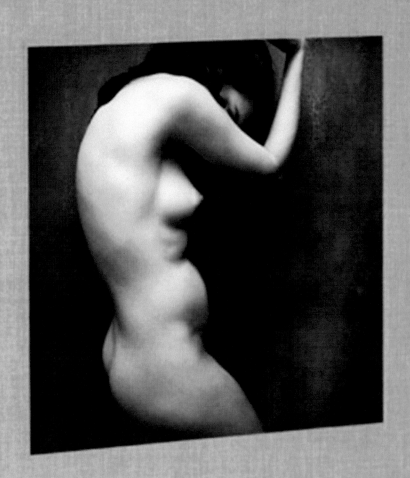

LISTEN

MARK SELIGER LISTEN

Assignment: Box 21 is a Swedish crime fiction book. The two main characters are detectives investigating deaths related to both drugs and sexual slavery. Although the story is a bit gruesome at times, I felt like there was more to the story.

Approach: I wanted to avoid shocking imagery and try to communicate something a bit smarter. In the story, there is some key information that is revealed on a video tape. I thought focusing on that could make for an interesting image. I worked with Lindsey Brunsman, a designer in our studio, on the idea of illustrating the title type out of video tape. She constructed the final illustration and we photographed it. Then, I added in the additional type. Henry Sene Yee at Picador was the art director I worked with on this project.

Results: Henry is great to work and his commitment to excellence is inspiring. Picador was pleased with the final cover. I enjoyed this project very much and am proud of the final cover.

Designer: Charles Brock | **Design Firm:** Faceout Studio | **Client:** Picador

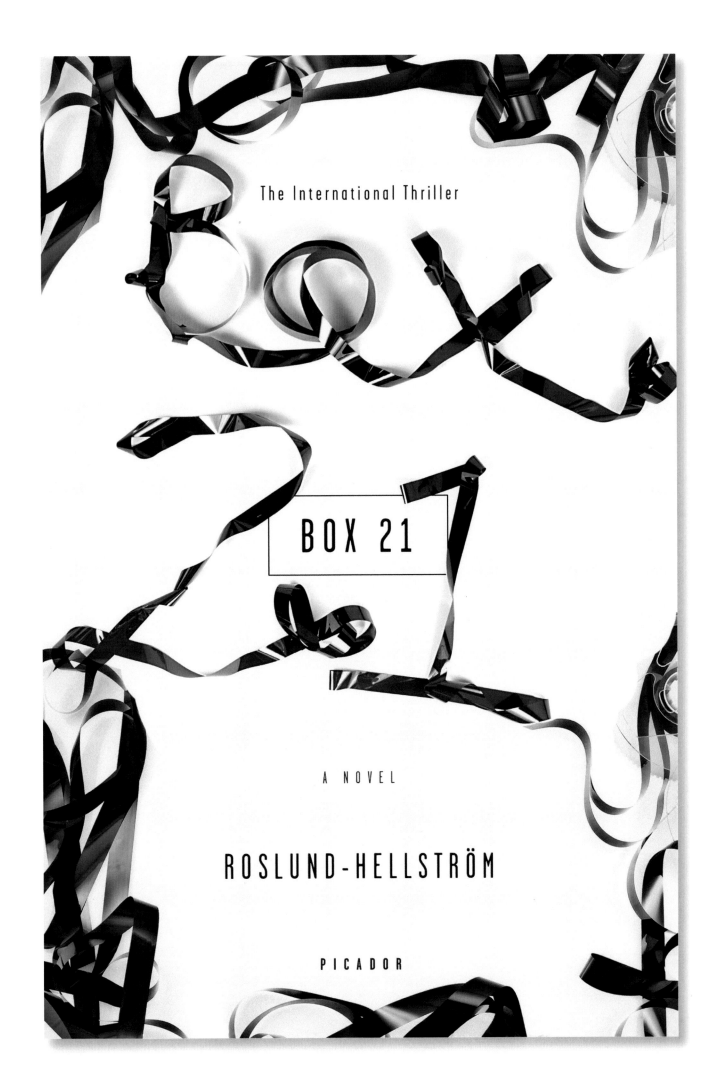

The International Thriller

BOX 21

A NOVEL

ROSLUND-HELLSTRÖM

PICADOR

Assignment: This book about all the cultural activities of BMW contains four hidden wheels, comes with a remote control and really does drive around the room. Culture moves. All 1,500 printed books feature a different, individual cover design. When displayed together they form a giant white and blue graphic reminiscent of the famous BMW headquarters building in Munich.

Designers: Karim Charlebois-Zariffa, Richard The, Joe Shouldice, Manuel Buerger | **Design Firm:** Sagmeister, Inc.
Creative Director: Stefan Sagmeister | **Client:** BMW

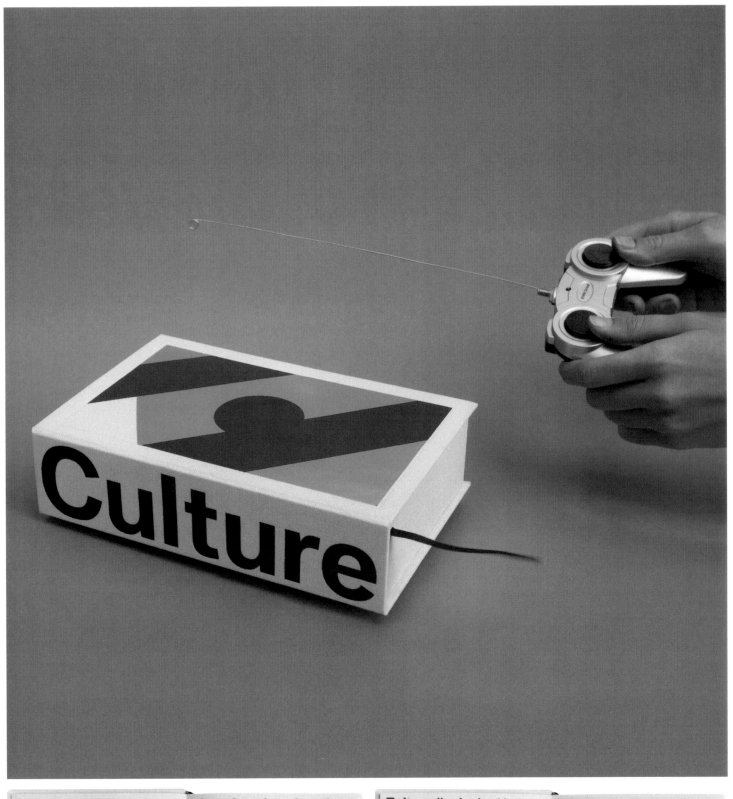

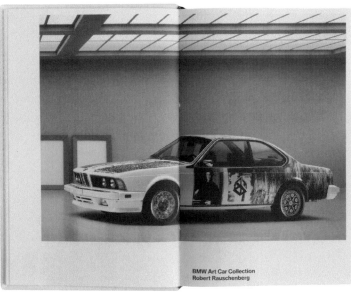

BMW Art Car Collection
Robert Rauschenberg

Zeitgenössische Kunst /
Contemporary Art

Assignment: his lavish publication introducing the art of the late German artist Oubey was designed as five distinct books. These books are contained in a fractal white slip case reflecting Oubey's formal interest in the sciences.

Results: You can purchase this book at Amazon

Designers: Seth Labenz, Roy Rub | **Design Firm:** Sagmeister, Inc. | **Creative Directors:** Dagmar Woyde-Koehler, Stefan Sagmeister
Photographer: Visuell GmbH | **Production Company:** Guz Gutmann, Laurence Ng | **Client:** Oubey

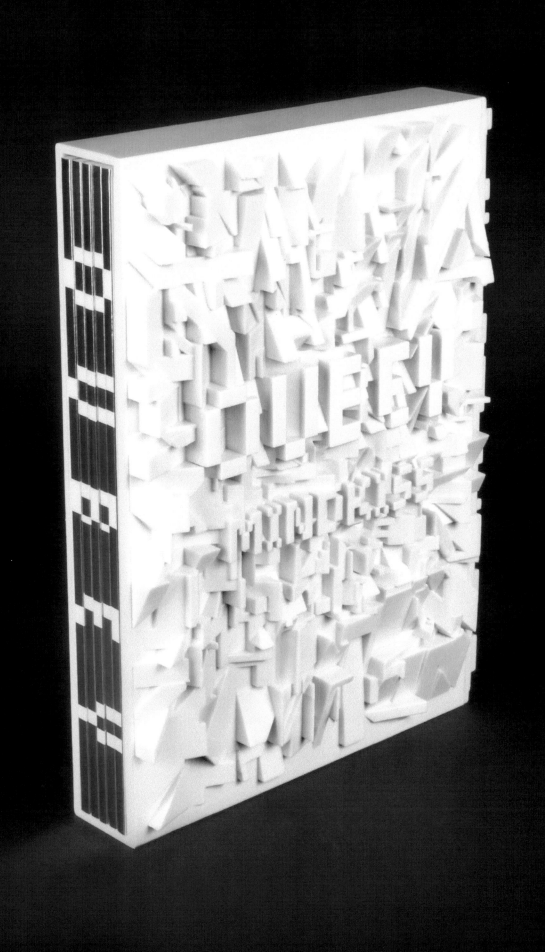

Assignment: The assignment was to create a book presenting some of Sweden's foremost antique dealers. Antique dealers today have a very important role as stewards of art and the decorative arts passing on not only the history of the antiques themselves but also the history and context in which they were made. The dealers in the book represents a wide span of fields as furniture, art, silver and so on. The challenge was to find a design that could represent all of these fields.

Approach: We chose to work with large pictures to illustrate the dealer's antiques. The historical part is very important so therefor sections with fact about stamps and similar was added to give the reader a possibility to learn more and grow an interest in antiques. This adds an extra value besides the presentation of the dealers. The cover stands for the different fields that the dealers represent. Our solution resulted in a plain and high quality cover where we used the two languages Swedish and English, that follows inside the book, to illustrate both the antiques and the modern antiques. The duality returns in the choice of typefaces — a roman and a sans serif typeface.

Results: The result is representing the branch and the subject both design-wise and artisan-wise. The finished book "Swedish Antique Dealers" by Sofia and Pontus Silfverstolpe was presented at the Antiques Fair 2010 in Stockholm, presenting 33 members from the Swedish Arts and Antique Dealer Association.

Designer: Jan Vana | **Design Firm:** Dolhem Design | **Client:** Sofia and Pontus Silfverstolpe

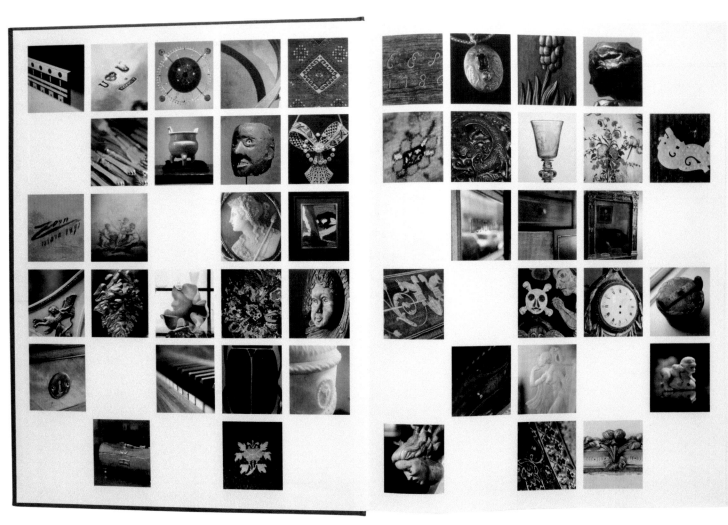

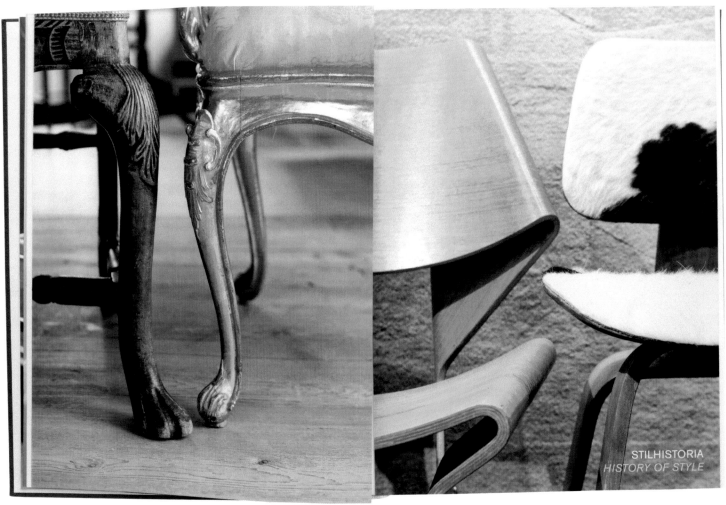

STILHISTORIA
HISTORY OF STYLE

Assignment: Design a Michael O'Brien photography book that includes poems by Tom Waits.

Approach: We took a subtle typographic approach that used two different papers — uncoated for the poems; coated paper for the photographs.

Results: The book has been a success and is getting a second print run.

Designers: DJ Stout, Barrett Fry | **Design Firm:** Pentagram | **Client:** University of Texas Press

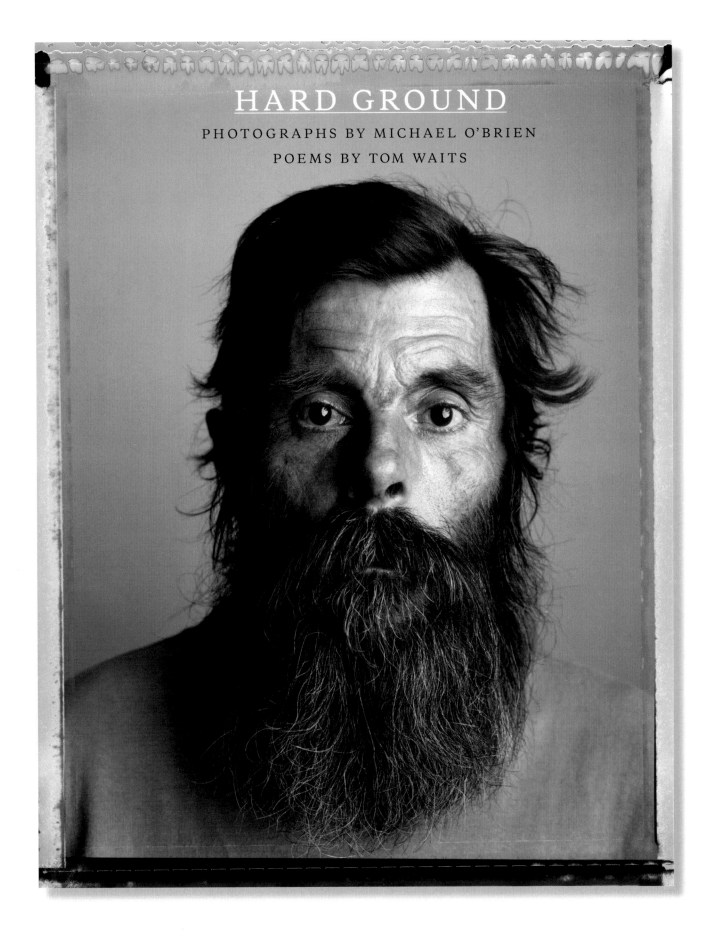

HARD GROUND

PHOTOGRAPHS BY MICHAEL O'BRIEN
POEMS BY TOM WAITS

Assignment: Barrio Boy is the story of a boy's journey from a rural Mexican village to the barrio of Sacramento, California in the early 1900s. Contrasting cultures and extraordinary events are recounted with the strong sense of a child's perspective and memory.

Approach: On the cover, the boy is depicted with eyes in shadow and obscured by the title, suggesting the struggle to maintain identity in a new culture. He wears a woven cowboy hat — a subtle reference to the unlikely blend of American and Mexican heritage.

Results: The client was happy with the final results. Her exact words were, "It is perfect. This is such a fantastic cover. Thank you, Tim."

Designer: Tim Green | **Design Firm:** Faceout Studio | **Client:** University of Notre Dame Press

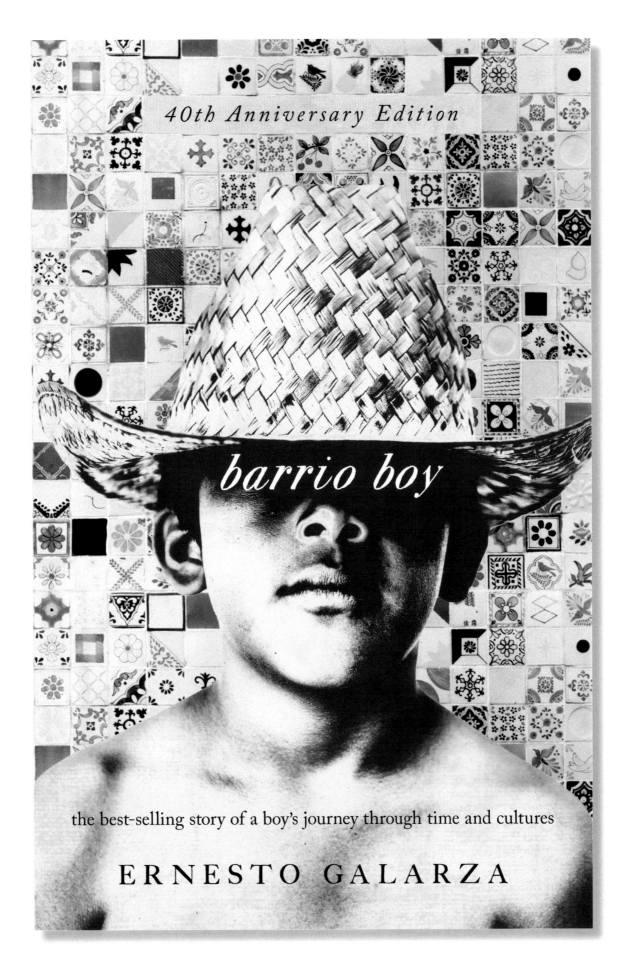

40th Anniversary Edition

barrio boy

the best-selling story of a boy's journey through time and cultures

ERNESTO GALARZA

Assignment: The assignment was to design a book that told the story of a talented chef, how his restaurants came to be and what his style of cooking is. It had to function both as a cookbook and as an image piece for the chef and his brand.

Approach: Our approach was to listen carefully to the kind of book the client wanted, study his aesthetic carefully, eat his food often and get to know as much as possible about the subject. Once we had a good idea what he and his brand stood for, we translated those ideals into a design direction we though would represent him well.

Results: The client loved the book. It sold more than 600 copies at a book launch event and has sold well in distribution and at the restaurants.

Designers: DJ Stout, Julie Savasky | **Design Firm:** Pentagram | **Client:** Uchi

uchi

THE COOKBOOK

BY TYSON COLE AND JESSICA DUPUY

FOREWORD BY LANCE ARMSTRONG

Assignment: Develop creative concepts that promote the Nike Tennis 2011 Spring product line to the 14 to 17-year-old tennis player. Concepts must be flexible enough to work within a variety of channels (such as retail stores, outdoor advertising, print advertising, online, etc.) across the globe while leveraging Nike's top tennis athletes.

Approach: Before concepting, writing or designing anything, we looked into what the Australian Open is all about and what that specific time of year means to a tennis player. For the ambitious athlete that Nike targets, it means to start the season strong. Coming out of a winter break, a dark period, where players prepare and train hard, their year opens with a big bang in Australia. We used signature moves of each of Nike's top tennis players to create powerful collages that symbolize their diversity of play and the explosive nature of the game at the beginning of each tennis season. Ultimately, the creative promotes the gear needed to rise to the top and start strong.

Designer: Justin LaFontaine | **Design Firm:** 160over90 | **Chief Creative Officer:** Darryl Cilli | **Copywriter:** Brendan Quinn | **Creative Director:** Tammo Walter
Executive Creative Director: Jim Walls | **Photographer:** Thomas Ammon | **Client:** Nike Tennis

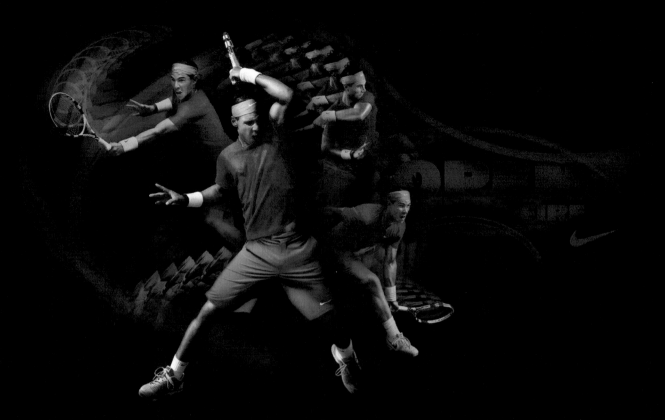

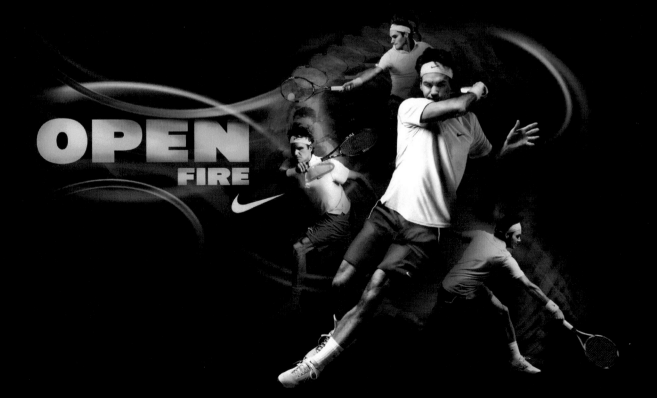

OPEN
FIRE

Assignment: New identity needed to express a new brand positioning for the Victoria Beckham label with its associated values and create a visual system that would unify various brand divisions, such as high fashion dresses, denim, eyewear and bags.

Approach: The immediate recognition of the brand comes from the association of Victoria and Beckham — the two words separately carried a host of alternative connotations. So we tried removing the break between the two words. In the process, we discovered an interesting rhythm to the word, with Victoria's last A providing a subtle division between the name and surname while, at the same time, providing a unifying bridge, a harmonious centre point. The noted repetition of the triangular characters — V, A, M — was suitably striking and hinted at a graphic solution that was at once unique and subtle. Close observation of the VB fashion collections, and especially the high fashion dresses also provided the clue for the development of the brand's visual language and an enhancement of the brand experience. The inspiring use of different textiles and fabrics compelled us to instill a tactile dimension to the brand communication. Undeniably, there is an immediate, almost instinctive experience attached to clothing. We feel somehow urged to feel, to touch the fabric before anything as reflective as trying anything on takes place. We therefore decided to extend this sensual experience into the packaging and paraphernalia realms, experimenting with printing processes such as die cutting, foil blocking, thermo-graphic print, etc. Ultimately, we developed an individual texture for each division, to be embossed on paper surfaces and supported by a unique color. These individually developed sub-identities were applied consistently throughout the divisions, and in the various incarnations of swing tags, envelopes, invitations, etc.

Designer: Sasha Vidakovic | **Design Firm:** SVIDesign | **Client:** Victoria Beckham

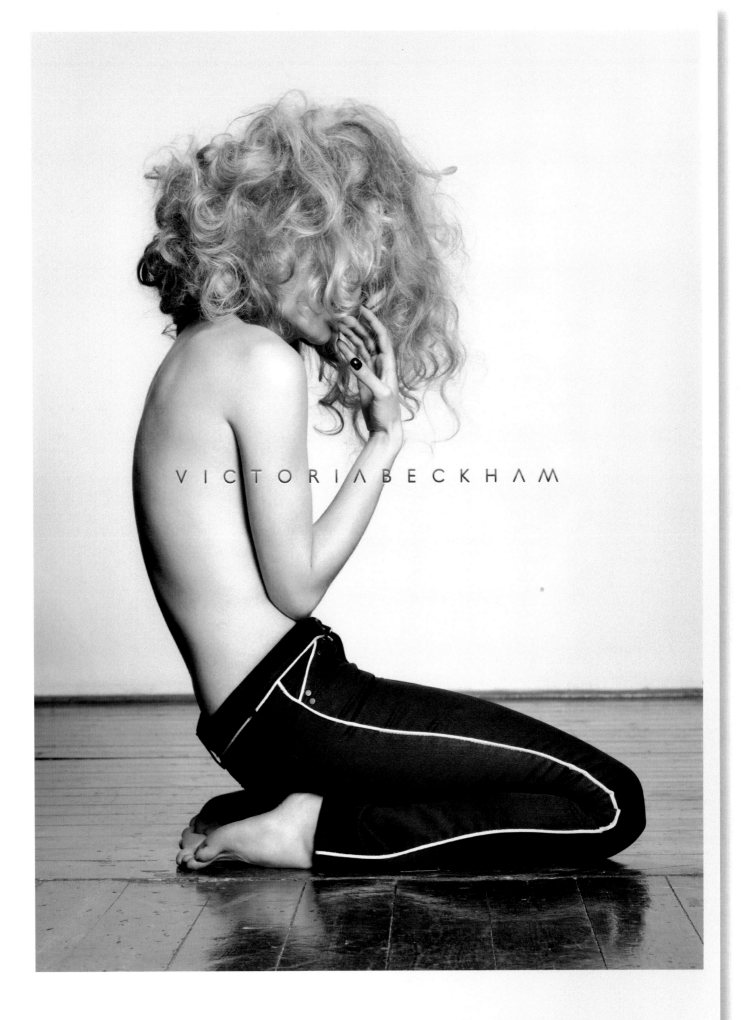

Italiano

Beckham Ventures
30 Panorama Dock
35-37 Parkgate Road
London
SW11 4NP
www.victoriabeckham.com

QUESTI OCCHIALI DA SOLE SONO CONFORMI ALLE SEGUENTI NORMATIVE

... europea: EN 1836 2005
... americana: ANZ Z80.3 2001
... australiana/neozelandese: AS/NZS 1067: 2003
OCCHIALI DA SOLE PER USO GENERICO ... NON IDONEI PER LA VISIONE DIRETTA DEL SOLE ... CURA DELLA LENTE DEL FILTRO 3 ... RIDUZIONE DEI, RIFLESSO ... E PROTEZIONE DAI RAGGI UV ... UV: 100% A 400nm

ISTRUZIONI PER LA CURA E LA PULIDA

QUALITÀ DELLA MONTATURA

Gli occhiali da sole VICTORIA BECKHAM sono ... a mano, nel rispetto degli standard qualitativi più elevati.
Le montature in plastica sono ricavate da fogli di ... policarbonato, vengono assemblate a mano e ... a mano per confezire una lavorazione ... in ogni stagione. I materiali in plastica ... vengono progettati e prodotti esclusivamente per VICTORIA BECKHAM.
Le montature metalliche sono assemblate a mano utilizzando titanio e leghe di alta qualità, ... vernice da rivestimento coloniale e smalti protettivi.

QUALITÀ DELLE LENTI

Tutte le lenti sono realizzate utilizzando le ... plastiche disponibili e vengono trattate per assorbire le radiazioni ultraviolette. UVA e UVB: esse proteggono l'occhio da lesioni di breve e lunga durata.

AVVISO: Queste lenti non sono idonee per l'osservazione diretta del sole (ad esempio durante le eclissi).

VICTORIABECKHAM

VICTORIABECKHAM

Assignment: Langara College is a British Columbian post-secondary educational institution that offers a wide range of university, career and continuing studies programs. Langara's reputation as a quality institution was perceived to be more "middle of the road" and no longer occupied a top-of-mind position. Our job was to better define Langara's key attributes and establish what makes their institution remarkable through a new, updated logo and brand platform. It was important to establish Langara's reputation for quality education and communicate their commitment to being a first-rate college.

Approach: We distilled the brand's essence down to a singular idea: "The College of Higher Learning." Higher learning means more than just textbooks and lectures. It comes from formal education, social interaction, problem-solving and teamwork. This became the springboard for the creative concept "Dialogue." The dialogue concept creates a unique platform that communicates the attributes of the brand. Unusual for the category, the dialogue concept is a headline-based platform.

Results: The re-brand was fully embraced by the College's administration staff, faculty, existing and prospective students. The re-brand launch party was extremely well attended. The 2010/11 View Book (20,000 copies) were fully distributed vs. the previous year when 15,000 copies were printed and 5,000 copies went into the recycle bin. Langara's goal of 30 percent funding through sponsorships was exceeded by 6 percent.

Designers: James Bateman, Lisa Ma I **Design Firm:** DDB Canada/Karacters Vancouver I **Account Director:** Lauren Rowe
Agency Producer: Courtney Smith I **Art Director:** Lisa Ma I **Copywriter:** Jarrod Banadyga I **Creative Director:** James Bateman I **Client:** Langara College

We don't just feed minds.

You are a student, not a number.

Assignment: The WilliamsWarn is the world's first personal brewery. It produces commercial quality beer, chilled and straight from the tap in just seven days. The WilliamsWarn is perfect for the home, workplace, bars or cafés.

Approach: Back in 2009, the WilliamsWarn was still a product in development, with no name, positioning or identity. Over the course of the following two years, the naming, positioning, marketing strategy, identity design and graphic system were developed while the product design evolved. A new category of "personal brewing" was established. As this was a machine capable of far more than homebrewing, it led to a positioning of: "Personal brewing without compromise" "Beer Drinkers" became "Beer Thinkers" and the name WilliamsWarn was born from the surnames of the two inventors: Ian Williams and Anders Warn. A modern day Rolls Royce, but for beer. The WilliamsWarn brand needed to reflect the hand-built, premium feel of the machine with its numbered makers' plate and stainless steel finish. It also needed to acknowledge beer and the simple nature of the product. The result was the WilliamsWarn "W" which shows the coming together of two beer glasses in that "cheers" moment. The circular housing device is a reference to beer mats. The personal feel was achieved through the use of the makers' signatures across collateral. A simple and classic color palette of black and silver references the materials used on the product alongside typography utilizing Trade Gothic and applied across stationery, packaging, collateral, website, video and product graphics.

Results: The WilliamsWarn has launched to worldwide acclaim. Although only initially available in New Zealand, the company received over 200 offers of distribution from over 50 countries in the first five months. WilliamsWarn aims to start exporting by early 2012 and expects $10 million plus annual export revenues by the following year. "When I saw the logo Studio Alexander came up with, I knew immediately it was perfect. I was expecting bright colors and a complicated design. It was one of those moments when you know something is just right. There was nothing to change and we've had a huge amount of very positive feedback." — Ian Williams, Director, WilliamsWarn

Designers: Richard Unsworth, Zoe Ikin | **Design Firm:** Studio Alexander | **Creative Director:** Richard Unsworth | **Client:** WilliamsWarn

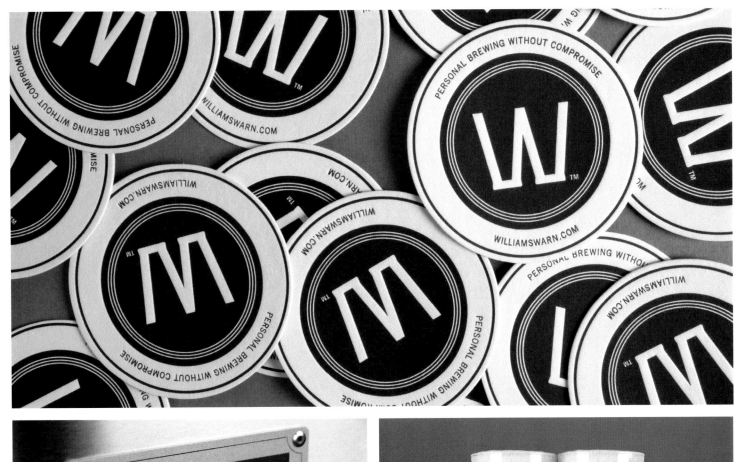

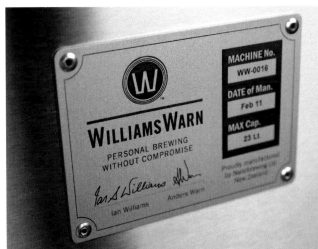

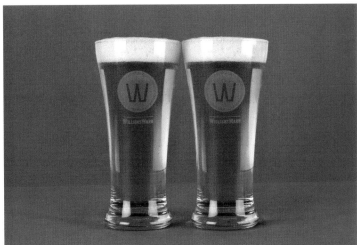

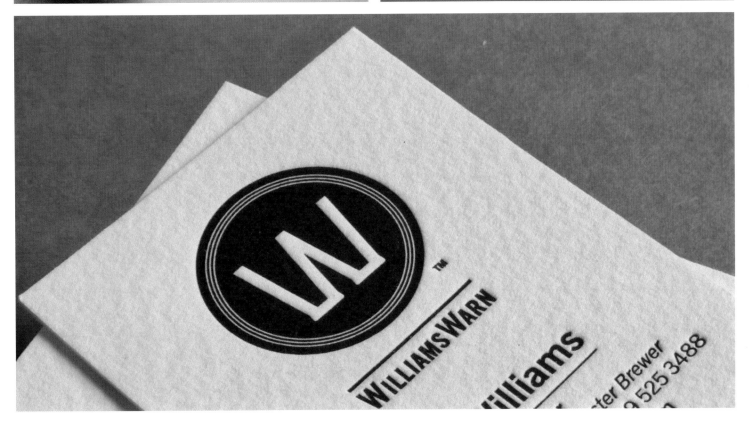

Assignment: We called the Jones Bros. Cupcake project, "Branding From Scratch," because we literally started with a blank sheet of paper that had no names or preconceptions. We started with research, positioning and naming. Phase two was to develop the visual identity, which included a primary logo, a secondary logo and supporting visual elements as well as a refined color palette. Phase three involved bringing the brand to life in the environment, both on the interior and exterior with signage, banners, window appliqués, menu boards and wall graphics. The final phase encompassed brand activation and rollout including advertising, website, social media and in-store promotion.

Results: Our clients are pleased and their business is successful. Customers and potential employees typically comment favorably on the branding, signage and packaging and many think Jones Bros. is a national franchise. Jones Bros. and the branding have appeared on local blogs, in publications and on national television in Cupcake Wars. In addition, our efforts have garnered a variety of local, regional and national recognition from the creative community.

Design Firm: Webster Design Associates | **President and Creative Director:** Dave Webster | **Art Directors:** Loucinda Hamling, Sean Heisler
Client: Jones Bros. Cupcakes

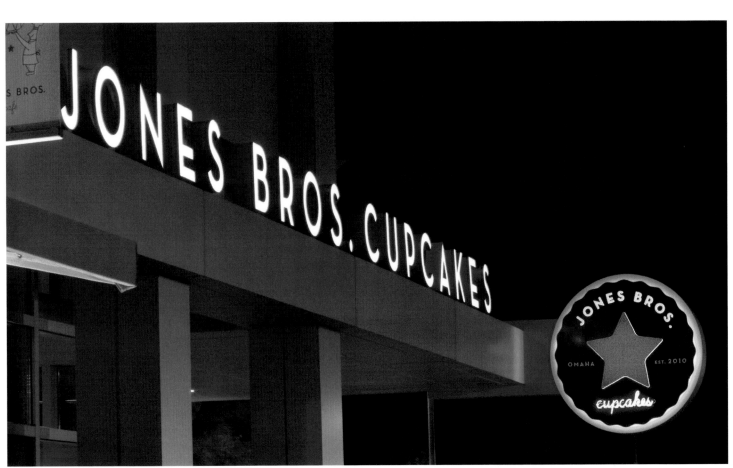

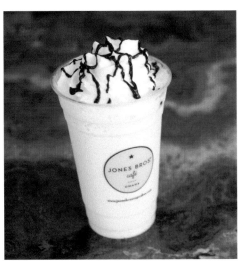

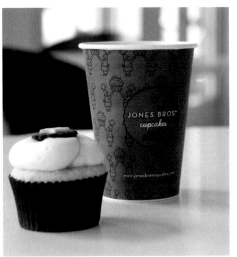

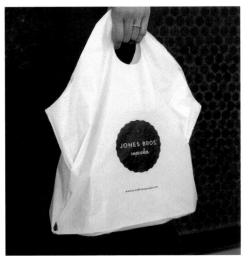

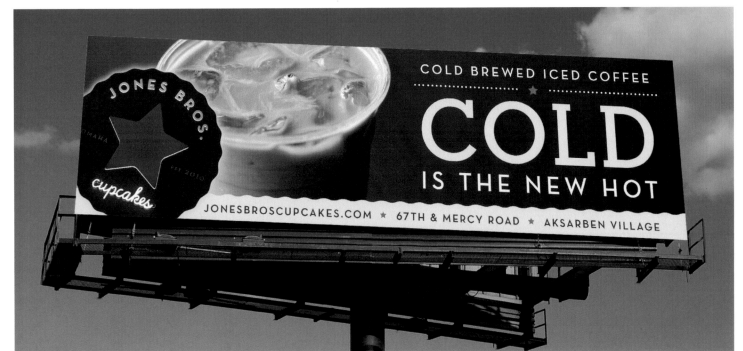

Assignment: The manufacturer of high-quality kitchens "Miele die Küche" has operated under the name "Warendorf" since the beginning of the year 2010. It was necessary to design an entirely new visual identity to reposition the brand in the premium segment.

Approach: The new logotyype and corporate design reflect the high quality standards in all product areas. The German name alludes to the long-standing tradition and authenticity of the brand and emphasizes that the kitchens are manufactured in Warendorf and are truly "made in Germany." The double crown logo formed from the letter "W signalizes the lasting value of these products. The corporate color "Titanium" is derived from the durable and elegant material of the same name. It gives an exclusive yet reserved look. The "Univers" typeface is known for its clear legibility and modern elegance.

Results: The result was a successful reposition of the brand in the premium segment with high acceptance of the new corporate design.

Designers: Carl Bartel, Atli Hilmarso | **Design Firm:** KMS TEAM GmbH | **Client Manager:** Alexandra Schneiderhan
Managing Partner: Knut Maierhofer | **Project Manager:** Nina Albrecht | **Team Manager:** Julia Oesterle | **Client:** Warendorf

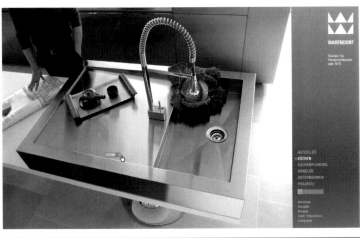

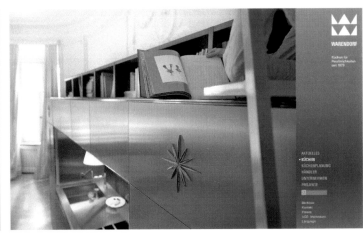

Assignment: From depictions of the grotesque to the satirical observation of the 19th century caricaturists, to the anarchical word play of the Surrealists, artists have harnessed the power of humor for centuries. This exhibition of 80 works took as its title and theme Divine Comedy, a tongue-in-cheek nod to Dante's great epic poem; that journey through the Inferno, Purgatory, and Paradise provided the structure for the show, catalogue and all marketing collateral.

Approach: Installed in Sotheby's 10th floor galleries, Inferno highlighted the darker side of humor — devils, heretics, death and violence. This part of the catalogue, exhibition and marketing collateral was portrayed as black or sometimes dark red and dramatic. Purgatory represented as gray, included the seven deadly sins (including lust, gluttony, greed and sloth) as well as moral issues related to politics and the church. Paradise featured heavenly joy — a place of virtue, faith, hope, love and beauty — and was depicted in bright white or light baby blue. The exhibition also featured a newly-commissioned installation for the building's York Avenue windows, in collaboration with the Public Art Fund; and was accompanied by a fully-illustrated catalogue with an essay by best-selling author James Frey.

Results: There was universal acclaim from clients, staff, and other art world professionals for all the design aspects of the show. It was deemed successful in that we are continuing the "formula."

Designers: Tirso Montan, Sandra Burch, Lisa Dennison | **Design Firm:** Sotheby's | **Client:** Sotheby's

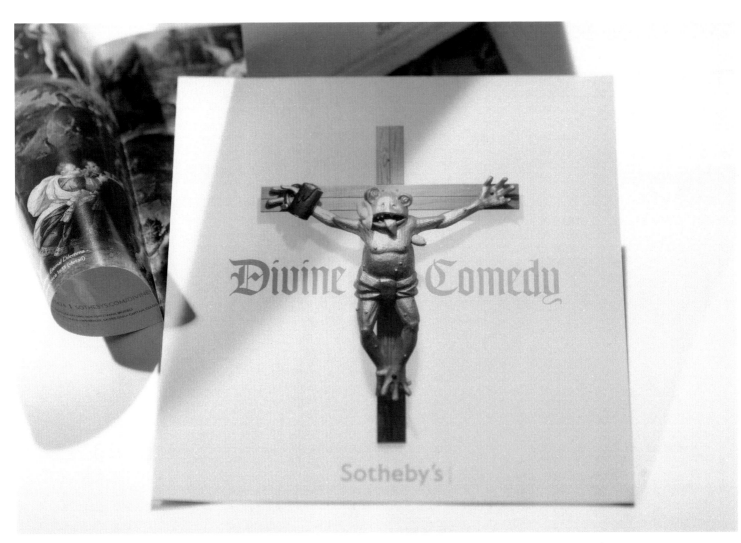

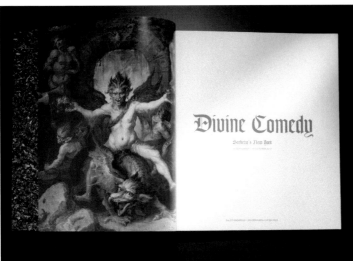

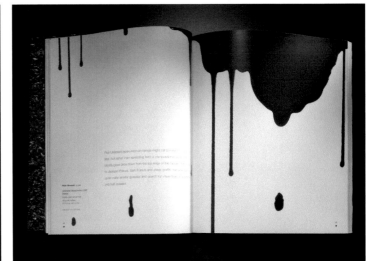

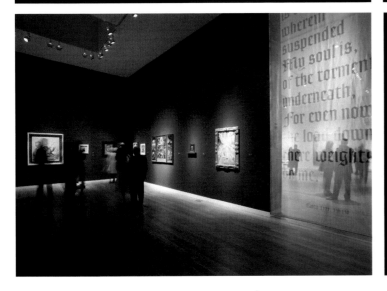

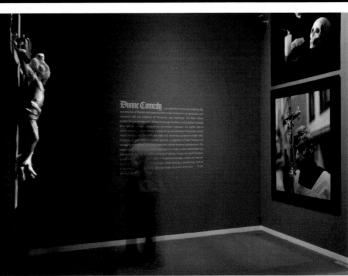

Assignment: The goal for the Cycle Kids Breakaway fundraiser was to brand the first-time event. We had a small budget to produce the materials, so we needed a creative but consistent approach for all of the necessary event items. We first named the program, then roughed out the mark and sub-marks and created the identity to be a flexible system — from a cycling jersey, to event tickets, posters, bags, T-shirts and water bottles. Once all of the materials were finalized, we had a sense that it worked pretty well but we couldn't really be sure until the day of the event. We thought all along that the cycling fundraiser and branding would create a positive energy, and that energy would appeal to kids, young families and seasoned cyclists. But not until the riders and volunteers came together in late May, ready to participate, did we really get a sense of what we created. We could see that we had made something special for Cycle Kids.

Approach: The process was developed through a very detailed brand audit that helped the Founder and event committee quickly see what we were proposing for the fundraiser. During that first presentation, we had selected the name and had our feedback on the likes and dislikes of the audit. We then turned our attention to the main brand and sub-brands, including some of the tertiary and supporting elements. We also knew the design and materials had to come together very quickly. With few design edits from the client, we were ready to send files to several vendors to produce the various materials well in advance of the late May cycling event.

Results: For obvious reasons, the client had some trepidation going into their first ever event and the founder placed a lot of pressure on the branding to be perfect for the fundraiser. Two months later, as people assembled near the starting line, the Founder of Cycle Kids said she was thrilled to see all of the jerseys and T-shirts gathered together. She later mentioned, several times, that it exceeded all of her expectations. We were very pleased to hear the news. Months later, she still hears positive feedback on the jerseys and the event.

Designer: Ben Scott | **Design Firm:** Weymouth Design | **Creative Director:** Robert Krivicich | **Client:** Cycle Kids

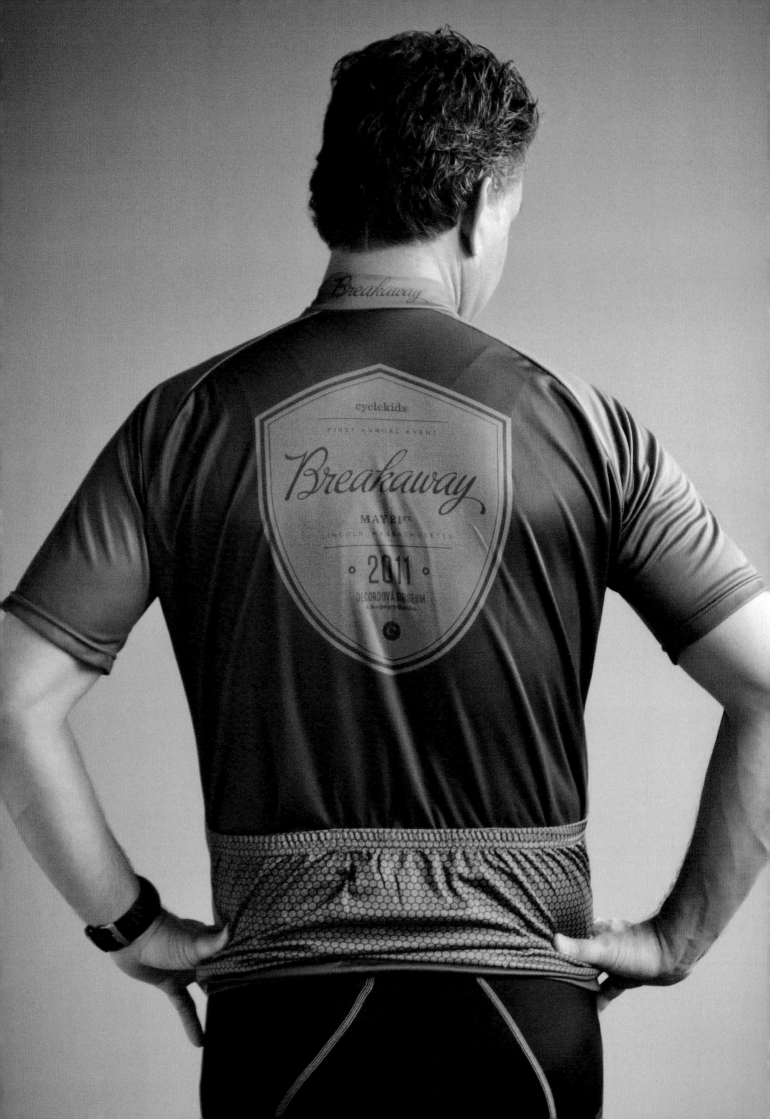

Assignment: Salon M Squared is a new salon focused on exquisite service, high quality products and progressive hair design. Before its debut, the salon approached Zync to help with a strategic, creative brand that would signal its arrival and define the salon's full range of services and client experience. In a crowded, competitive field, Salon M Squared needed to stand out.

Approach: The first step in our branding process was to research the salon's competitors. We looked at everything from their overall marketing strategies to their online presence, from their image to their color palette. This scope of research provided us with a clear picture of the salon's opportunities to distinguish itself. The brand and interior design were developed in tandem to create a cohesive brand and consistency between the brand promise and the space. We designed two versions of the logo to provide Salon M Squared with the flexibility it needs for a variety of marketing initiatives, including signage, direct mail, brochures, gift cards, e-mail and social media campaigns. Their website is especially important and had to fully embody their brand — progressive design, quality and exquisite service. The site includes an online booking system and details about salon services and products. The clients can also purchase gift cards, write feedback, sign-up for salon promotions, and follow updates through various social media channels.

Results: We developed a look and feel that embodies a professional, fashion-forward and relaxing experience to appeal to the salon's sophisticated clientele. The salon's website not only strengthened consistency with the branded communications, it has also served to eliminate missed appointments and boosted bookings. We worked with Salon M Squared to map out a brand that would allow them to stand out from the competition. With its new brand in place, Salon M Squared has a solid foundation and a bright future.

Designers: Charlie Kim, Jenny Vivar, Peter C. Wong, Annie Navaleza-Paradis | **Design Firm:** Zync | **Creative Director:** Marko Zonta
Project Manager: Heather Martinez | **Client:** Salon M Squared

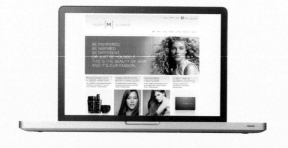

PRESENT THIS CARD
TO RECEIVE 15% OFF
SALON SERVICES ANY
MONDAY TO FRIDAY.

SALON [M] SQUARED

186 Wilson Avenue
Toronto, Ontario M5M 4N7
T 647 346 6454

www.salonmsquared.ca

SALON [M] SQUARE

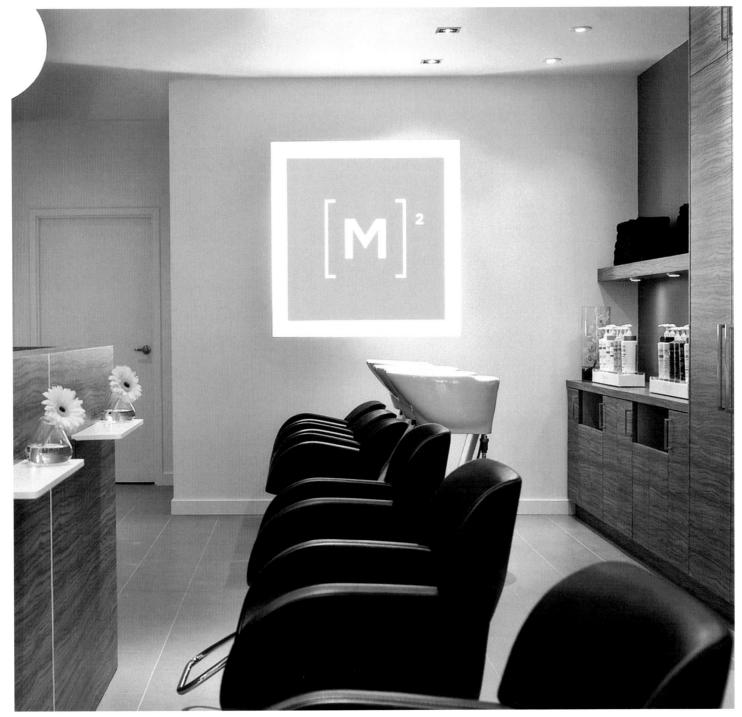

Assignment: The goal is to develop trademark name, modern and stylish logo, brand legend and funky products design for newly created laptop sleeves and accessories company. Designs should differ from other business-oriented boring classic sleeves.

Approach: Legend says that Blobs are funky and strange intelligent creatures. They are very sociable and curious. It is difficult to say where exactly their world is since it is located in a different space-time continuum. Any descriptions of it are only partly correct because there are no adequate definitions neither in our dictionary nor in our terms. Therefore, all further description is based on the totality of our perceptions about blobs and described in terms that are accessible to our understanding. Name of these creatures comes from the word "blob" (bubble) due to our understanding of their form and movement. The striking feature of the blobs world is a variety of colors — it is infinite and the vast majority of colors can not be described or replicated in the human world. The main characteristic of blobs is the color.

Results: BLOBS become popular shortly after the launch of sales. Fan clubs were created in popular social media networks. Without any advertising support BLOBS found their friends and owners in different places of the world from Iceland and Russia to Thailand and USA.

Designers: Sergii Artemov, Gera Artemova, Oleksii Chernikov | **Design Firm:** Artemov Artel | **Client:** BLOBS

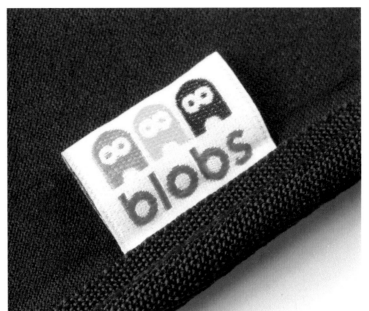

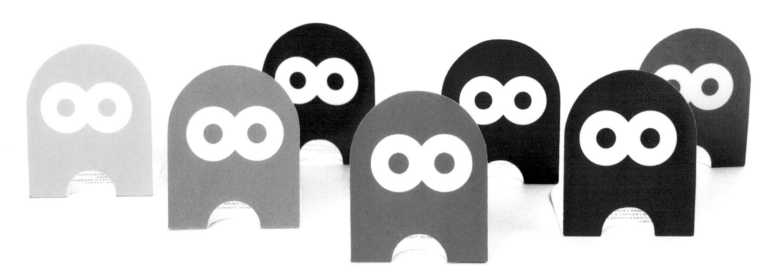

They are **always** with you

Where do **blobs** come from?

Always dreamed to be an **Astronaut?**

Bags coming soon

Assignment: The Lincoln Children's Museum seeks to raise $5 million to improve and expand its exhibits. This campaign was targeted to the general public to generate donations.

Approach: The concept was simple. Use vibrantly colorful children's play tools to announce that Lincoln needs to build a better children's museum. As part of the overall campaign, this brochure also deepened the concept by adding incomplete photos of children at play, which had to be filled in with stickers.

Results: The fundraising campaign has already reached its monetary goal, but the creative campaign will continue to encourage ongoing donations.

Design Firm: Bailey Lauerman | **Art Director:** James Strange | **Creative Director:** Raleigh Drennon | **Illustrator:** James Strange
Print Producer: Gayle Adams | **Client:** Lincoln Children's Museum

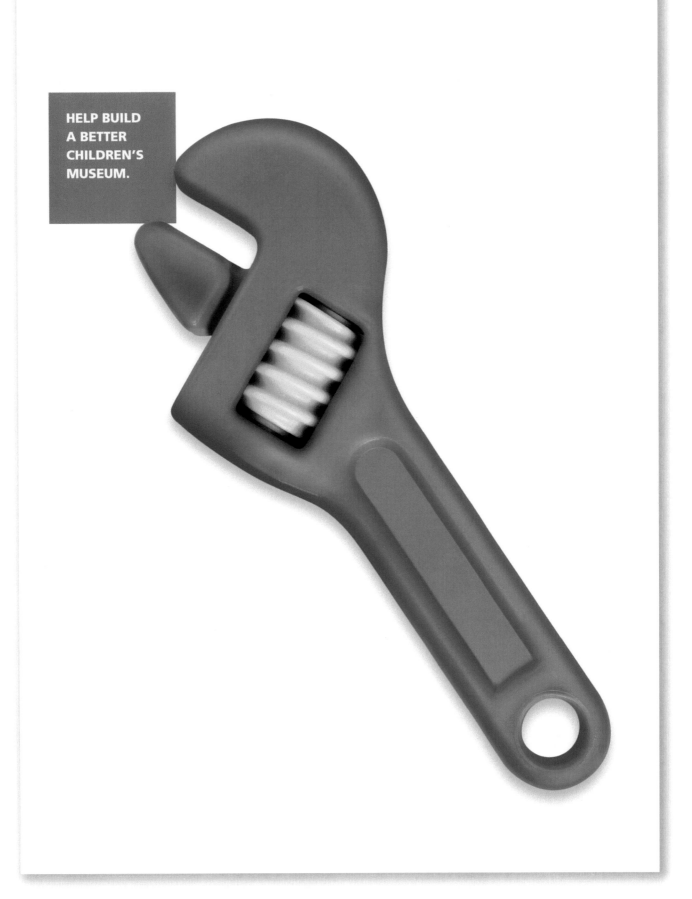

HELP BUILD
A BETTER
CHILDREN'S
MUSEUM.

Assignment: The Sammlung Schack is a noted collection of German art of the 19th century and part of the Bayerische

Staatsgemäldesammlungen (Bavarian State Picture Collections). Coinciding with the centenary of the gallery building, the Sammlung Schack

presented itself with renovated interiors, walls painted in vivid colors changing from room to room and a new corporate design.

Approach: The new corporate design is based on two main features. First, the use of the DIN typeface, which is common to all the art museums

of the Bavarian State (for instance the Pinakothek museums). Second, a "corporate pattern" consisting of the iteration of three aligned

rectangles, which are derived from the tripartite façade of the building.

Results: The new corporate design gives the museum a fresh appearance attracting a broader public. All the same, it avoids any kind of forced

fashionability that could interfere with the characteristics of the paintings.

Designer: Teresa Lehmann I **Design Firm:** KMS TEAM GmbH I **Client Manager:** Katja Egloff I **Managing Partner:** Michael Keller
Team Manager: Mark Ziegler I **Client:** Bayerische Staatsgemäldesammlungen

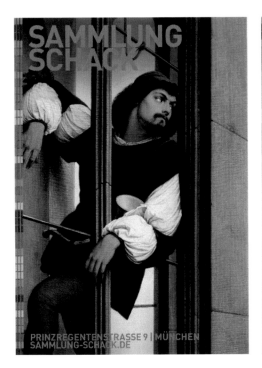
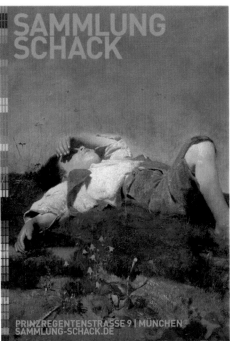
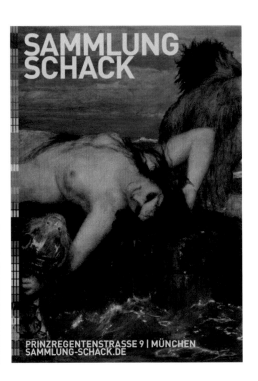

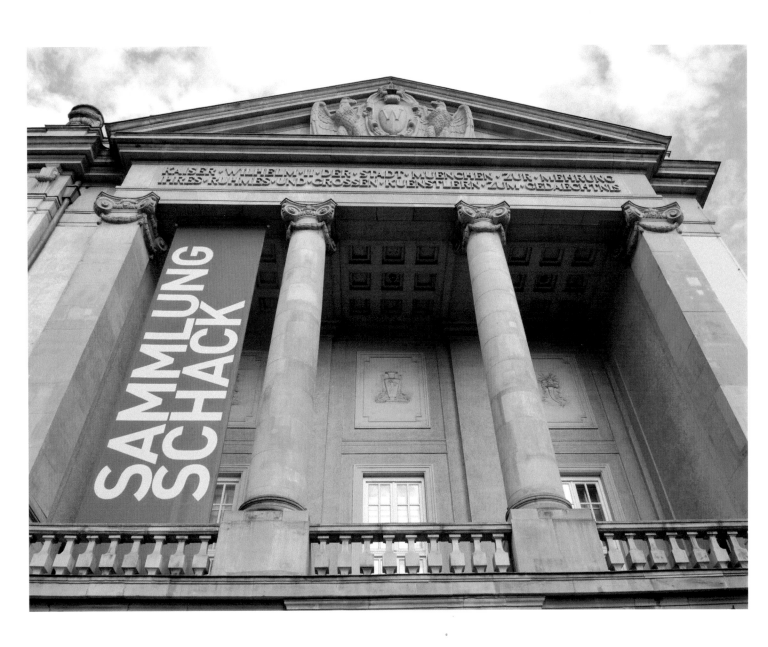

Assignment: The Australian National Academy of Music is Australia's elite training centre for young classical musicians. It occupies a unique niche on the Australian classical music landscape by offering a performance-based training program that fosters inventiveness, imagination and courage in developing the country's future musical leaders. The Academy required a captivating presence to become a marketing beacon for its 2010 performance season and symbolize its risk taking personality.

Approach: From the outset, the intent was to avoid cliché classical music stimuli and focus instead on the potent and unusual whilst being respectful of the art form. The cover image was specifically created to speak with an unexpected and abstract tone whilst exploring a simplistic yet powerful iconography. It seeks to come across as a fresh twist on a traditionally conservative genre, representing the intertwining of music with the soul and embodying the uniqueness and aspiration of youth. The stark, monochromatic color scheme and custom typography continues within the internal of the brochure.

Results: The client and its industry associates deemed the resulting season branding highly successful in reflecting the leading-edge character of the Academy. Sparking interest at various points of contact for the organization's existing subscriber base and general public alike, it played a role in increased ticket sales and enticing world class artists to mentor and perform with its students.

Designer: Mike Barker | **Design Firm:** Mike Barker Design | **Client:** Australian National Academy Of Music

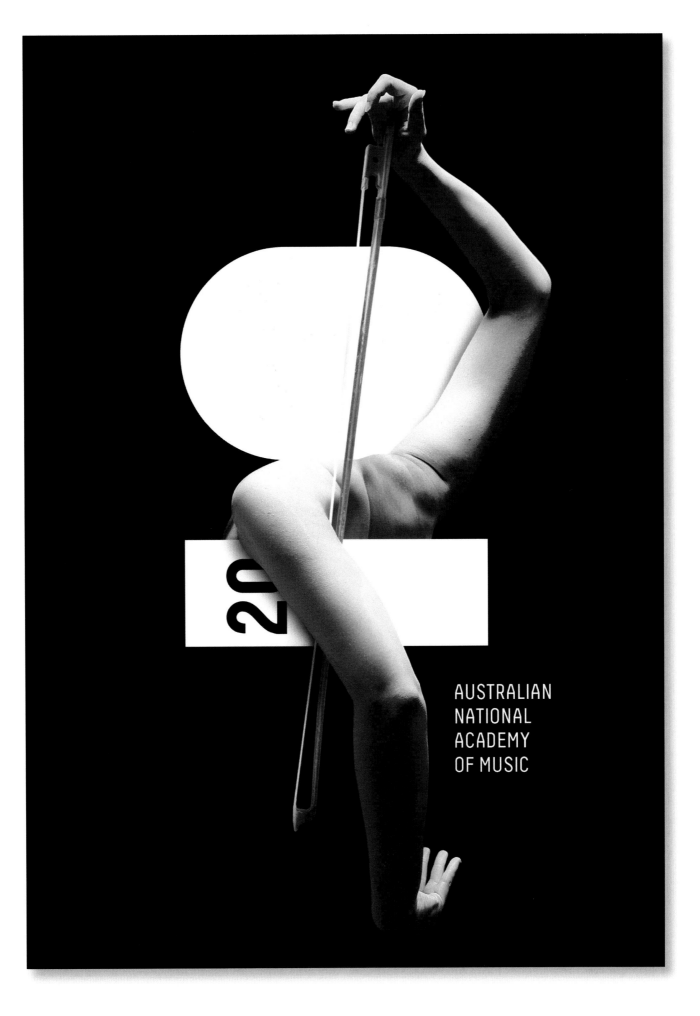

20

AUSTRALIAN
NATIONAL
ACADEMY
OF MUSIC

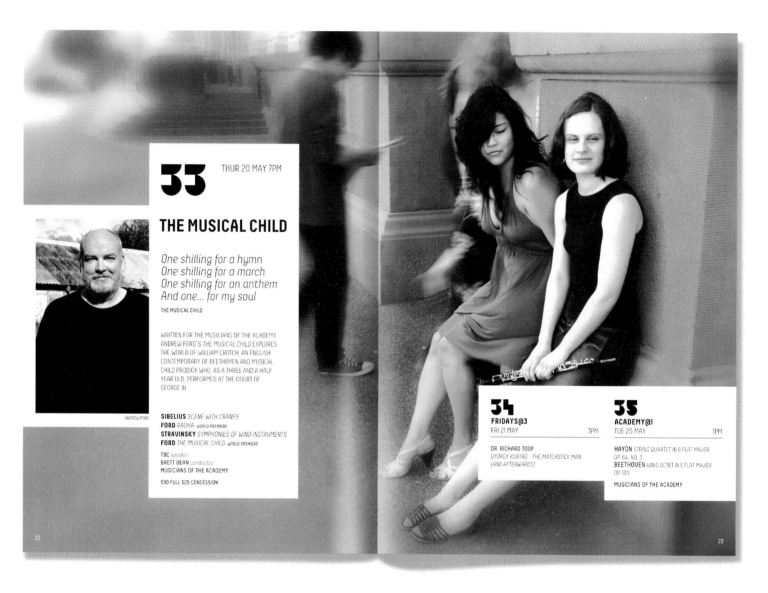

33
THUR 20 MAY 7PM

THE MUSICAL CHILD

One shilling for a hymn
One shilling for a march
One shilling for an anthem
And one... for my soul
THE MUSICAL CHILD

WRITTEN FOR THE MUSICIANS OF THE ACADEMY,
ANDREW FORD'S *THE MUSICAL CHILD* EXPLORES
THE WORLD OF WILLIAM CROTCH, AN ENGLISH
CONTEMPORARY OF BEETHOVEN AND MUSICAL
CHILD PRODIGY WHO, AS A THREE AND A HALF
YEAR OLD, PERFORMED AT THE COURT OF
GEORGE III.

SIBELIUS *SCENE WITH CRANES*
FORD *RAUHA* WORLD PREMIERE
STRAVINSKY *SYMPHONIES OF WIND INSTRUMENTS*
FORD *THE MUSICAL CHILD* WORLD PREMIERE

TBC *speaker*
BRETT DEAN *conductor*
MUSICIANS OF THE ACADEMY

$50 FULL $25 CONCESSION

ANDREW FORD

34
FRIDAYS@3
FRI 21 MAY 3PM

DR. RICHARD TOOP
GYÖRGY KURTÁG - THE MATCHSTICK MAN
(AND AFTERWARDS)

35
ACADEMY@1
TUE 25 MAY 1PM

HAYDN STRING QUARTET IN B FLAT MAJOR
OP 64, NO. 3
BEETHOVEN WIND OCTET IN E FLAT MAJOR
OP 103

MUSICIANS OF THE ACADEMY

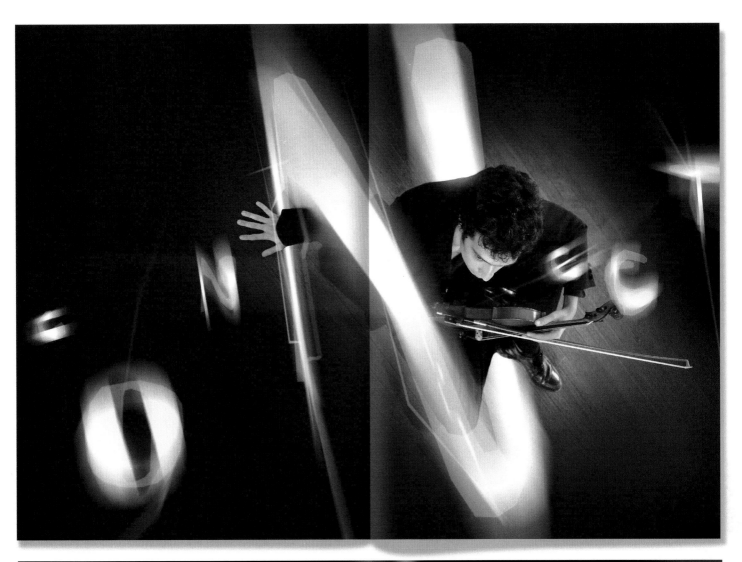

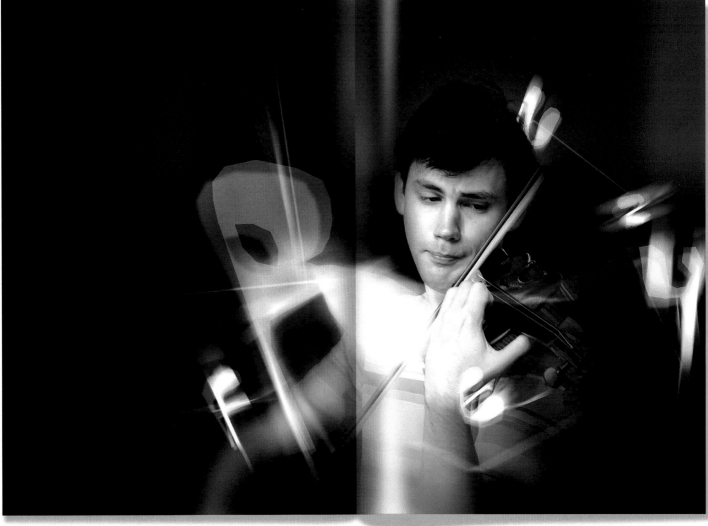

Assignment: Version-X was tasked with creating all new literature for I.C.O.N.'s re-designed product line in anticipation of their U.S. launch. We needed to create a set of brochures that truly captured the brand's essence of class and style. Each book had to have its own personality, but feel like it belonged with the others as a complete set. There was a lot of information to present, but it had to be done in a way that kept potential customers and clients interested and wanting more.

Approach: The overall focus of each piece was to present I.C.O.N.'s products in a clear and interesting way with the use of sharp, punchy photography with bold, contrasting typography and colors. Each book was designed with different color schemes, layout styles and printing effects, but the set is unified by being bound at the same dimensions and designed with the same branded typefaces. There is a sense of individuality for the different services and products, but also a sense of cohesion when the books are brought together.

Results: I.C.O.N.'s popularity has exploded in the U.S. with increased demand for product distribution, educational seminars and further product line expansion. The brochures have gone through multiple press runs to support increased salon and consumer demand for brand interest and I.C.O.N. is creating more new, innovative hair care products all the time.

Designers: Steve Silvas, Adam Stoddard I **Design Firm:** Version-X Design I **Art Director:** Adam Stoddard I **Creative Director:** Chris Fasan I **Client:** I.C.O.N.

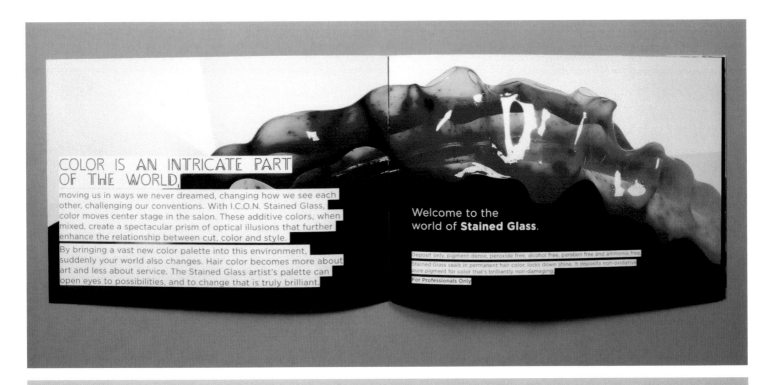

COLOR IS AN INTRICATE PART OF THE WORLD,

moving us in ways we never dreamed, changing how we see each other, challenging our conventions. With I.C.O.N. Stained Glass, color moves center stage in the salon. These additive colors, when mixed, create a spectacular prism of optical illusions that further enhance the relationship between cut, color and style.

By bringing a vast new color palette into this environment, suddenly your world also changes. Hair color becomes more about art and less about service. The Stained Glass artist's palette can open eyes to possibilities, and to change that is truly brilliant.

Welcome to the world of **Stained Glass**.

Deposit only, pigment-dense, peroxide free, alcohol free, paraben free and ammonia free. Stained Glass seals in permanent hair color, locks down shine. It deposits non-oxidative pure pigment for color that's brilliantly non-damaging.

For Professionals Only

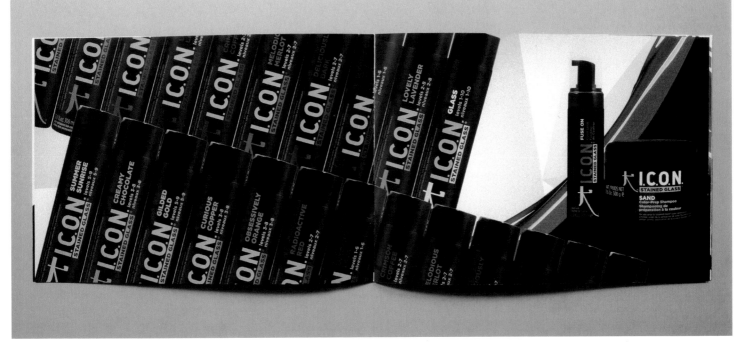

WHAT IS COLOR?

Color plays a vitally important role in our world. It can sway thinking, change actions, and cause reactions. It can irritate or soothe, raise your blood pressure or even suppress your appetite.

As a powerful form of communication, color is irreplaceable. It makes a statement, announces a personality, and creates an illusion that becomes reality.

The Electromagnetic Spectrum

RADIO TV MICROWAVES INFRARED UV X-RAYS GAMMA COSMIC

VISIBLE LIGHT

Color Refraction

PRIMARY

SECONDARY

TERTIARY

THE THEORY OF COLOR

A color circle, based on red, yellow and blue, is traditional in the field of art and has been since 1666 when Sir Isaac Newton developed the first circular diagram of colors. Since then scientists and artists have studied and designed numerous variations of this concept, but the theory persists.

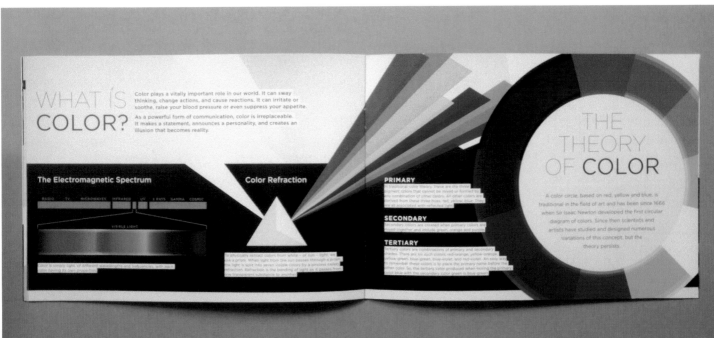

Assignment: To create a brochure to market Chateau St. Tropez for rental purposes. To communicate the special atmosphere of the chateau, a second villa within the estate and to position the property as one of the finest contemporary homes on the Cote d'Azur, France. A secondary requirement was to communicate that Chateau St. Tropez was one of the properties within the overall brand of Domaine De Luxe.

Approach: In our research, we discovered that the original chateau would now be 100-years-old. We decided to combine the legend of St. Tropez, the actors, writers, artists and film stars, into a celebratory brochure. For the main entrance reception hallway, we purchased a one-off six-foot signed print of Brigitte Bardot by Terry O'Neil and this became the icon of the Chateau. From there we designed the book with spreads to both chart the history of the village, the building of the original chateau and the restoration to its current glorious condition.

Results: The Chateau has been consistently booked for large scale parties, weddings and as a highly exclusive villa for private rental.

Designer: Steven Taylor | **Design Firm:** Steven Taylor & Associates | **Client:** Bourne Capital Chateau St. Tropez

ONE HUNDRED YEARS OF

CHATEAU ST TROPEZ

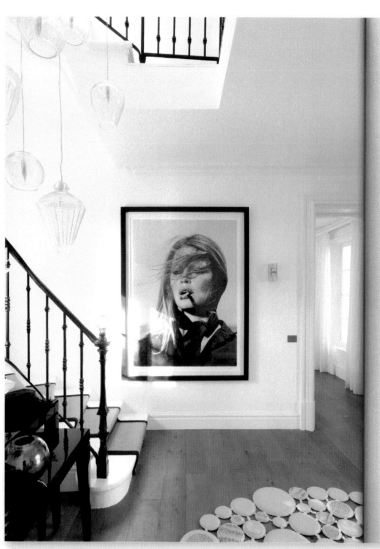

BB

and Vadim, film stars, writers, artists, and pop stars have created a mystique about St Tropez.

Chateau St Tropez has always remained private – a home fit for the famous and infamous to dine, recline and be entertained in grand style. A place where privacy is guarded and indulgence is encouraged. Life here is as simple or sophisticated as you wish.

The Chateau includes a huge lounge and dining room on the ground floor with French windows opening out to the terraces.

Inside or out, lounging around is such a pleasure – huge white sofas, canapes throughout the day, a chilled glass of chablis or champagne. Lie back and prepare to be convinced – you thoroughly deserve this much care, attention and indulgence.

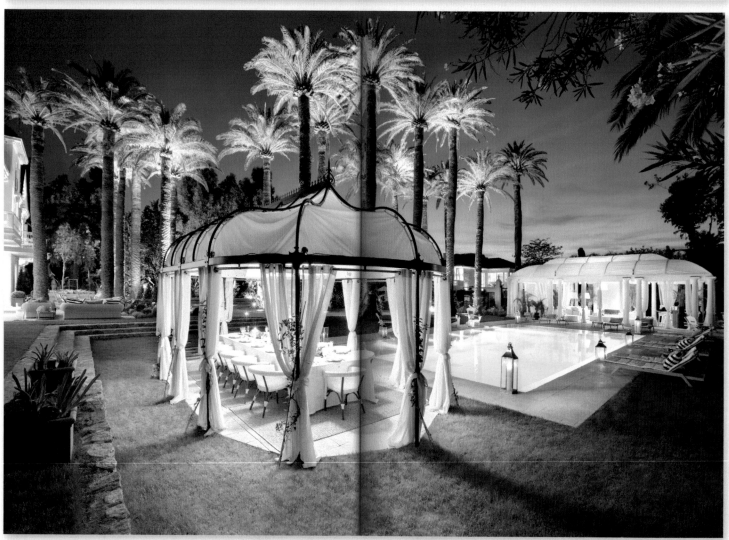

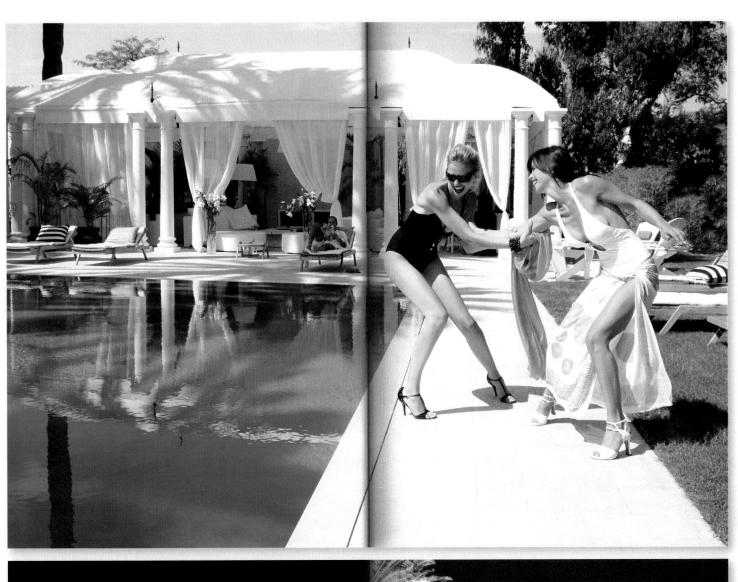

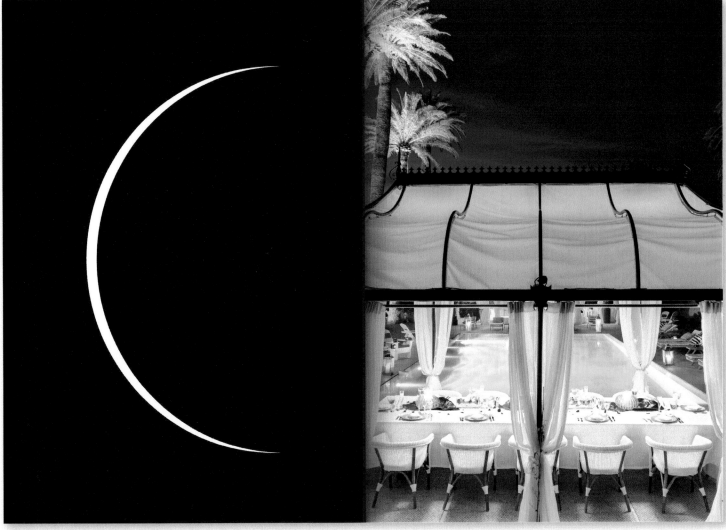

Assignment: We tasked with creating a brochure to encourage chartering of this 1930s private classic yacht.

Approach: While the yacht is magnificent in her own right, we wanted to communicate the very special time that each guest would enjoy onboard. We therefore took the theme of the life in a day and photographed models, crew, children and even a dog throughout the day and night as they enjoyed their time on Talitha. The strategy was to show that the atmosphere on board was informal, family orientated, elegant and extremely comfortable. The cover was designed in Decco style in keeping with the theme of the yacht.

Results: The brochure has achieved its objective and is a focus for enquiries.

Designer: Steven Taylor | **Design Firm:** Steven Taylor & Associates | **Client:** Talitha

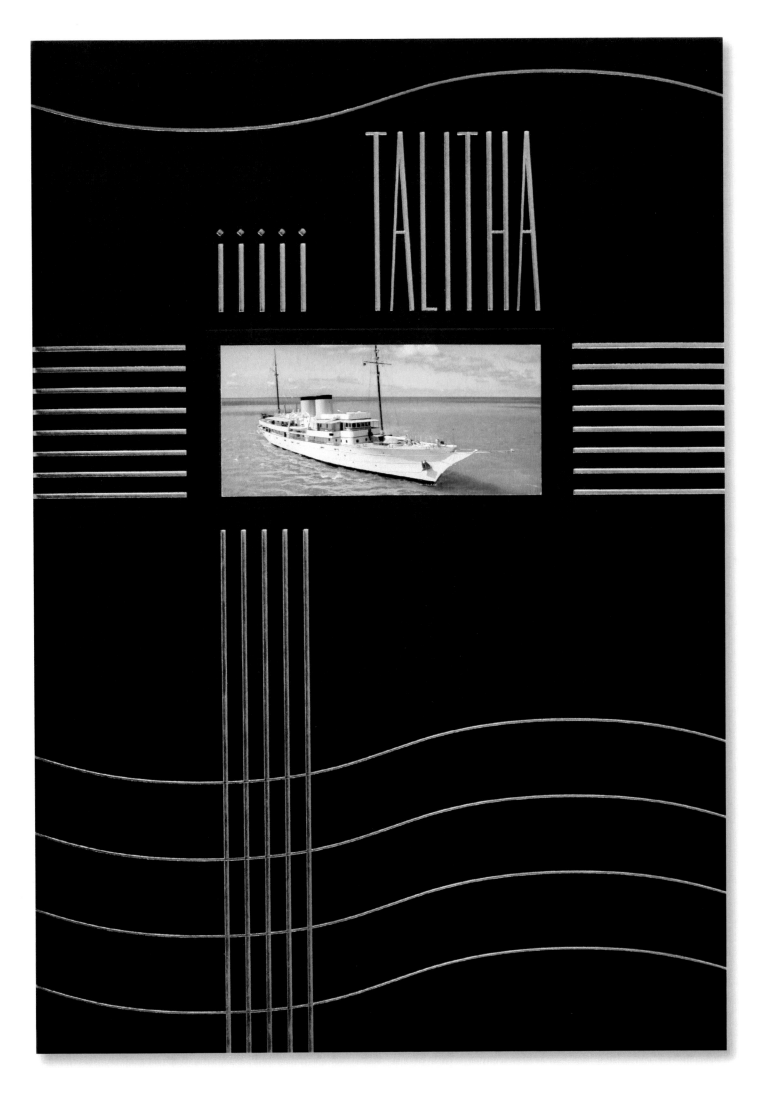

TALITHA

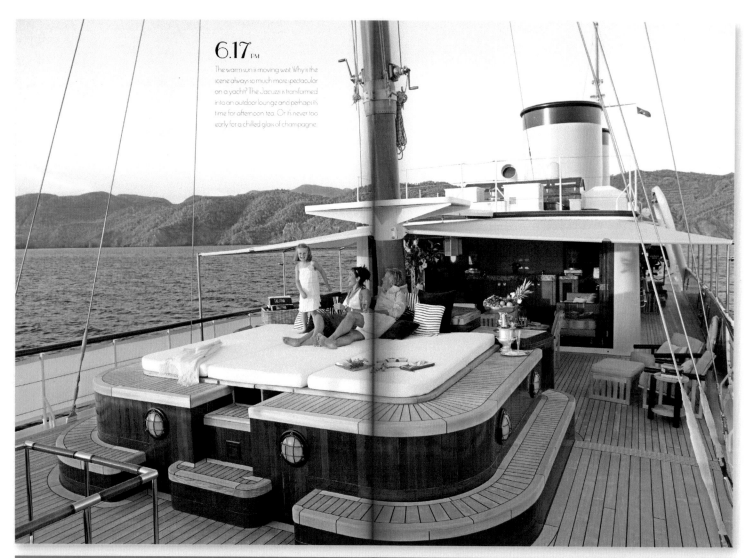

6.17 PM

The warm sun is moving west. Why is the scene always so much more spectacular on a yacht? The Jacuzzi is transformed into an outdoor lounge and perhaps it's time for afternoon tea. Or it's never too early for a chilled glass of champagne.

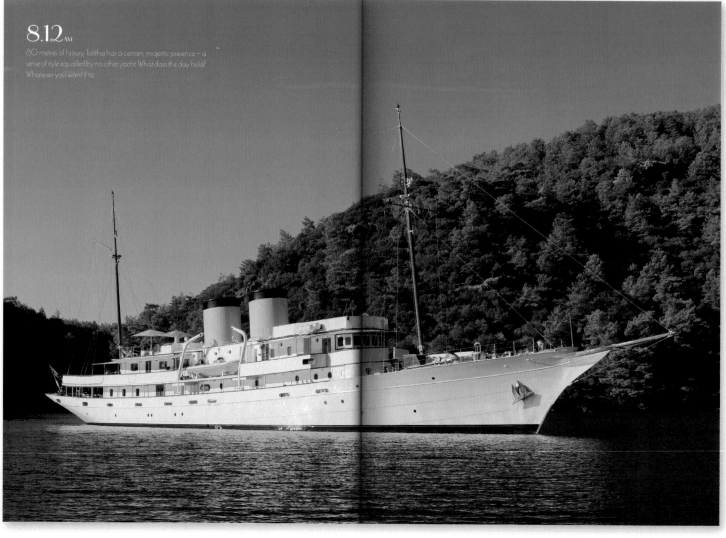

8.12 AM

80 metres of history, Talitha has a certain, majestic presence – a sense of style equalled by no other yacht. What does the day hold? Whatever you want it to.

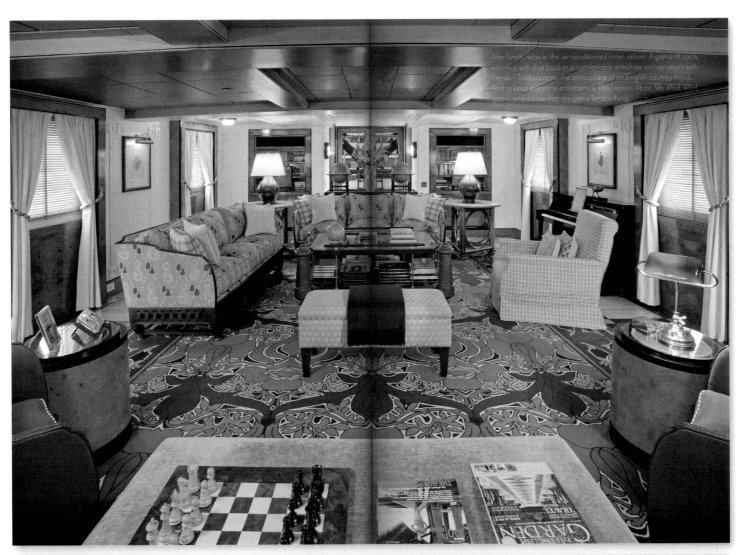

After lunch, relax in the air conditioned main saloon. A game of cards, continue with that book in a comfortable armchair, conversations with friend – Talitha creates the atmosphere of an English country house. And to keep everyone entertained, PlayStation, Xbox, Wii, iPod, iPad, games and a crew that are game for anything.

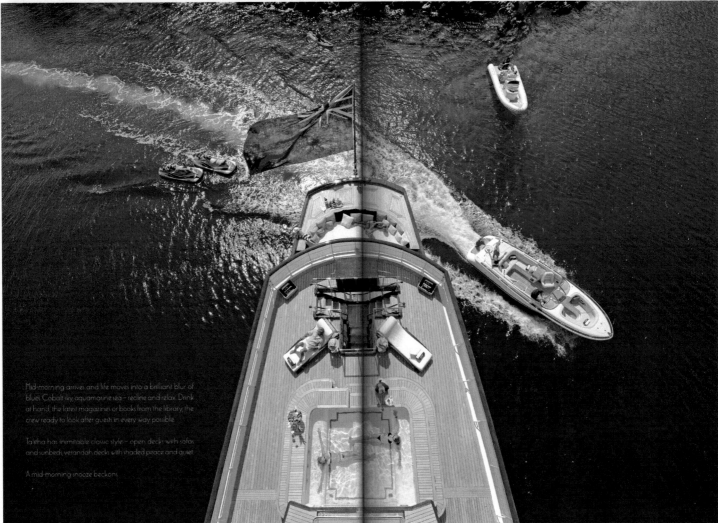

Mid-morning arrives and life moves into a brilliant blur of blues. Cobalt sky, aquamarine sea – recline and relax. Drink at hand, the latest magazines or books from the library, the crew ready to look after guests in every way possible.

Talitha has inimitable classic style – open decks with sofas and sunbeds, verandah decks with shaded peace and quiet.

A mid-morning snooze beckons.

Assignment: Pelikan Artline came to us to bring about a brochure that proclaimed the Swiss Bags brand to the Australian marketplace. Swiss Bags creates high end business oriented bags and leather accessories. Their portfolio of products is targeted towards the higher end of the market, and they wanted a brochure that immediately arrested attention. Swissbags needed to assert itself as a premium and distinctive brand.

Approach: With the brochure we wanted to create a piece that acted like a physical advertisement of the bags themselves. An immediate idea was the creation of a brochure that looked like one of their products themselves. We developed this idea via a unique die-cut, the leather texture being manipulated to look a part of the over and the selection of paper and laminating to give the look and feel of the bag. The inside was tastefully designed to give a very classy display of the entire Swissbags range. Different product types utilized a clever color and shape system to differentiate themselves.

Results: B2B customers and dealerships were ecstatic about the product and the brochure. Pelikan Artline loved the response it got from the market, and this concept immediately positioned Swiss Bags as a premium brand in the perceptions of re-sellers. Keen interest was shown in stocking the expensive products — the bag-brochure was a standout and easily attracted major attention.

Designer: Trent Herbert | **Design Firm:** Flame | **Art Director:** Vinesh V. George | **Client:** Pelikan Artline

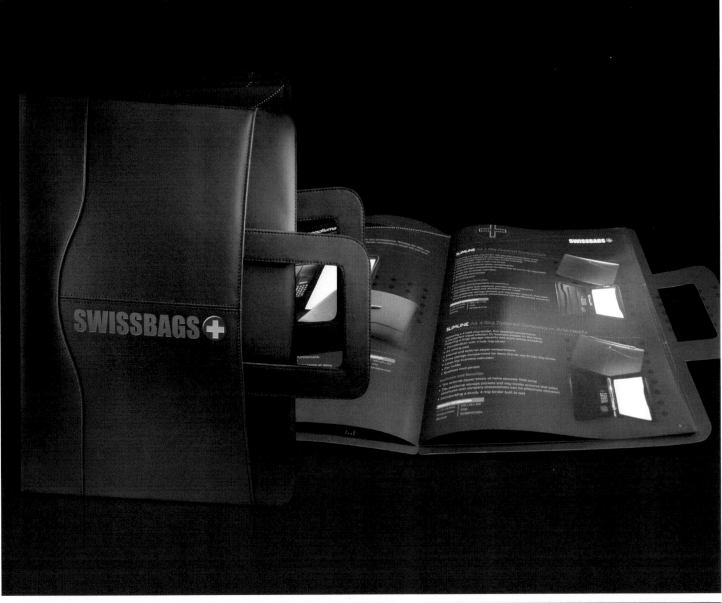

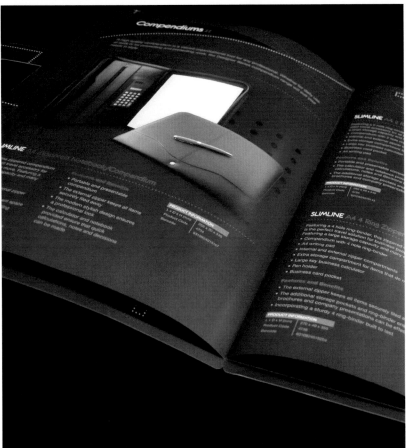

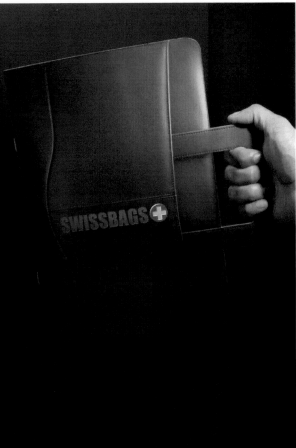

Assignment: Shift perceptions about the Cessna Citation CJ4 business jet, from the belief that is a smaller, underpowered jet — to the realization that is a powerful performer designed for the demands of corporate flight departments.

Approach: A heavy, etched metal book, sent as a direct mail to C-suite decision makers, conveyed the power of the CJ4 in four areas — range, speed, size and runway performance — while delivering performance capabilities with simple, clear information graphics.

Results: Not known at this time.

Designers: Jared Rawlings, James Strange | **Design Firm:** Bailey Lauerman | **Art Director:** James Strange | **Copywriter:** Raleigh Drennon
Creative Director: Raleigh Drennon | **Print Producer:** Gayle Adams | **Client:** Cessna

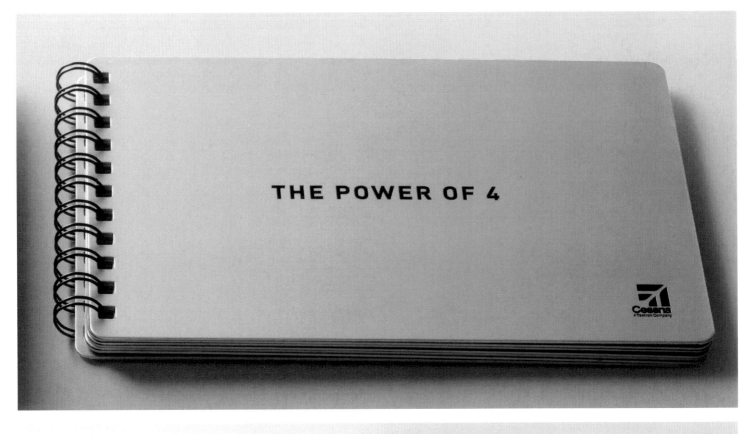

THE POWER OF 4

Cessna
A Textron Company

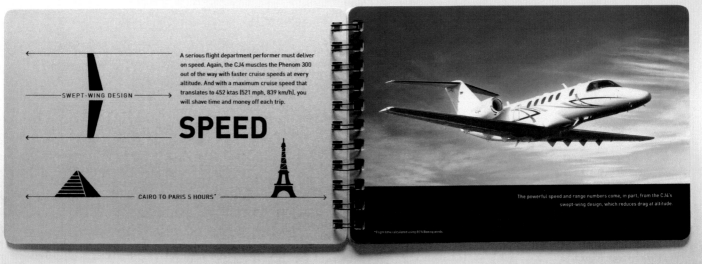

SWEPT-WING DESIGN

A serious flight department performer must deliver on speed. Again, the CJ4 muscles the Phenom 300 out of the way with faster cruise speeds at every altitude. And with a maximum cruise speed that translates to 452 ktas (521 mph, 839 km/h), you will shave time and money off each trip.

SPEED

CAIRO TO PARIS 5 HOURS*

*Flight time calculated using 85% Boeing winds.

The powerful speed and range numbers come, in part, from the CJ4's swept-wing design, which reduces drag at altitude.

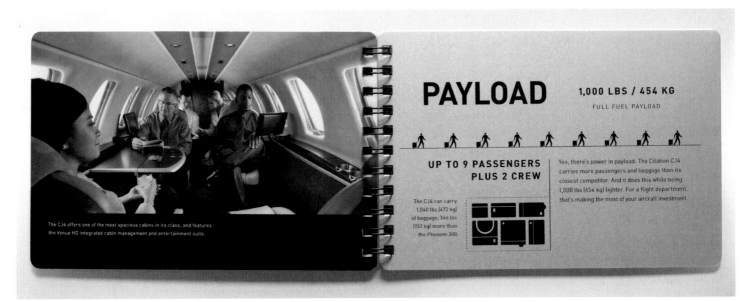

The CJ4 offers one of the most spacious cabins in its class, and features the Venue HD integrated cabin management and entertainment suite.

PAYLOAD

1,000 LBS / 454 KG
FULL FUEL PAYLOAD

UP TO 9 PASSENGERS PLUS 2 CREW

The CJ4 can carry 1,040 lbs (472 kg) of baggage, 346 lbs (157 kg) more than the Phenom 300.

Yes, there's power in payload. The Citation CJ4 carries more passengers and baggage than its closest competitor. And it does this while being 1,000 lbs (454 kg) lighter. For a flight department, that's making the most of your aircraft investment.

Assignment: This is the tenth in a series of typographic calendars, created to promote the knowledge and understanding of typography and the typographers who created the life-blood of the global communication industry.

Approach: In addition to meeting the basics of ell the day and date, the calendar gives the background to each face shown, including the designer, foundry, typographic provenance, plus holidays in the US, UK and Canada. Each designer's birthday is added where appropriate on his or her month. The typefaces for 2011 come from the archives of 20th Century design and architectural icons including A.M. Cassandre, Le Corbusier and Frederic Goudy, plus from contemporary stars including Zuzana Licko, Christian Schwartz and Ondrej Jób.

Results: Effectiveness is hard to track but it continues to be sold to a wider and wider series of retailers and generally sells out each year. If there is any over-stock, those calendars are donated to design schools within California. We recommend that the large calendar sheets be used as wrapping paper after the month has passed

Designers: Kit Hinrichs, Dang Nguyen | **Design Firm:** Studio Hinrichs | **Client:** Studio Hinrichs

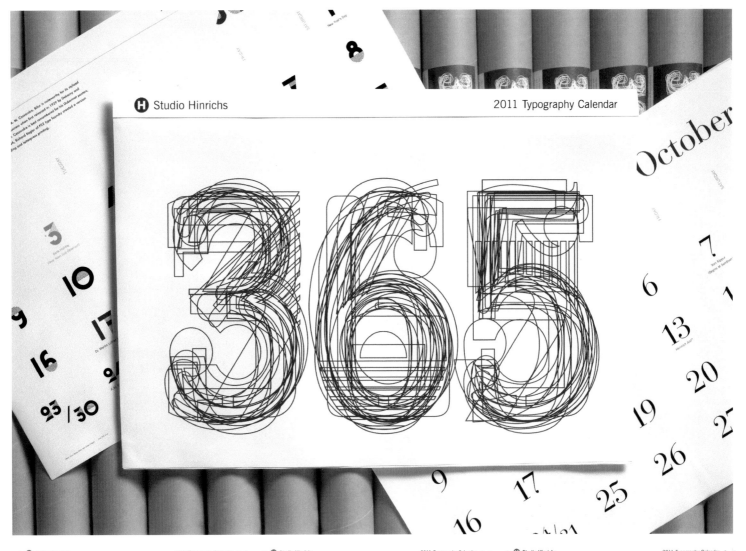

Studio Hinrichs — 2011 Typography Calendar

January

						1
2	3	4	5	6	7	8
9	10	11	12	13	14	15
16	17	18	19	20	21	22
23/30	24/31	25	26	27	28	29

February

		1	2	3	4	5
6	7	8	9	10	11	12
13	14	15	16	17	18	19
20	21	22	23	24	25	26
27	28					

March

		1	2	3	4	5
6	7	8	9	10	11	12
13	14	15	16	17	18	19
20	21	22	23	24	25	26
27	28	29	30	31		

April

					1	2
3	4	5	6	7	8	9
10	11	12	13	14	15	16
17	18	19	20	21	22	23
24	25	26	27	28	29	30

May

1	2	3	4	5	6	7
8	9	10	11	12	13	14
15	16	17	18	19	20	21
22	23	24	25	26	27	28
29	30	31				

June

			1	2	3	4
5	6	7	8	9	10	11
12	13	14	15	16	17	18
19	20	21	22	23	24	25
26	27	28	29	30		

July

					1	2
3	4	5	6	7	8	9
10	11	12	13	14	15	16
17	18	19	20	21	22	23
24/31	25	26	27	28	29	30

August

	1	2	3	4	5	6
7	8	9	10	11	12	13
14	15	16	17	18	19	20
21	22	23	24	25	26	27
28	29	30	31			

September

				1	2	3
4	5	6	7	8	9	10
11	12	13	14	15	16	17
18	19	20	21	22	23	24
25	26	27	28	29	30	

Assignment: The Bicentennial Calendar allows you to connect every date and weekday from 1900 to 2099. It was sent out as a promotional piece for our studio. It's a limited edition of 100 pieces, signed and numbered by the designers. Our goal was to create a special gift for clients and friends that contrasts with the fast moving online-world of our times — a piece of work that reflects the benefits of high quality printed matters by special haptic experience, classic, type driven design and timeless content. We were fascinated by the concept of an everlasting calendar when we first heard about it, especially the idea of typographically reinterpreting such a complex system of letters and numbers that is usually designed in a very unemotional and visually unappealing way. Everything else, like the design, the letterpress printing and the decision for the paper, were like natural results of these initial thoughts.

Results: In addition to the positive feedback from clients and friends, the calendar was published in several blogs and international design books, which lead to great interest and requests for the calendar from all over the world.

Designers: Patrick Vallée, Carolin Sonner | **Design Firm:** Sonner, Vallée u. Partner | **Client:** Sonner, Vallée u. Partner

Assignment: The assignment was to develop a back-to-college catalog that inspired students, acted as a practical planning tool and reminded our guests that they can do all of their college shopping at Target.

Approach: We gave the catalog the look and feel of a college campus newspaper, right down to the paper stock. For further authenticity, we hired actual college journalists to write original articles that brought their "expert" perspective. In addition to a massive nationwide mailing, we strategically distributed copies at places that college kids hang out (campus coffee houses, student unions, etc.).

Results: This was the strongest performing back-to-college catalog in Target's history, with sales results up across the board

Designers: Eric Vermilyea, Aaron Melander, Courtney Gooch, Jeff Barbian | **Design Firm:** Target | **Illustrator:** Mike Perry
Photographer: RJ Shaughnessy | **Client:** Self-Promotion

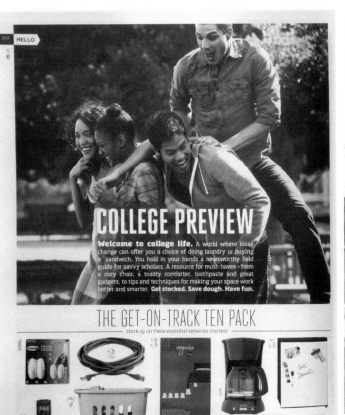

COLLEGE PREVIEW

Welcome to college life. A world where loose change can offer you a choice of doing laundry or buying a sandwich. You hold in your hands a newsworthy field guide for savvy scholars. A resource for must-haves – from a cozy chair, a toasty comforter, toothpaste and great gadgets, to tips and techniques for making your space work better and smarter. **Get stocked. Save dough. Have fun.**

THE GET-ON-TRACK TEN PACK
stock up on these essential semester starters

1 3M COMMAND HOOKS 6 pk. $5.69	2 25-FT. BELKIN ETHERNET CABLE $20.99	3 4-PK. ROOM ESSENTIALS 6" BED STANDS $8.99	4 SUNBEAM 12-CUP PROGRAMMABLE COFFEEMAKER $19.99	5 EMERSON 2.8-CU. FT. DRY ERASE FRIDGE $89
6 AUDIOVOX CLOCK RADIO WITH iPOD DOCK $29.99	7 ROOM ESSENTIALS LIDLESS HAMPER $6.99	8 EPSON NX125 STYLUS ALL-IN-ONE PRINTER, SCANNER AND COPIER $29.99	9 BELKIN POWER STRIP $13.49	10 20-PK. ENERGIZER AA BATTERIES $9.99

RAD PAD

Want to bring your space to life? Start with great lighting and go from there. From decorative pillows to framed art, a little flourish will transform your pad into a proper hang.

ILLUMINATION
$29.99 STICK FLOOR LAMP WITH SHADE

$16.99 STICK LAMP WITH SHADE

HEY GOOD LOOKIN'
$5.99–39.99 MIRRORS

$9.99–19.99 DECORATIVE PILLOWS

$12.99 RHINESTONE CHANDELIER WALL DECAL

cool quarters
Lauren D.
Michigan State University

At one time, my dorm room was adorned with hot pink and electric purple accents, and bulletin boards emblazoned with flower thumbtacks.

here's some tricks I learned along the way:

HELLO CLICKY SHOPPERS
Shop Target.com for an extended online-only assortment of large or tiny gear, including exclusive college-type things to do your space justice.

$9.99 ... $45.99

ANATOMY OF A WELL-WIRED STUDENT

Tech-savvy students take their gadgets on the go. From study aids to gear for chill time, we break down all the thrifty ways to wire your world.

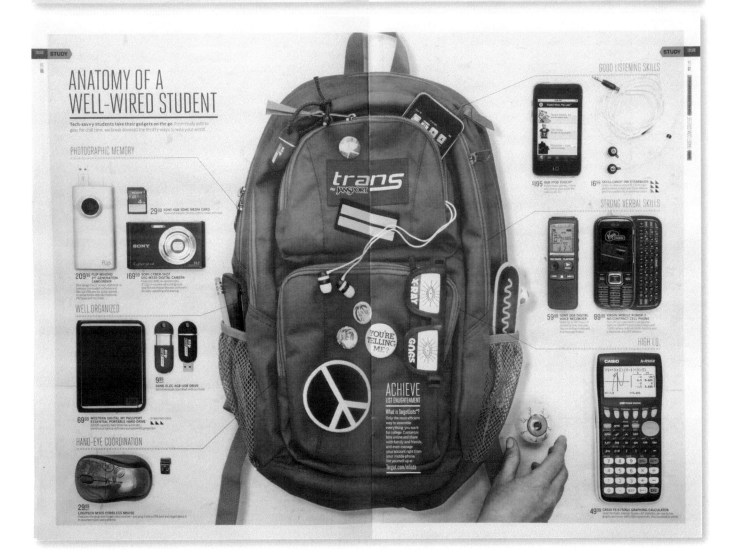

PHOTOGRAPHIC MEMORY
$209.99 FLIP MINOHD 2ND GENERATION CAMCORDER

$29.99 SONY 4GB SDHC MEDIA CARD

$169.99 SONY CYBER-SHOT DSC-W330 DIGITAL CAMERA

WELL ORGANIZED
$69.99 WESTERN DIGITAL MY PASSPORT ESSENTIAL PORTABLE HARD DRIVE

$9.99 DANE-ELEC 4GB USB DRIVE

HAND-EYE COORDINATION
$29.99 LOGITECH M305 CORDLESS MOUSE

GOOD LISTENING SKILLS
$195 8GB iPOD TOUCH

$16.99 SKULLCANDY INK'D EARBUDS

STRONG VERBAL SKILLS
$59.99 SONY 2GB DIGITAL VOICE RECORDER

$89.99 VIRGIN MOBILE RUMOR 2 NO-CONTRACT CELL PHONE

HIGH I.Q.
$49.99 CASIO FX-9750Gii GRAPHING CALCULATOR

ACHIEVE
LIST ENLIGHTENMENT

What is TargetLists? Only the most efficient way to assemble everything you want for college. Customize lists online and share with family and friends, and even manage your account right from your mobile phone. See yourself up at target.com/mlists

Assignment: Marazzi's catalogues showcase hundreds of products. We were asked to redesign them with the aim of creating a more simplified system and make it easier for users to find the products they need, while also expressing the high quality of Marazzi's tile collections. Separate catalogues — one aimed at architects and the other at contractors — were developed but both retain the consistency of the core brand.

Approach: SVI Design devised a crisp, modular structure that could accommodate a large number of permutations, such as tile dimensions and formats. Dividers bring a more emotive quality to the catalogues and balance the technical information. The highly engineered covers and binding are a tribute to Marazzi's reputation for technical achievement and experimentation. The imagery was chosen to communicate the elements air, fire and water, alluding to the natural world from which the company takes all of its inspiration.

Results: The client was delighted with the result. Our design and organizational principles went on to influence the company's website redesign.

Designer: Sasha Vidakovic | **Design Firm:** SVI Design | **Client:** Marazzi

Monolith
LEVIGATI

Product Description Lorem ipsum dolor sit amet, consectetur adipiscing elit. Maecenas vitae tellus sed tellus gravida consectetur. Aliquam erat volutpat. Fusce bibendum, nulla vel egestas eleifend urna urna iaculis odio nec suscipit turpis diam in ipsum. Pellentesque habitant morbi tristique senectus et netus et malesuada fames ac turpis egestas. Integer neque mauris vulputate a feugiat ac accumsan in nulla Nulla facilisi. Fusce bibendum, nulla vel egestas eleifend urna urna iaculis odio nec suscipit turpis diam in ipsum.

Monolith
LEVIGATI

Conforme/According to
UNI EN 14411 - G Bla GL

Product Name & Colour A

MH 27	30x60	MH 27	30x60
MJ 80	30x60 Retificato	MJ 80	30x60 Retificato
MJ 8C	15x60 Retificato		
MJ 9D	30x45 Retificato		
MJ 8G	15x45 Retificato		
MJ 88	30x30 Retificato		
MJ 84	15x30 Retificato		

Product Name & Colour A

MH 27	30x60	MH 27	30x60 Retificato
MJ 80	30x60 Retificato	MJ 80	30x60 Retificato
MJ 8C	15x60 Retificato	MJ 8C	15x60 Retificato
MJ 9D	30x45 Retificato		
MJ 8G	15x45 Retificato		
MJ 88	30x30 Retificato		
MJ 84	15x30 Retificato		

Product Name & Colour A

MH 27	30x60
MJ 80	30x60 Retificato
MJ 8C	15x60 Retificato
MJ 9D	30x45 Retificato

Product Name & Colour A

MH 27	30x60
MJ 80	30x60 Retificato
MJ 9D	30x45 Retificato
MJ 8G	15x45 Retificato
MJ 88	30x30 Retificato
MJ 84	15x30 Retificato

Product Name & Colour A

MH 27	30x60
MJ 80	30x60 Retificato
MJ 8C	15x60 Retificato
MJ 9D	30x45 Retificato
MJ 8G	15x45 Retificato
MJ 88	30x30 Retificato
MJ 84	15x30 Retificato

Product Name & Colour A

MH 27	30x60
MJ 80	30x60 Retificato
MJ 8C	15x60 Retificato
MJ 9D	30x45 Retificato
MJ 8G	15x45 Retificato
MJ 88	30x30 Retificato

Assignment: We used images created by Santi Rodríguez punching the piece to create a sort of watermark or mark of the photographer.

Approach: A dye was used to generate a watermark to be boring all the photos in the catalogue, exposing the most important and the photo ID.

Results: The purpose of this piece was to capture advertising agencies, fashion and beauty magazines and companies dedicated to the image. Finally captured different customers and jobs.

Designer: Xose Teiga I **Design Firm:** Xose Teiga Studio I **Client:** The Black Shooter

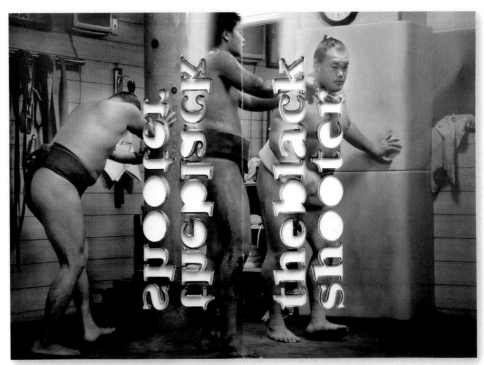

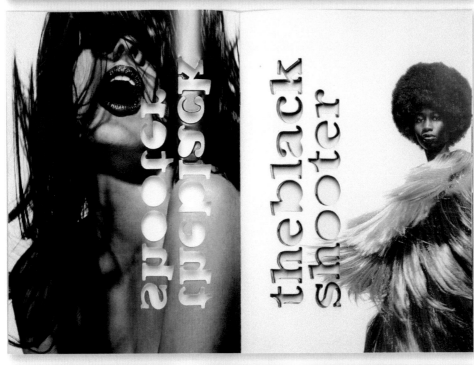

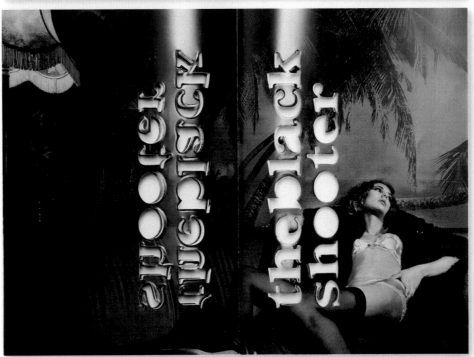

Assignment: Tandus Flooring is still a relatively new brand name within the interiors industry, having only recently completed their transition from three brands into the new singular name. To reinforce this fact within the market, they decided, for the first time, to showcase all their products in one catalog format. The older patterns that were once associated with the previous brands would now be officially linked with the new Tandus Flooring brand name. The catalog is a reference tool for Architects and Interior Designers for quick pattern and color specifications of Tandus Flooring products.

Approach: We considered how this catalog would be best used as a reference tool, deciding to break the patterns down by their product platforms — Powerbond, broadloom, modular and woven. Each platform was highlighted by a thick tab page that can fold and hide inside, if so desired. Within each platform we broke the patterns down by graphic style and scale, going from large to small. This allows the reader to quickly flip to the platform they want, find the graphic style they need, then which colors they like, and request samples. If anyone looks for a particular pattern name, they can flip to the back where we placed an index with pattern names, platforms, coordinates and other relevant information. The front section allows for design award and trade show news, a description of their new product portfolios, an explanation of their coordinate numbering system and a visual showcase of selected collections.

Results: The reaction has been very positive with the initial 10,000 copies requested and handed out, requiring a mid-year reprint. Brand awareness is up, and most importantly, so are sales.

Designers: Lionel Ferreira, Laura Ferreira | **Design Firm:** Ferreira Design Company | **Client:** Tandus Flooring

2011

PRODUCT GUIDE

ııı Tandus
FLOORING

WOVEN

04

Drawing on the weaving techniques handed down through centuries, our design team takes a modern approach to woven broadloom. Tandus Flooring's wovens embody luxury and performance, while offering interesting studies in texture and relief.

FULL VOLUME II 60102

Yarn type: TDX
Dye method: Solution Dyed
Pitch: 135/5.0 inch (19.7 rows/10cm)
Pattern match: 0.40" W x 0.45" L
Woven backings: Crossweave®, CrossCushion™
Coordinate group: 15
$$$$

Suzanne Tick Design

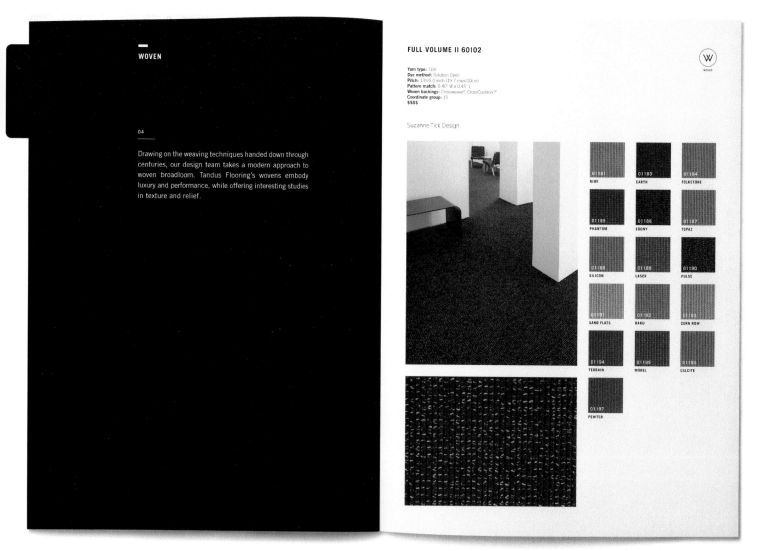

01181 KIWI	01183 EARTH	01184 FOLKSTONE
01185 PHANTOM	01186 EBONY	01187 TOPAZ
01188 SILICON	01189 LASER	01190 PULSE
01191 SAND FLATS	01192 RAKU	01193 CORN ROW
01194 TERRAIN	01195 MOREL	01196 CALCITE
01197 PEWTER		

NAMESAKE

AUTHENTICITY COLLECTION
COORDINATE GROUP 15

COLOURWORKS II 32032

Yarn type: Solutia Nylon
Dye method: Piece Dyed
Gauge: 1/10
Pattern match: N/A
Broadloom backings: Super-Lok®, LifeLong™, ErgoStep™
Coordinate group: Solids
$$

05001	05002	05003	05004	05005	05006	05007
AUBERGINE	BLUEGRASS	CAFE AU LAIT	FLINT	BITTERSWEET	BRUSHED SILVER	CHILI
05008	05009	05010	05011	05012	05013	05014
CITRON	EUCALYPTUS	PUMPERNICKEL	VERIDIAN	GLACIER	GLASS BLOCK	GREEN OXIDE
05015	05016	05017	05018	05019	05020	05023
GREY BOUCLE	LICHEN	SIENNA	LUNA	MAGENTA	MAHOGANY	MESQUITE
05025	05027	05029	05122	05142	05152	05223
PUMPKIN	TEAL	SORREL	CANVAS	BISCOTTI	SANDBOX	PLATINUM
05225	05226	05232	05237	05252	05253	05254
STETSON	TUNDRA	BEACHFRONT	BRONCO	ASTORIA	TERRAIN	ELEMENTAL
05255	05256	05259	05262	05289	05296	05324
TAWNY	CAFE NOIR	HICKORY	OPALINE	RESIN	BEECHWOOD	SISAL
05327	05337	05346	05354	05385	05387	05428
SAVANNAH	CAMEROON	SUN GLOW	SHINE	CAT'S EYE	TURF	MANZANITA
05438	05528	05557	05566	05578	05652	→
PAPRIKA	CINNA MOCHA	PIMENTO	SHALIMAR	VINEYARD	AURA	MORE COLORS

Assignment: Design a cover for "Otheroot," the new release of the Romanian cross-metal band, Implant for Denial. The album being Romanian in its original form had all the lyrics translated into English and was re-recorded in Germany. The album was a special edition box set containing both versions of the songs (English and Romanian). The album was launched simultaneously in Germany, Austria and Switzerland.

Approach: The concept I extracted from the music was the theme of "Translation" — the whole album was all translated from Romanian into English and recorded for this special International edition thus the process of translation (linguistic, visual and referential) became the principal idea/drive behind the design of "Otheroot." Another idea was to "translate" Romanian visual references into globally recognizable symbols with a faulty twist. The subject of "error" became an inevitable conceptual element because of its irrefutable link to the subject of "translation."

Results: Wow!

Designers: Ovidiu Hrin, Eugen Neacsu | **Design Firm:** Synopsis | **Creative Director:** Ovidiu Hrin | **Photographer:** Eugen Radut
Project Manager: Silvia Hrin | **Client:** Mam Management Group & Firefield Records

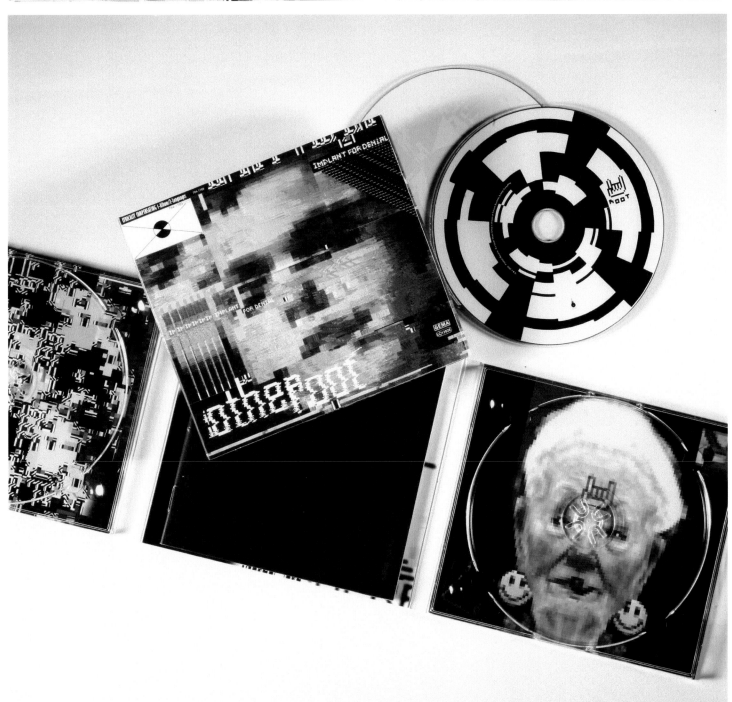

Assignment: Bunny Wailer is a music legend — an early pioneer of Reggae. And he's really hard to track down.

Approach: The design emphasizes the exoticism of Wailer's existence through the use of traditional Reggae patterns and colors.

Designer: Benjamin Bours | **Design Firm:** GQ Magazine | **Art Director:** Fred Woodward | **Client:** GQ Magazine

Assignment: This is an opening spread for a Richard Burbridge portrait series of actors known for their tough-guy character roles.

Approach: Title cards from hardboiled films of the 1930s and 1940s inspired the typography.

Designer: Thomas Alberty | **Design Firm:** GQ Magazine | **Art Director:** Fred Woodward | **Photographer:** Richard Burbridge | **Client:** GQ Magazine

THE LAST WAILER

EVEN THE NAME IS LEGEND, BUNNY WAILER. He grew up *in* the same house as BOB MARLEY, *and together with* PETER TOSH, *they created not just* THE WAILERS *but a new template for sound. But only Bunny remains, and today he lives in his own private Zion. He is not an easy man to visit.* John Jeremiah Sullivan *ventured to* KINGSTON, JAMAICA, *shortly after that city burned last summer, to find reggae's most righteous survivor*

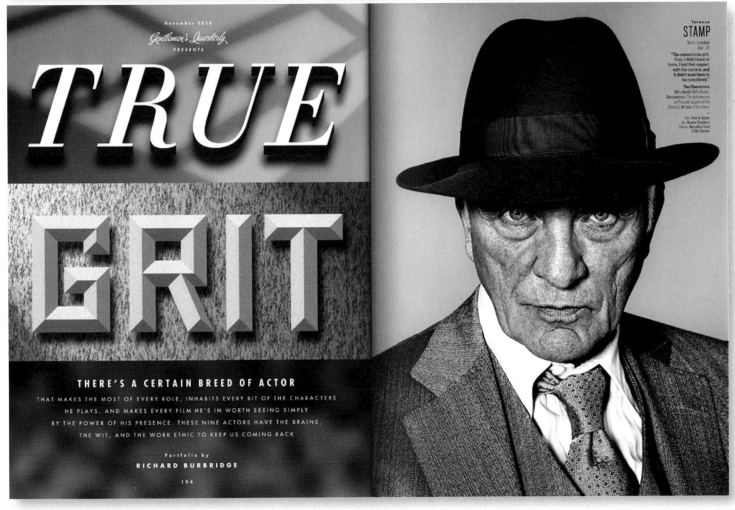

TRUE GRIT

THERE'S A CERTAIN BREED OF ACTOR

THAT MAKES THE MOST OF EVERY ROLE, INHABITS EVERY BIT OF THE CHARACTERS
HE PLAYS, AND MAKES EVERY FILM HE'S IN WORTH SEEING SIMPLY
BY THE POWER OF HIS PRESENCE. THESE NINE ACTORS HAVE THE BRAINS,
THE WIT, AND THE WORK ETHIC TO KEEP US COMING BACK

Portfolio by
RICHARD BURBRIDGE

Terence
STAMP
Born: London
Age: 71

"The camera's my girl. Thus, I didn't have to learn. I had that rapport with the camera, and it didn't even have to be considered."

The Characters
Billy Budd (*Billy Budd*),
Bernadette (*The Adventures of Priscilla Queen of the Desert*), Wilson (*The Limey*)

Suit: Reed & Taylor
Tie: Brooks Brothers
Fedora: Borsalino from JJ Hat Center

Assignment: This is the opening spread for a story about a radical school of thought that says with certain biological advances people can live as long as 200 years.

Approach: The inspiration for the dimensional lettering came from a gamut of biological imagery, including molecular structure, chromosomes and the banding pattern seen in a gel electrophoresis genetics test.

Designer: Anton Ioukhovets | **Design Firm:** GQ Magazine | **Art Director:** Fred Woodward | **Photographer:** Chris Buck | **Client:** GQ Magazine

Assignment: GQ gave Zach Galafianakis a fill-in-the-blanks essay to complete for his May 2011 cover story.

Approach: To add to the absurdity, this was designed to give the appearance that Galafianakis had written his mad libs via telegram.

Designer: Benjamin Bours | **Design Firm:** GQ Magazine | **Art Director:** Fred Woodward | **Photographer:** Martin Schoeller | **Client:** GQ Magazine

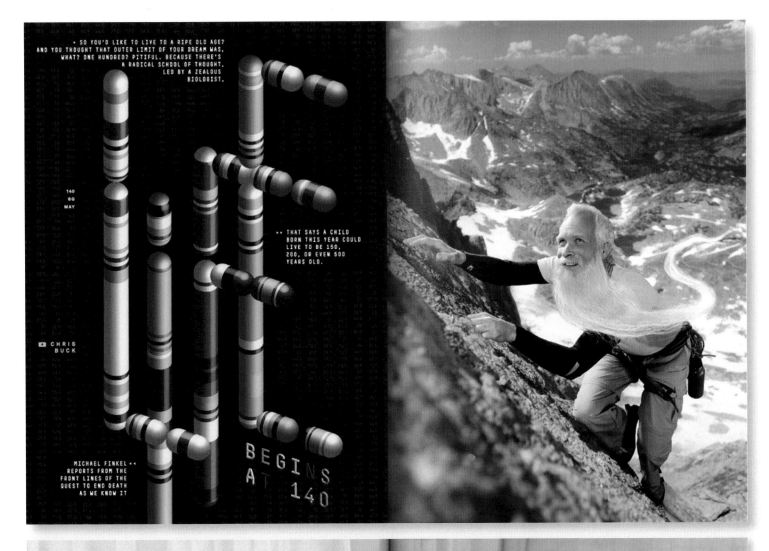

• SO YOU'D LIKE TO LIVE TO A RIPE OLD AGE? AND YOU THOUGHT THAT OUTER LIMIT OF YOUR DREAM WAS, WHAT? ONE HUNDRED? PITIFUL. BECAUSE THERE'S A RADICAL SCHOOL OF THOUGHT, LED BY A ZEALOUS BIOLOGIST,

•• THAT SAYS A CHILD BORN THIS YEAR COULD LIVE TO BE 150, 200, OR EVEN 500 YEARS OLD.

◀ CHRIS BUCK

MICHAEL FINKEL ◀◀ REPORTS FROM THE FRONT LINES OF THE QUEST TO END DEATH AS WE KNOW IT

L︎IFE BEGINS AT 140

>> THE WORLD SUCKS, BUT I HAVE SOME PLANS

Hi, my name is ZACH GALAFIANAKIS. We all know the planet is going through a tough time. So many problems, so few PROBLEM-SOLVING PEOPLE. So in a stroke of genius and MAGAZINENESS, GQ asked me to tackle these issues in the most powerful way possible: BY COMPLETING A FILL-IN-THE-BLANKS. This should solve everything

PHOTOS BY
MARTIN SCHOELLER

Assignment: This is the opening spread for a story about Victoria's Secret model, Miranda Kerr.

Approach: The simulated effect of tearing away a peephole to the following spread is a wink to those GQ readers who are overly anxious

to see more of her.

Designer: Anton Ioukhovets | **Design Firm:** GQ Magazine | **Art Director:** Fred Woodward | **Photographers:** Inez Van Lamsweerde, Vinoodh Matadin
Client: GQ Magazine

Assignment: This piece had to address the possible three-year sentencing of Wesley Snipes after he was convicted of federal tax evasion and fraud.

Approach: The design imagines Wesley Snipes filling out his first tax form in a decade.

Designers: Benjamin Bours, Anton Ioukhovets | **Design Firm:** GQ Magazine | **Art Director:** Fred Woodward | **Photographer:** Richard Burbridge
Client: GQ Magazine

AMONG THE GLORIOUS WINGED
CREATURES THAT WALK DOWN THE
RUNWAY FOR VICTORIA'S SECRET, NONE
IS MORE LOVELY THAN THE AUSSIE
MIRANDA KERR. OR MORE DANGEROUS.
JUST ASK THE POOR SAP WHO ALMOST
GOT FIRED FOR LOOKING AT ONLINE
PICTURES OF HER AT WORK. NOW, HERE
AT GQ, WE LIKE SEXY, BUT WE ALSO
LIKE EMPLOYMENT. SO THIS MONTH WE
OFFER NOT ONLY FRESH PHOTOS OF
MIRANDA BUT ALSO HELPFUL ADVICE ON
HOW TO ENJOY THEM WITHOUT GETTING
S*!TCANNED BY *STEPHEN SHERRILL*

PHOTOGRAPHS BY
*INEZ VAN LAMSWEERDE
& VINOODH MATADIN*

DiRTY

ANGEL

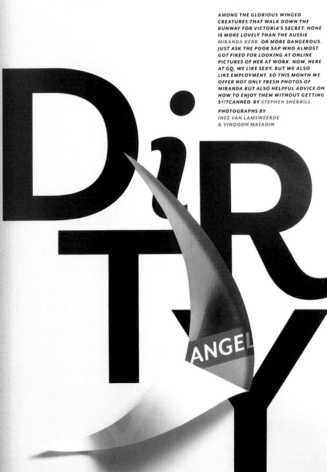

GQ122	a Employee's social security number	APRIL 0000-2010	
b Employer identification number (EIN)		1 Wages,	
Print or Type	**c** Employer's name, address, and ZIP code	3 Social S	
		5 Medica	
		7 Social	
d Employee's First Name Last Name WESLEY SNIPES		9 Advanc	
e Employee's address	**f** ZIP code	11 Nonqua	
15 State		13 Statutory employee	
		14 Other	

IS READY TO PAY!

16	Depending on whom you ask, Snipes—	16
17	who was convicted of willfully failing to file tax returns—	17
18	is either crazy, insanely gullible, or one of the greediest,	18
19	most arrogant celebrities to ever step in front of a judge.	19
20	So which Wesley Snipes may soon be serving	20
21	the three-year prison sentence?	21
22	**CHRIS HEATH** finds out .	22

Photograph by Richard Burbridge ▶

Form **G-Q** Income Tax Return

Copy 1 — For State, City, or
Local Tax Department

2010

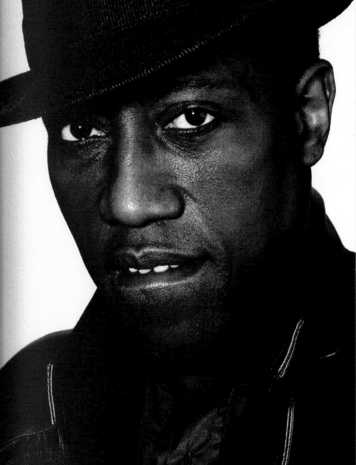

Assignment: GQ sent a correspondent to Amsterdam to chronicle his experience working at a "coffee shop," where marijuana is legally sold.

Approach: The illustration is based on the painting Night Hawks by Edward Hopper. The puffy, hand drawn type plays on the illustration in the form of cartoonish marijuana smoke.

Designer: Benjamin Bours | **Design Firm:** GQ Magazine | **Art Director:** Fred Woodward | **Illustrator:** Zohar Lazar | **Client:** GQ Magazine

Assignment: This article was about the National Enquirer's campaign to get a Pulitzer Prize for its political reporting.

Approach: The story's all-type opening spread suggests a blown up collage of the tabloid's colorful headlines.

Designer: Thomas Alberty | **Design Firm:** GQ Magazine | **Art Director:** Fred Woodward | **Client:** GQ Magazine

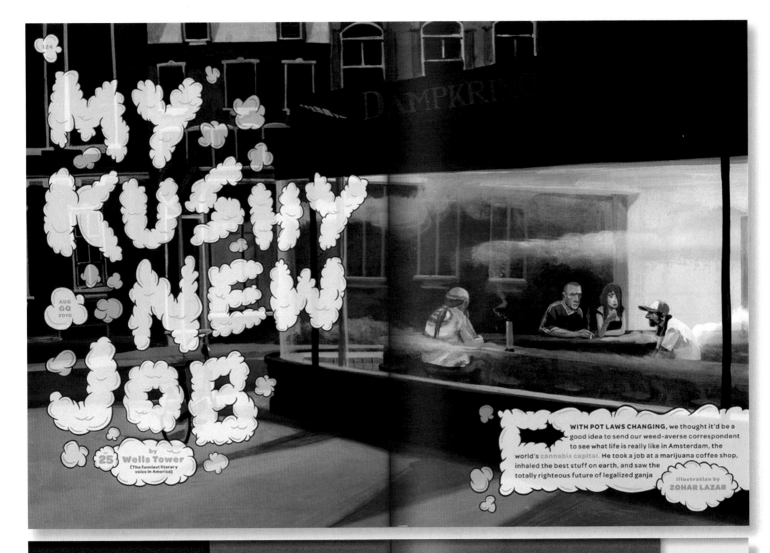

MY KUSHY NEW JOB

AUG GQ 2010

25

by Wells Tower
(The funniest literary voice in America)

DAMPKRING

WITH POT LAWS CHANGING, we thought it'd be a good idea to send our weed-averse correspondent to see what life is really like in Amsterdam, the world's cannabis capital. He took a job at a marijuana coffee shop, inhaled the best stuff on earth, and saw the totally righteous future of legalized ganja

Illustration by ZOHAR LAZAR

Three-headed babies! **ELVIS LIVES!** **EXCLUSIVE! JOHN EDWARDS'S** **LOVE CHILD!** And...a Pulitzer?! (WELL, ALMOST.)

ALEX PAPPADEMAS EMBEDS WITH THE *BADASS REPORTERS* AT THE

NATIONAL ENQUIRER

June 2010 • GQ.COM • 185

to find out how this onetime **SCANDAL SHEET** has become

THE RESPECTED *PAPER OF RECORD* WHEN IT COMES TO *HARD–* *NOSED REPORTING* AND BREAKING THE BIG SCOOPS OTHER PAPERS CAN'T

ALL THE DIRT THAT'S FIT TO PRINT

Assignment: This is the opening spread for a profile on the comedian Gary Shandling, who was featured in GQ's special comedy issue.

Approach: The inspiration for this idea comes from a mention in the story of Shandling's habitual note-making: reminders, joke ideas, to-do lists and personal anecdotes. Mark Todd illustrated the headline, deck, author and photographer's names onto Post-It notes.

Designer: Delgis Canahuate | **Design Firm:** GQ Magazine | **Art Director:** Fred Woodward | **Illustrator:** Mark Todd | **Photographer:** Danielle Levitt **Client:** GQ Magazine

Assignment: This is the opening spread for a story that examines the rising evidence that the use of cell phones is harmful to our health.

Approach: By juxtaposing the echoed shapes of a cell phone and a pack of cigarettes, the reader quickly understands that cell phones may be the next unrealized health threat.

Designer: Chelsea Cardinal | **Design Firm:** GQ Magazine | **Art Director:** Fred Woodward | **Photographer:** Tom Schierlitz | **Client:** GQ Magazine

 2010 KV

 The Comedian's Comedian's Comedian

 never not funny no.35

 He's a boxer, a Buddhist, a hoops junkie,

 and a kind of Yoda to every funny person born since 1960

 (Sandler, Silverman, Apatow, Gervais, Baron...

 AMY WALLACE survives a rare sparring session with

 Garry Shandling,

 the reclusive master of American comedy

 GQ 143 TNL

 BY Danielle Levitt,

WARNING: YOUR CELL PHONE MAY BE HAZARDOUS TO YOUR HEALTH

EVER WORRY THAT

THAT GADGET YOU SPEND HOURS HOLDING NEXT TO YOUR HEAD

MIGHT BE DAMAGING YOUR BRAIN?

WELL, THE EVIDENCE IS STARTING TO POUR IN, AND IT'S NOT PRETTY. SO WHY ISN'T ANYONE IN AMERICA DOING ANYTHING ABOUT IT?

BY CHRISTOPHER KETCHAM

Assignment: The Reinventor is an editorial feature in American Way magazine, introducing American Airlines passengers to a mature and perpetually evolving Robert Plant.

Approach: Mr. Plant was unavailable for a custom photo shoot but his team was gracious enough to provide unpublished images from a recent session. Pouring over the submissions, we found this shot of Plant's head engulfed in a kinetic, golden mane and knew we had something special. Playing off of the ambiguity of the photograph, the letters "R" and "P" were reduced to simple, geometric shapes that dominate the typography. Further details visually expressed the content of the headline with forms evocative of an inventor's schematics.

Results: Unknown

Design Firm: American Airlines Publishing | **Art Director:** Samuel Solomon | **Design Director:** David W. Radabaugh | **Project Coordinator:** Betsy L. Semple
Client: American Way

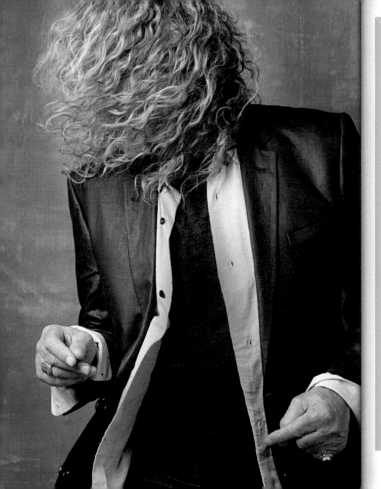

THE REINVENTOR

Thanks to a fierce commitment to innovation, **Robert Plant** is as relevant in music today as he was when he first came on the scene 40 years ago with a little band called Led Zeppelin.

by STEPHEN HUMPHRIES
photographs by GREGG DELMAN

Assignment: "Bad Babies" is an editorial fashion story for Earnshaw's magazine featuring children's clothing. We thought it would be fun to create shots of babies getting booked for various crimes. A crying child is booked for disturbing the peace and a child scribbling on the wall with a crayon is picked up on a vandalism rap.

Approach: We went to great lengths to be authentic: We typed everything out on a vintage manual typewriter, spent hours studying the typography and design of booking sheets and court papers and looked at many old mug shots for reference. We even consulted with a former federal agent about the terminology used in the layout.

Results: It made people in laugh and created a buzz in the children's fashion world.

Designer: Trevett McCandliss | **Design Firm:** 9Threads | **Creative Directors:** Nancy Campbell, Trevett McCandliss | **Photographers:** Michael Brian
Client: Earnshaw's

COMMISSIONERS BRIEFING
DEPARTMENT USE ONLY

A3

To: Juvenile Offender Task Force

Cc: Michael Brian, Photographer

From: Commissioner of Police

Subject: "Bad Babies" Crime Wave

Directive Summary:

Apprehend perpetrators implicated
in a rash of crimes committed by
individuals under the age of three.
Note: Though the suspects' alibis
may be fake, their organic
clothing is all natural. Individual
may become agitated when approache

D.D.S. (rev. 8-62)
SUPPLEMENTARY COMPLAINT REPORT
(DO NOT FOLD THIS REPORT)

U.F. 61
File No. 34

Charges: ASSAULT

Date of Report: 3/4/10

Investigating Officer: Sgt. Lynn Grannis

Suspect: Jayden Morrow

Incident Report:

Subject had already placed himself on
"the naughty spot" by the time officers
arrived on the scene. While inconclusive
inconclusive evidence, this suggested
that: a) he knew he'd committed a crime,
and b) it wasn't his first offense. The
sole witness was a harried-looking
woman presumed to be the subject's mother
toting a squalling infant who bore an
uncanny resemblance to the suspect --
except for an egg-shaped lump rising on
his forehead. In separate statements,
two neighbors noted they have observed
the suspect regularly whomping his
twin brother in an attempt to assert
his birthright. The witness verified
that our suspect preceded his sibling
into the world by two whole minutes,
but claimed the motive behind today's
assault was an inequitable distribution
of French fries.

PCT. **PCT. POST.** **INVESTIGATING OFFICER'S SIGNATURE:**
Lynn Grannis

Clover New
York jumpsuit.

NYC DEPT OF CORRECTIONS
03 04 10
BOOKING NUMBER 6C500

D.D.S. (rev. 8-62)
SUPPLEMENTARY COMPLAINT REPORT
(DO NOT FOLD THIS REPORT)

U.F. 61
File No. 37

Charges: DISTURBING THE PEACE

Date of Report: 4/2/10

Investigating Officer: Sgt. Roger McNab

Suspect: Hailey St. James

Incident Report:

Officers responded to a call regarding
a major disturbance at the local "Wiggly
Wiggly. Witnesses described the scene
in the candy aisle as a regular
occurrence for the suspect and her
mother, with Hailey found flat on her
back with arms sprawled out, legs kicking
and uvula vibrating with every blood-
curdling noise infraction. (The mother
appeared to be attempting to
disassociate herself from the crime,
but a handful of drool-dampened Kleenex
suggested otherwise.) Officers subdued
the subject's outbursts before
loading her into a police
vehicle, but once in the backseat the
teary-eyed toddler proceeded to hit even
higher decibels.

Note: The D.A. is working on a plea
bargain granting the little girl
immunity if she agrees to be the face of
her preschool's "No Means No" campaign.

PCT. **PCT. POST.** **INVESTIGATING OFFICER'S SIGNATURE:**
Roger McNab

Chapter One
Organics dress
and bloomers;
Bobux shoes.

NYC DEPT OF CORRECTIONS
04 02 10
BOOKING NUMBER A4708

D.D.S. (rev. 8-62)
SUPPLEMENTARY COMPLAINT REPORT
(DO NOT FOLD THIS REPORT)

U.F. 61
File No. 64

Charges: PUBLIC NUDITY

Date of Report: 4/2/10

Investigating Officer: Sgt. Cole Washington

Suspect: Olivia McCarthy

Incident Report:

Reports of the subject's incarceration
seemed no surprise to her caregivers at
Happy Tomorrows Daycare. Despite having
having never crossed charges before,
nursery school staff unanimously reported
exasperation, with one noting the other
kids have "seen more of L Olivia's
pampers than they have their own toes."
Witness statements demonstrated their
collective suspicion of poor breeding,
and when police questioned the suspect's
parents about her lackof decorum, this
officer observed a shocking level of
passive indifference toward her repeat
offenses.

PCT. **PCT. POST.** **INVESTIGATING OFFICER'S SIGNATURE:**
Cole Washington

NYC DEPT OF CORRECTIONS
04 02 10
BOOKING NUMBER 1B652

Assignment: The Auckland Museum holds the world's largest Maori and Pacific collection, and is a natural history and a war memorial museum. LATE is part of a broad programme to reposition and reconnect the museum with its external audiences, particularly the hard to reach 20 to 40-year-old age group.

Approach: The opportunity to experience a cocktail of debate, music and community is rare amongst Auckland entertainment offerings. The idea was to build an identity both aligned to the AM campaign identity as well as the concept of LATE, utilizing the metaphor of neon. Each letter of the word LATE was built as a stand-alone neon mounted in a Perspex cube. The letters serve as an event identity through posters, online and physically at the event as stage signage.

Results: The LATE at the museum program has had a huge impact on audience development. Visitor numbers up to 1,000 people attend every last Thursday night every month attracted by contemporary content of music, fashion and debate that is relevant to them. The LATE event has successfully repositioned the museum as a social hub and one relevant to a younger adult audience. The neons themselves have proved not only to symbolize the LATEs themselves, but also to stand alone as an exhibit in their own right. They have become the centre of advertising campaigns for the LATE series, the major part of the LATE event set design and the backdrop to bands and other entertainment. They are recognised both in their own right as a symbol of LATE and an active demonstration of the Museum's outreach to an untapped audience. From a cost perspective, the idea of investing in an object and rethinking it for different promotional purposes has saved considerable cost for the client.

Designers: Dean Poole, Aaron Edwards, Tony Proffit, Max Lozach | **Design Firm:** Alt Group | **Creative Director:** Dean Poole | **Client:** Auckland Museum

Assignment: After the recapitalization by European bank Caixa Geral de Despositos, HKLM were approached by Mercantile Lisbon Bank to rebrand the Bank. They were tasked with:

• Repositioning the bank within the South African banking community and growing its relevance within the wider SME sector

• Evolve the graphic identity and all brand touch points to suit this repositioning

• Create a brand specific banking environment that reflected the new identity and emphasized personal attention and privacy.

The new image of the bank must be reflective of credibility as a banking institution and our unique personalized service offering.

Approach: HKLM assessed the Banks current positioning within the South African Banking community, with respect to what was working, what was unique and what was seen as being redundant in its offerings and approach to banking. HKLM boiled down the essence of the brand to passionate, uncomplicated and tailored. The name "Mercantile Lisbon Bank" was changed to "Mercantile Bank" to communicate that the institution was still a bank for all South Africans. The identity was totally overhauled. However, since we still wanted to retain a legacy of sea-trade, the identity had to appear contemporary, relevant and aggressive. The iconography was pulled through to all collateral, brochure-ware and signage. The Bank's exteriors and interiors were evolved from the old traditional banking environment with Portuguese stylistic overtones (earthy tones and tiling) to a simple, clean, light environment that reflected the modernity of the new identity. The interior facilitates personal interaction with clients and allows for client privacy. The design allows for an obvious clear flow through the bank's interior, enhancing the ease of banking but at the same time respecting the client's privacy. The interior's finishes are clean and crisp, with good clear lighting as required by the new identity. Fit out has been modularized to enable an easy multi-branch rollout throughout the country

Results: Share price doubled within a year. CA-Ratings, South Africa's principal locally owned ratings agency, announced that it "has raised the long-term and short-term ratings of Mercantile Bank."

Design Firm: HKLM Group | **Director:** Graham Leigh | **Environmental Creative Director:** Michael Hinze | **Client:** Mercantile Bank

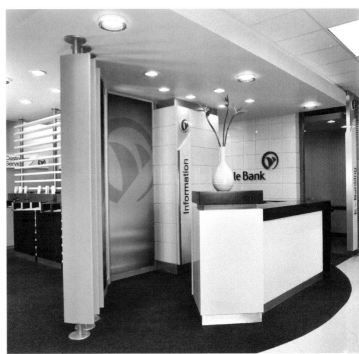

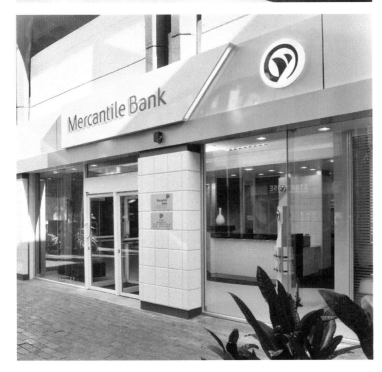

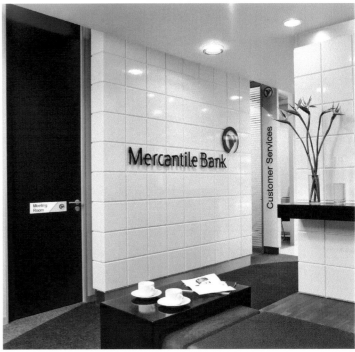

Assignment: Kids who visit the Ford Kids' Escape will find a fun and whimsical space just for them. We designed an environment where kids can take a break from the grown-up world of car shopping to have an outdoor play theme complete with a custom tree house to climb in and slide down, green grass to roll in, felt boulders to rest on, a tree that doubles as a book shelf and an interactive goldfish pond that's too realistic to describe.

Results: Our client is delighted and the space is not only a winner with kids and parents, but it has also earned us some nice accolades from the creative industry.

Designer: Drew Watts | **Design Firm:** Webster Design Associates | **Creative Director:** Dave Webster | **President:** Dave Webster | **Art Director:** Derek McClure
Client: Ford Baxter of Omaha

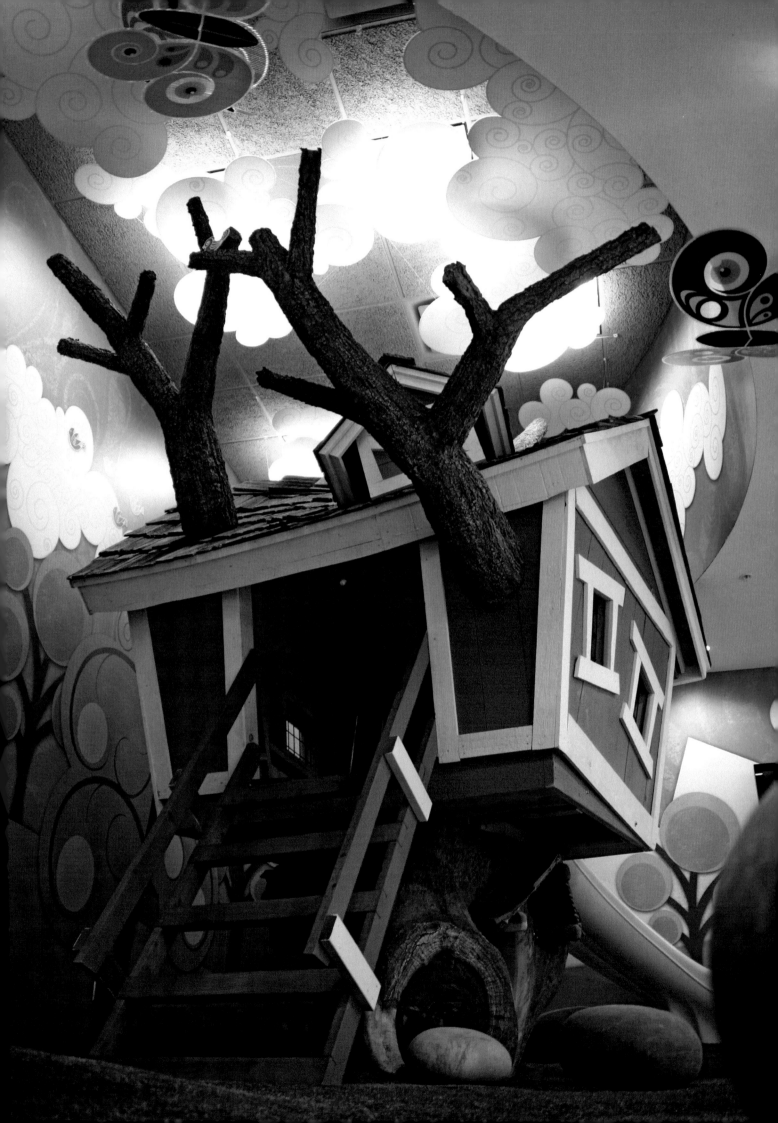

Assignment: Teknion's commitment to sustainable business practices encompasses the design, development and manufacture of all its products. These same principles informed our design choices for the new 2010 IIDEX exhibit.

Results: Our experience working with this team was an enjoyable one. They worked closely with our internal project team to ensure that each objective was met with the best possible solution. The firm was able to go beyond our expectation to design a booth that became one of the 'must see' spaces at the show. The booth was fabulous, and had a steady flow of visitors all bursting with positive comments. In taking our booth design from concept to completion this design firm once again demonstrated exceptional reliability and design excellence. Multiple awards were attained and many product and design accolades ensued. Working with this team proved to be very rewarding.

Designers: Peter Fishel, David Hard, Michael Vanderbyl | **Design Firm:** Vanderbyl Design | **Creative Director:** Michael Vanderbyl | **Client:** Teknion

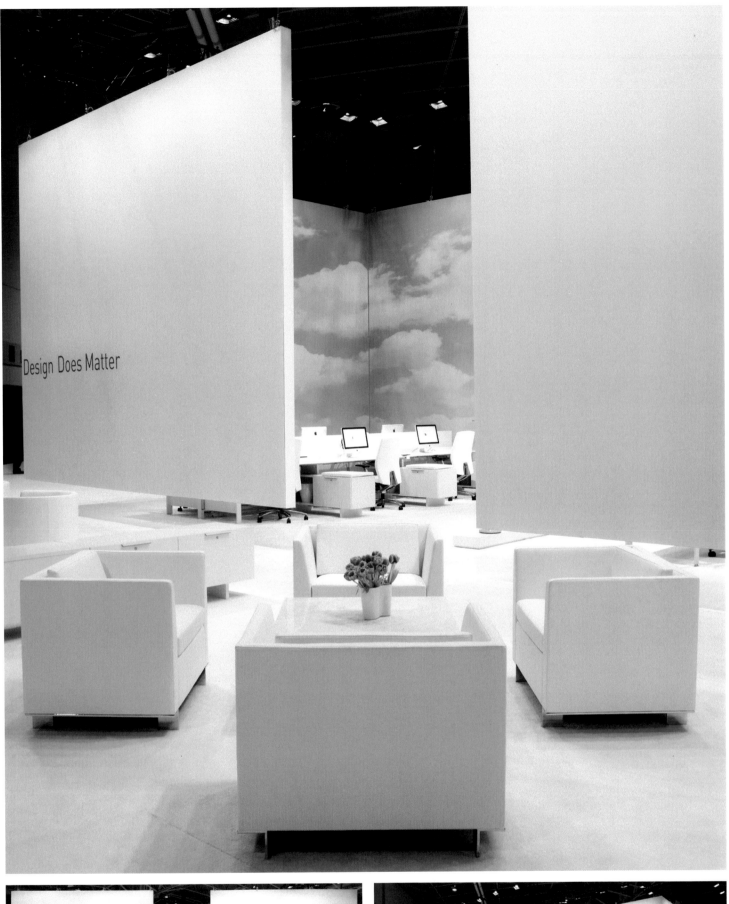

Design Does Matter

Design Does Matter

Teknion

Teknion Design Does Matter

Assignment: This 6,500-square-foot traveling exhibit tells the story of the race to reach the South Pole, one of the most stirring tales in the annals of Antarctic expeditions. At the beginning of the 20th century, a British leader, Robert Falcon Scott, and a Norwegian, Roald Amundsen, led their separate teams on the 1,800-mile journey from the edge of the Antarctic continent to the Pole. The exhibit follows the two teams from departure through the establishment of their Antarctic camps, and on the actual journey to the pole and back. In the section on their base camps, exacting recreations of the living and working quarters of each team are complemented by artifacts of their journeys. In the section on the journey itself, mini-dioramas illuminate particular challenges of the trek, which culminates in a dome representing the South Pole. The graphic challenge was to create an environment that evoked both the Antarctic landscape and the era, while bringing the story and its players to life.

Approach: The graphics refer to the materials used on both expeditions; intro panels are printed on mdf, the modern-day equivalent of the humble lumber used in the explorers' packing crates and huts, skis and sledges. The wall graphics are printed on Tyvek; its detailing, sewn and lashed to a frame with grommets, evokes the tents, tarps and sails that were an integral part of both expeditions. The exhibition's typography references newspaper titling of the day; titles are double or triple-decked, using an eclectic mixture of serif and sans-serif faces (including Franklin Gothic, a typeface of the period). The multi-layered titling also provides the visitor with several different points of entry into the content; besides providing an effective summary, it is expansive enough to include interesting details. A simple color-coding system — Norwegians red and Brits blue — allows the visitor to immediately identify the different teams throughout the show. Infographics compare differences in equipment and men. And on the journey to the pole, a parallel timeline illustrates the advance of the teams; it is punctuated by panels announcing key decisions, successes or failures. The backgrounds of both wall graphics and label decks were left white; the silhouetted photos use the white space as a stand-in for the vast Antarctic landscape. This treatment gives depth to the graphics, and also reduces the imagery to the most basic elements of the challenge: man versus the elements. The exhibit introduced an additional element to encourage visitor participation in the story: ID cards for three main members of each expedition were dispensed at the entrance. Graphics were keyed with photo icons, so visitors could follow their team member throughout the show, finding them in photos, searching for objects that belonged to them, and discovering whether they won the race on arriving at the pole.

Designers: Elizabeth Anderson, Kelvin Chiang | **Design Firm:** American Museum of Natural History Exhibition Department
Director of Exhibition: Catharine Weese | **Manager:** Dan Ownbey | **Printer:** ColorEdge Visual | **Production Manager:** Antonia Gabor
Client: American Museum of Natural History

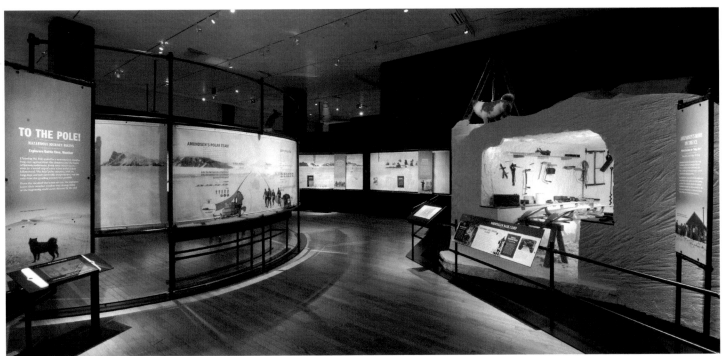

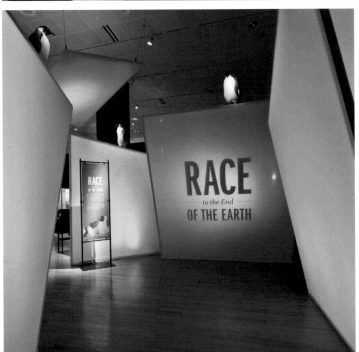

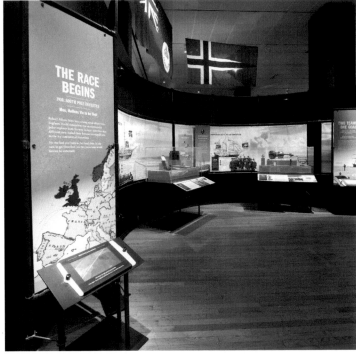

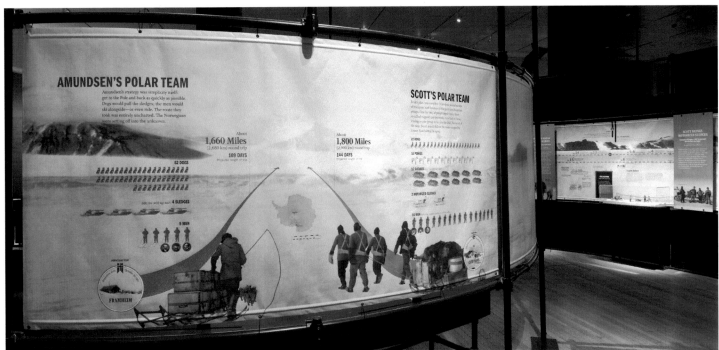

AMUNDSEN'S POLAR TEAM

Amundsen's strategy was simplicity itself: get to the Pole and back as quickly as possible. Dogs would pull the sledges, the men would ski alongside—or even ride. The route they took was entirely uncharted. The Norwegians were setting off into the unknown.

About
1,660 Miles
(2,680 km) round trip
109 DAYS

52 DOGS

4 SLEDGES

5 MEN

FRAMHEIM

SCOTT'S POLAR TEAM

About
1,800 Miles
(2,900 km) round trip
144 DAYS

Assignment: The Smithsonian Institution's Arctic Studies Center, Anchorage Museum, Alaska, includes a resource and study center, an archaeology lab, a seven-screen synchronized orientation film, an immersive soundscape listening space, and a 10,000-square-foot permanent exhibition gallery that presents over 600 objects and tells the stories of the Alaskan Native communities that produced them. The project is a reunion of Alaskan Native cultural and heritage with the dynamic voices of contemporary Alaskans.

Approach: The process for creating the Arctic Studies Center involved working closely with a team of architects and experts, including the world-renowned David Chipperfield Architects, of London; the Anchorage-based firm and architect of record, Kumin Associates; experts from the Smithsonian; and local Native community members. The new Arctic Studies Center received an enthusiastic welcome from the 12 cultural groups living in Alaska, who are represented in the exhibition and participated in the museum's planning and development. Members of these groups also formed an Advisory Panel and enhanced the design process by providing insight into the objects and Native life, setting a new standard in community engagement, museum presentation, and collaborative interpretation.

Results: At the Arctic Studies Center the result has been that all of the Alaskan Native communities can now experience their voices being heard in the exhibition. Visitors who are unfamiliar with Alaskan Native culture have an unforgettable encounter with these communities and their arresting, little-known material culture. The Center empowers Alaskan Native cultures to tell their story and to recover their lost heritage. It also complies with the government's Native American Graves Preservation and Repatriation Act (NAGPRA). The Center can take pride in serving as a global benchmark and as an institution for regional cultural centers serving indigenous peoples to aspire to.

Designers: Caroline Brownell, John Locascio | **Design Firm:** Ralph Appelbaum Associates, Inc. | **3-D Designer:** Nikki Shah-Hoseinni
Content Coordinators: Diana Greenwold, Maggie Jacobstein | **Content Developer:** Anne Bernard | **Copy Editor:** Nikki Amdur
President: Ralph Appelbaum | **Project Director:** Tim Ventimiglia | **Project Manager/Senior Exhibit Designer:** Jennifer Whitburn
Client: Anchorage Museum Building Committee

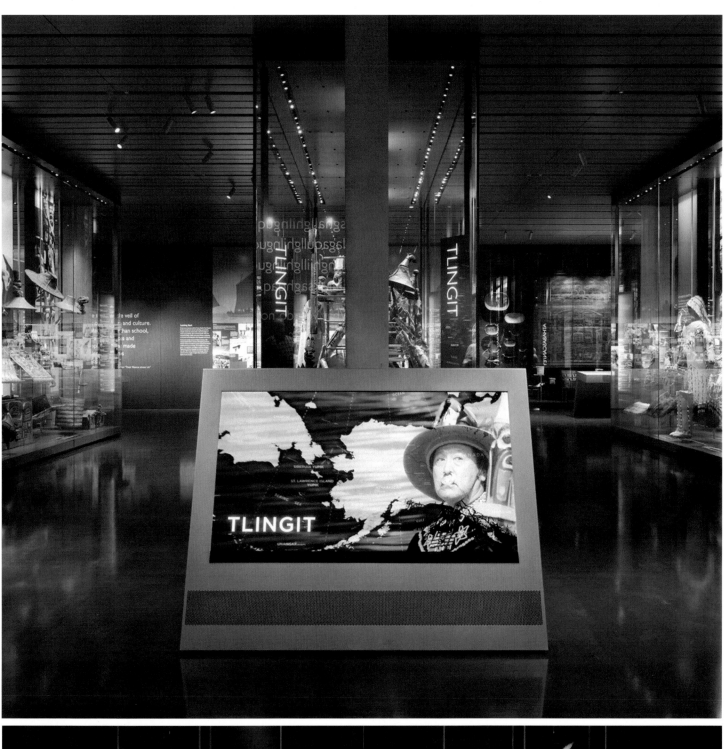

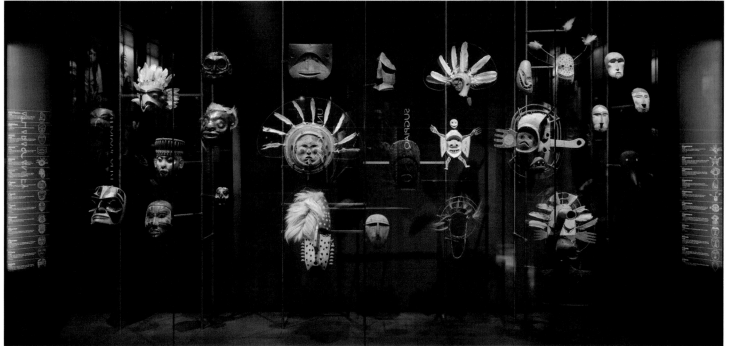

INUPIAQ

"We can shoot th
I wonder how fa
That's the future
That's what we w
future generatio
our cultures."

Assignment: Oculus is located in the north aisle of the crypt of St Paul's Cathedral, an underground burial space from the time of Sir Christopher Wren. The historic tombs of Lord Nelson and the Duke of Wellington surround the aisle and much of the original fabric of the building remains here. The primary reasons for St Paul's Cathedral's desire to create Oculus were to help visitors gain a greater understanding of the Cathedral, its history and the Christian faith and generally to provide better access for disabled visitors. Previously, unless visitors took a guided tour through the Cathedral, there was very little interpretation about the Cathedral's past — especially the three previous churches that have existed on the St Paul's site. Visitors were also deterred from visiting many areas of the Cathedral, due either to accessibility issues or closed galleries. Through Oculus, St Paul's wanted to embrace the Cathedral's history and overcome these accessibility issues through an elegant timeline piece and commissioned films.

Approach: RAA was inspired by the Cathedral itself. Nothing else exists like it in the world. It is Sir Christopher Wren's absolute masterpiece and it affects its visitors on both a grand scale and an intimate level. RAA attempted to do just the same with Oculus — to create something grand and unforgettable, something that stirs the soul, yet also create a sense of warmth and intimacy. Situating our work within the 1,400-year-history of the Cathedral meant incorporating the Cathedral's past within a modern design. RAA achieved this through our lighting approach, which highlights the undulations and texture of the Cathedral's walls, and by ensuring our designs and choice of materials were both original and resonant with the fabric. RAA's design brings out key moments in the Cathedral's 1,400-year history — from its founding in 604 AD to defining events in the Cathedral today — all contextualised within significant world history dates. The Timeline illuminates the aisle with a series of lightboxes and backlit glass panels, drawing visitors to the space and into Oculus. RAA devised a system of carefully considered elements to enable a unique, immersive experience, using the latest projection technology.

Results: The Right Reverend Graeme Knowles, Dean of St Paul's Cathedral said, "We are proud to welcome our visitors to Oculus. The team at RAA has helped us to realise our vision, by designing a beautiful, innovative and dynamic space unlike any other. Oculus will certainly carry St Paul's Cathedral into the 21st century."

Designers: Phillio Tefft, Vicci Ward, Katherine Skellon, Esteban Botero, Nuria Montblanch, Helen Eger, Mat Mason, Holles Houghton
Design Firm: Ralph Applebaum Associates Inc. | **Client:** St. Paul's Cathedral

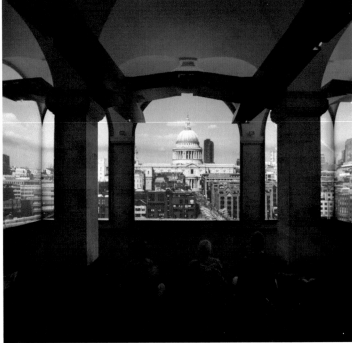

Assignment: The challenge to the designer was to create a compelling retrospective display of a multidisciplinary designer's work in a limited space on a very limited budget. Physical space limitations prohibited displaying the designer's three-dimensional objects. The solution was to print oversized images of both 2 and 3 dimensional work. To display these oversize images, a custom system was designed using many "off the shelf" items, including stainless steel yachting cable and turnbuckles with custom wall attachment plates. The cables were installed diagonally with a seven-foot clearance height to allow free movement throughout the space and provide maximum display area. Stock photo clips and weights secured the print to cable attachment. In addition to the images, actual print samples were suspended from the ceiling 4 feet off the floor with lightweight stainless steel cable to allow visitors a more personal view of the exhibiting designer's work. By freeing the exhibit from the confines of the gallery walls, it provided for a maximum amount of display area. The display acts as metaphor for the designers work: the crossing of two and three-dimensional boundaries.

Designers: Peter Fishel, Michael Vanderbyl | **Design Firm:** Vanderbyl Design | **Creative Director:** Michael Vanderbyl
Client: Western Washington University

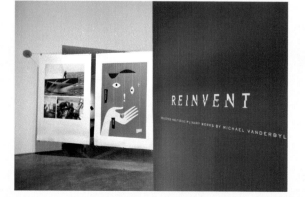

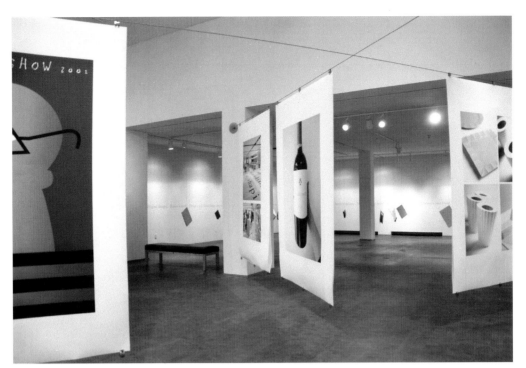

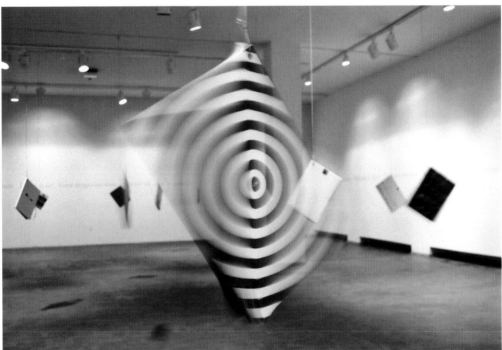

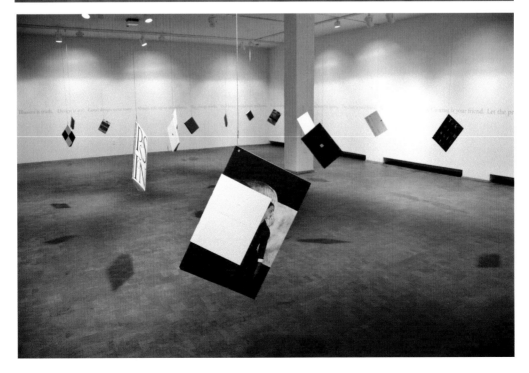

Assignment: The picture shows a still life of three different firecrackers. It was used for a New Years greeting card in 2011.

Approach: The picture belongs to a series of personal work. The 3D image was rendered for a large format print.

Illustrator: Peter Kraemer | **Design Firm:** Peter Kraemer | **Client:** Self-Promotion

146 MY BODY CLOCK ILLUSTRATION **GOLD**

Assignment: This picture of an alarm clock with twisted dial is part of a series of personal work. It is particularly personal, because it reveals me as a night person. The name on the clock face, "McTwisp", refers to the White Rabbit in Tim Burton's movie Alice in Wonderland.

Approach: The complete picture is rendered in 3-D. The motion effects for the pointers, bells and screws are reworked in Photoshop.

Illustrator: Peter Kraemer | **Design Firm:** Peter Kraemer | **Client:** Self-Promotion

147 GLOBAL APPLICATION GUIDE: TRANSMISSIONS ILLUSTRATION **GOLD**

Assignment: Castrol Offshore has undertaken an in-depth review of lubricants and applications to create a globally available, consistent and comprehensive product range. Imagery was required to clearly illustrate the 15 working applications for this range on production platforms and support vessels.

Approach: Images were modeled using a 3D design package before being rendered with a consistent lighting and polished technique that could be achieved across the whole range of applications.

Results: It was launched at the 2011 Offshore Technology Conference, Houston, Texas, and was one of a suite of 15 illustrations that supported the launch of the Global application guide.

Designers: Jessica Britton, Paul Ellis | **Illustrator:** Jim Meston | **Design Firm:** Oakwood Media Group | **Creative Director:** Neil Sims

Client: Castrol Offshore

Kub. Kanonenschlag
Kal. a, Kl II

Knallkörper mit der Zündschnur
nach oben auf den Boden stellen,
am äußersten Ende der Zündschnur
anzünden und sich rasch entfernen.
Nach dem Anzünden nicht in der
Hand halten!
Nur im Freien verwenden!

Assignment: After the successful re-branding of I.C.O.N.'s product packaging, literature and support materials, Version-X was asked to create an online experience that would take the brand's aesthetic to the next level.

Approach: The site was re-thought from the ground up to convey the new direction and provide a more intuitive & informative browsing experience. One of the technical hurdles was that the site needed to be presented in both English and Spanish. Utilizing emerging font embedding methods, the site was designed around using large type and custom fonts that could easily be switched between the multiple languages. The site also features cycling background images that scale dynamically to the size of the browser. Built on the ExpressionEngine content management system, the site serves up a beautiful front-end that's fulfills consumer needs, as well as a robust back-end that allows for easy content updates.

Results: The launch of I.C.O.N.'s new web presence has set the bar for what an online experience can and should be in the professional hair care industry. I.C.O.N.'s customer interaction has grown significantly with the new user-friendly interface and has resulted in the company's exponential growth into social and rich media.

Designer: Adam Stoddard I **Design Firm:** Version-X Design I **Creative Director:** Chris Fasan I **Client:** I.C.O.N.

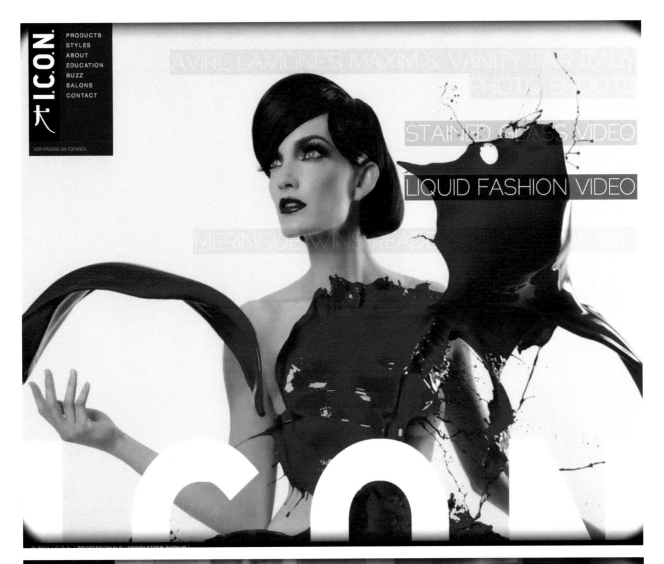

AVRIL LAVIGNE'S MAXIM & VANITY FAIR ITALY
PHOTO SHOOTS

STAINED GLASS VIDEO

LIQUID FASHION VIDEO

MERINGUE

PRODUCTS
STYLES
ABOUT
EDUCATION
BUZZ
SALONS
CONTACT

I.C.O.N.

VER PÁGINA EN ESPAÑOL

© 2011 I.C.O.N. | PROFESSIONALS | NEWSLETTER SIGNUP |

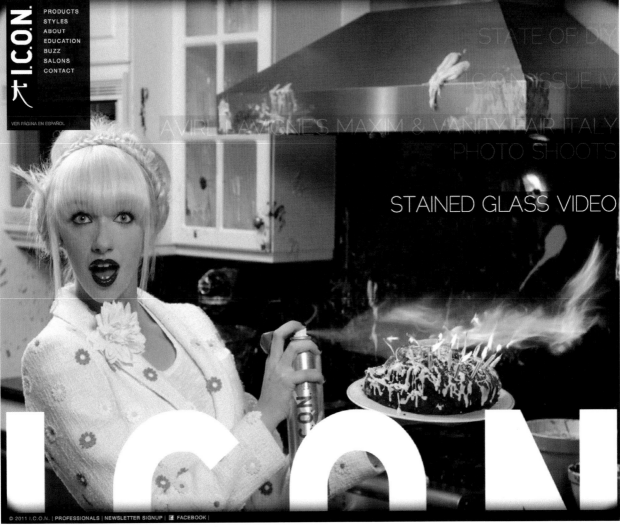

PRODUCTS
STYLES
ABOUT
EDUCATION
BUZZ
SALONS
CONTACT

I.C.O.N.

VER PÁGINA EN ESPAÑOL

STATE OF DIY

ICON ISSUE IV

AVRIL LAVIGNE'S MAXIM & VANITY FAIR ITALY
PHOTO SHOOTS

STAINED GLASS VIDEO

© 2011 I.C.O.N. | PROFESSIONALS | NEWSLETTER SIGNUP | ⨍ FACEBOOK |

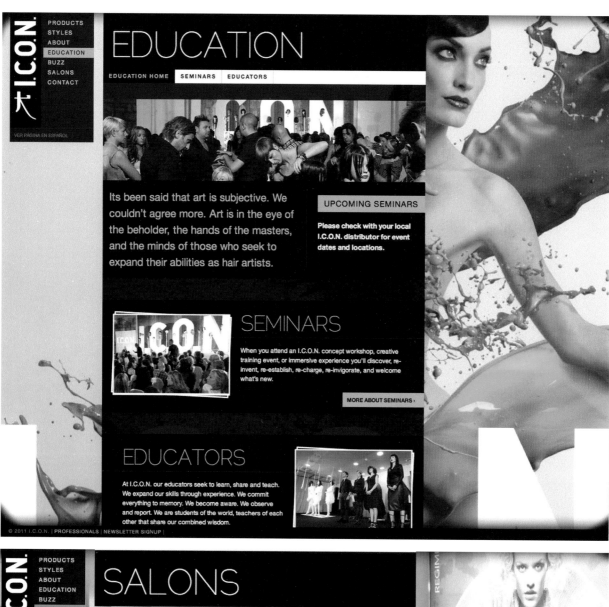

EDUCATION HOME SEMINARS EDUCATORS

EDUCATION

Its been said that art is subjective. We couldn't agree more. Art is in the eye of the beholder, the hands of the masters, and the minds of those who seek to expand their abilities as hair artists.

UPCOMING SEMINARS

Please check with your local I.C.O.N. distributor for event dates and locations.

SEMINARS

When you attend an I.C.O.N. concept workshop, creative training event, or immersive experience you'll discover, re-invent, re-establish, re-charge, re-invigorate, and welcome what's new.

MORE ABOUT SEMINARS ›

EDUCATORS

At I.C.O.N. our educators seek to learn, share and teach. We expand our skills through experience. We commit everything to memory. We become aware. We observe and report. We are students of the world, teachers of each other that share our combined wisdom.

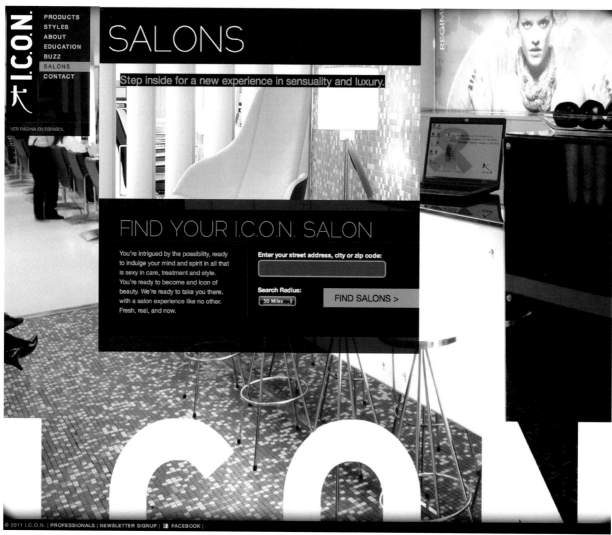

SALONS

Step inside for a new experience in sensuality and luxury.

FIND YOUR I.C.O.N. SALON

You're intrigued by the possibility, ready to indulge your mind and spirit in all that is sexy in care, treatment and style. You're ready to become and icon of beauty. We're ready to take you there, with a salon experience like no other. Fresh, real, and now.

Enter your street address, city or zip code:

Search Radius:

50 Miles

FIND SALONS >

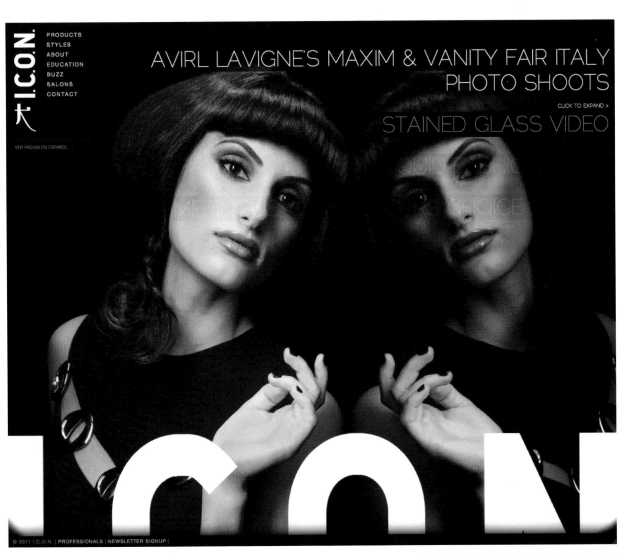

I.C.O.N.

PRODUCTS
STYLES
ABOUT
EDUCATION
BUZZ
SALONS
CONTACT

VER PÁGINA EN ESPAÑOL

AVIRL LAVIGNE'S MAXIM & VANITY FAIR ITALY PHOTO SHOOTS

CLICK TO EXPAND >

STAINED GLASS VIDEO

© 2011 I.C.O.N. | PROFESSIONALS | NEWSLETTER SIGNUP |

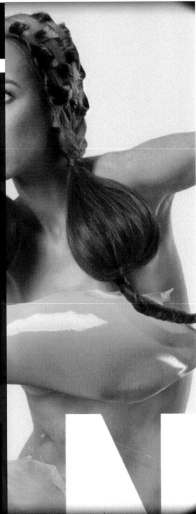

I.C.O.N.

PRODUCTS
STYLES
ABOUT
EDUCATION
BUZZ
SALONS
CONTACT

VER PÁGINA EN ESPAÑOL

PRODUCTS

PRODUCTS HOME CARE STYLE COLOR INDIA WHAT'S NEW

HYDRATION MOISTURIZE & NOURISH

DRENCH
moisturizing shampoo

Saturate hair with moisture, manageability and shine. Lather in a rich, hydrating luxury for deep-penetrating performance.

DETAILS ›

FREE
moisturizing conditioner

De-stress with this lightweight rinse-out conditioner that instantly allows hair to feel liberated, hydrated, free.

DETAILS ›

INNER HOME
moisturizing treatment

A super moisture mask that works from the inside out to restore, replenish and repair structure from the inner to outer layer.

DETAILS ›

DETOX REJUVENATE & INVIGORATE

ENERGIZE
detoxifying conditioner

Continues to energize hair into a more strengthened resiliently bright, youthful appearance. Cool the scalp while promoting healthier, silkier hair.

DETAILS ›

ENERGY
detoxifying shampoo

Gives hair energy by invigorating and balancing for a re-life. Stimulate and purify the scalp to promote healthier hair.

DETAILS ›

SHIFT
detoxifying treatment

An essential, pre-shampoo treatment to shift the overall state of the hair from scalp to ends to sooth and stimulate healthy hair growth and refresh the senses.

DETAILS ›

ANTI-AGING MAXIMUM STRENGTH & PROTECTION

ANTIDOTE
anti-aging replenishing cream

The true smart antidote to wrap each hair strand, eliminating the unwanted effects of age while priming hair for desired style. Help damaged, aging hair to recover youth prior to styling.

FULLY
anti-aging shampoo

Packed full of powerful anti-agers and antioxidants to protect hair and give it a youthful, more supple look and feel. Encourage body with age-targeting antioxidants and nutrients.

RESPOND
anti-aging conditioner

Respond to the specific needs of the hair with natural environmental protectors to provide weightless strength and instant gratification. Moisturize aging hair and follicles for a youthful look and feel.

© 2011 I.C.O.N. | PROFESSIONALS | NEWSLETTER SIGNUP | FACEBOOK |

Assignment: Michael Alberstat is a very talented photographer whose bright lights were being hidden beneath the bushel of a poor online brand presentation. He requested The White Room's aid in building a brand and website that would better express his classic sensibility and lend him the credibility to acquire larger accounts.

Approach: The White Room explained to Michael the importance of investing in a custom website and avoiding the template modification alternative saturating his industry. The firm's designers created a custom flash site combining the purity of a clean grid and beautiful typographic navigation to capture the timeless elegance of Michael's work. The site provides a user-friendly online experience for art directors and designers sourcing talent. It is easily expandable and refreshed. Once a year, the splash quote and homepage image are changed to keep things new and interesting. The watchwords for the site are "classic" and "memorable."

Results: Michael Alberstat's new website has elevated his status within the industry and made a substantial contribution to achieving his goal of winning larger accounts. Completely replacing his need to submit book portfolios, it is his biggest and most important marketing tool. Art directors and designers, he reports, continue to shower it with praise.

Designer, Creative Director: Karolina Loboda, Neil Rodman | **Design Firm:** The White Room, Inc. | **Art Director:** Karolina Lobada
Programmer: The White Room, Inc. | **Client:** Michael Alberstat

Assignment: Architectural Woodwork Industries is a multi-disciplinary architectural services company based in Philadelphia, PA.

AWI has contributed to the success of some of the most iconic buildings of our times such as The Kimmel Center for the Performing Arts,

The Burj-Khalifa, Dubai, and the Experimental Media and Performing Arts Center at Rensselaer Polytechnic Institute.

Approach: We designed the website to showcase AWI's work by telling the story of each project: its challenges, solutions, and results.

The use of engaging, full frame images and detailed drawings provide a compelling user experience.

Creative Director, Designer: Lorenzo Ottaviani | **Design Firm:** Lorenzo Ottaviani Design, Inc. | **Content Management:** Eamon Sisk
Web Developer: Mary Phillipuk | **Client:** Architectural Woodwork Industries, Inc.

Assignment: The Carnegie Mellon University School of Drama, one of the premier drama schools in the country, was in need of a redesigned website that reflected the caliber of the experience, the education, the place and the people who include current students, alumni and faculty. The goals were to: (1) Capture the true character of the institution, described as vibrant, creative, edgy and progressive, (2) Attract ideal students, (3) Demonstrate and encourage diversity, (4) Show the process to finished art by providing a window into the work, people, areas of study and expertise that go into the final production and (5) Help engage and reconnect the alumni. To match the caliber of the school, it was important that the site make a strong first impression of not just a great school, but also of a theatre that creates great productions in all aspects. There had to be an energy level that matched what was physically going on inside the building.

Approach: Big bright colors and simple direct navigation on the homepage, where each horizontal silo opens up to a larger stage area helps guide the user quicker to specific content. The colorful margin banding picks up on that season's color scheme, adding a timeliness and freshness. Throughout the site, there is a wealth dynamic, energetic photography — facilitated by a collapsible slideshow viewer. Careful consideration was given to type hierarchy and copy length, working closely with a writer to ensure proper, consistent voice.

Results: Whereas the old website was never used as a marketing tool, today it is their primary vehicle for making first contact with prospective students, involvement current students, promoting themselves, and reaching out to alumni. It has infused a new sense of energy into the marketing department and faculty members to contribute on-going web content (writing, photos, video) all easily uploaded and organized through a custom content management system. The website has also increased office and box-office efficiency, being a more effective device than previous at answering and directing questions."

Designers: Bill Krowinski, Laura Smous, Larkin Werner, James Nesbitt | **Design Firm:** Wall-to-Wall Studios
Client: Carnegie Mellon University School of Drama

Assignment: Division of Labor is a creative and strategic brand studio. They write, direct and produce content to promote brands across all media

platforms. Print is disposable, and becomes more archaic every day. We wanted to create something special that people don't want to throw away.

Approach: The challenge was to create an identity system that people wouldn't confuse with an actual government agency. This was done by

a modern take on union membership cards, stamps and seals. We did this through letterpress on French Poptone in combination with a set of

rubber stamps. In case you were wondering, the Latin means: "Don't let the bastards grind you down."

Results: "Mikey's great design has brought us lots of new friends and fans." — Paul Hirsch

Designer: Mikey Burton | **Design Firm:** Mikey Burton | **Client:** Division of Labor

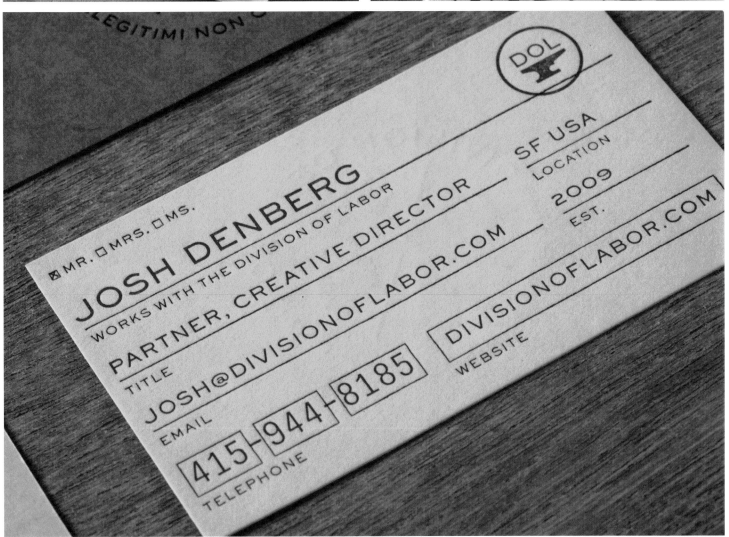

☒ MR. ☐ MRS. ☐ MS.

JOSH DENBERG
WORKS WITH THE DIVISION OF LABOR

PARTNER, CREATIVE DIRECTOR — SF USA
TITLE · LOCATION · 2009 EST.

JOSH@DIVISIONOFLABOR.COM
EMAIL

DIVISIONOFLABOR.COM
WEBSITE

415 - 944 - 8185
TELEPHONE

DIVISION OF LABOR
143 BALTIMORE · CORTE MADERA, CA 94925

DIVISION OF LABOR · ILLEGITIMI NON CARBORUNDUM

DIVISION OF LABOR · ILLEGITIMI NON CARBORUNDUM

DON'T BEND ME BRO.

DON'T BEND ME BRO.

DON'T BEND ME BRO.

Assignment: Logo design for DVDs and website applications for Robbie Massie of 9.81 Films. Based out of Bozeman, Montana, this skilled group of friends produce and star in extreme skiing, ski mountaineering and speed flying films.

Approach: I felt I needed to incorporate an "X" in the design and mountaineering elements somehow. The logo would most likely need to knockout of 4-color on a DVD so it needed to be simple and readable for small applications.

Results: We were able to wrap up the job after the first presentation.

Designer: Bruce Holdeman | **Design Firm:** 601 Design Inc. | **Client:** Robbie Massie

Assignment: Blue Earth Group is a building developer in Melbourne, Australia that specializes in innovative, contemporary, environmentally aware space. The use of a "B" as a three-dimensional diagram highlights the multi-dimensional nature of this company and creates an optical illusion that reinforces its many-faceted focus. The logo appears with different textures across environmental on- and off-site advertising.

Designer: Peter Watts | **Design Firm:** Watts Design | **Client:** Blue Earth

Assignment: Teliolibro is a second-generation bookstore. Their father was one of the few selling forbidden books in a small bookshop in Valencia during Franco's regime. He started a small company publishing books of free creation on designers.

Approach: The brand plays with the word "book" and the name of the customer by creating a library.

Designer: Eduardo del Fraile | **Design Firm:** Eduardo del Fraile | **Client:** Julio Telio

Teliolibro

Assignment: Despite being a de facto leader of the Romanian electronic commerce, eMAG was not perceived as a market leader. Apart from the impeccable business performance, the enviable market share and millions of loyal customers, eMAG needed to express its leadership through a powerful identity in order to conquer also the share of heart, but without losing the accumulated brand equity. At the same time, a radical brand identity change was not advisable, given the market position and the extended and faithful consumer base.

Approach: The brand audit revealed a very complex type of brand, with a myriad of facets relating to its internal and external audiences. Consequently, Brandient established the brand idea in accordance with the audit findings, bringing to light the very essence of eMAG: enabling the self-gratification of its customers. The approach of the redesign was to capitalize on the familiarity of the old brand elements, namely the brand name, the chromatic palette and the logo structure, but also to permeate them with the new brand promise and enliven them up to the rhythm of the modern customer. This is how the modular logo was born, to convey that each day eMAG brings you new reasons of enjoyment in an up-to-minute, relevant and dynamic way. Notably, the concept of flexible identity is best suited for online entities — the logo switching cost is close to zero and you may serve custom logos for various moments and occasions, on a per user basis and adequate to its demographics. Thus, eMAG's brand idea "Your joy, anticipated" is reflected in a dynamic, polymorphous logo illustrating the different facets of joy: coziness and comfort (red slippers, sofa), childish exhilaration n (toy rocket), surprise (present box), wonder, pride, sexiness, etc. And the logo stays relevant while truly dynamic: a present-themed logo is served to a user on her/his birthday, the medal-logo marks a national sports team's win and so on.

Results: The new identity was received excitedly by the organization, and the office interiors and showrooms were decorated in the spirit of the new logo. The brand capitalized on its increased awareness and sales raised. Most notably, the new identity also enabled a very simple and versatile communication platform — both online and offline — with greater impact and significantly lower cost. Therefore, with a happy organization, higher revenues and lower communication costs, the client could not be any happier.

Designers: Cristian "Kit" Paul, Ciprian Badalan | **Design Firm:** Brandient | **Client:** Dante International Ltd.

Assignment: This was designed as our company logo. In Norwegian, gevir means antler.

Designer: Björne Höydal | **Design Firm:** Gevir Design | **Client:** Gevir Kommunikasjon

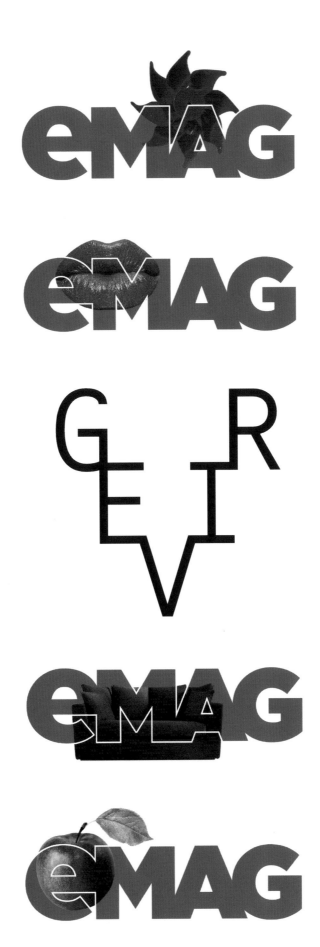

Assignment: Felix Bullock Guitar Studio is a classical guitar studio committed to providing inspirational instruction to maximize student potential. The proprietor views his approach to teaching as a reflection of his relationship with his music. As a result, we sought to find a unique way to incorporate the proprietor's initials into his instrument.

Approach: Our solution uses the instrument's iconic strings, tuning keys and body to create the proprietor's initials. The composition's juxtaposition of abstract elements, like music, is open to interpretation, seeking to engage the viewer in discovering the letters "F" and "B" within the design.

Results: The innovative identity has been instrumental on positioning the studio as a leading voice in classical guitar pedagogy.

Creative Director, Designer, Illustrator: Earl Gee | **Design Firm:** Gee + Chung Design | **Client:** Felix Bullock Guitar Studio

Assignment: The assignment was to create a logo for a new CNC router cutting business. We wanted the logo to look like it was something that could be fabricated with this kind of equipment.

Approach: Wood and aluminium are the materials that are usually cut and it was decided to use these elements to make the logo and also serve as an example of the kind of cutting the CNC cutter can do. The typeface needed to be customized so that when the letter was cut out, the form would stay intact. Over the course of two meetings, around 40 designs were shown.

Results: The last design instantly clicked with both the client and myself.

Designer: Bruce Holdeman | **Design Firm:** 601 Design, Inc. | **Client:** Toolpath Design

Assignment: To communicate that Creative Week is the hub event for all creative professionals in New York.

Approach: We listed all the iconic elements of New York: the grid system, subway graphics, sky scrappers, bridges, etc. Nothing better communicated the idea of everyone converging on a central point than street signs. Using this visual vocabulary, we showed that all creative roads lead to Creative Week.

Results: The client loved it.

Designer: Matt Luckhurst | **Design Firm:** Collins | **Creative Directors:** Brian Collins, Lee Maschmeyer | **Client:** Creative Week New York

Assignment: To create a proud visual icon commemorating 25 years of Willie Nelson's Farm Aid.

Approach: We wanted to evoke the classic integrity of American farmers — not overly fancy, but obviously honorable.

Results: The Farm Aid folks were reluctant at first but very happy in the end.

Designer: Michael Schwab | **Design Firm:** Michael Schwab Studio | **Client:** Farm Aid

Assignment: I was asked to design the 100th anniversary of the Steamboat Springs train depot which houses the Arts Council office and art galleries.

Approach: I used the letter forms from the main Arts Council logo that I had designed earlier and since this was the anniversary of the Steamboat Springs train depot, I couldn't see doing anything without some kind of a train illustration.

Results: I would say we had mixed results. Both Marion and I were happy with the logo but we ended up adding a tagline explaining it was the 100th anniversary of the depot to bring more attention to milestone.

Designer: Bruce Holdeman | **Design Firm:** 601 Design, Inc. | **Client:** Marion Kahn Communications

Assignment: To design an identity for a new specialty cafe that would have a warm, inviting feeling. The name for this business reflects the desire of two identical twins to provide a venue for their delicious and high quality food and beverages. The two magpies in the logo reflect the owners (and their charm) and the design is reminiscent of French pâtisseries further reflecting their talent for tasty goodies.

Approach: We used the two magpies representing each of the owners and a soft blue for a relaxing setting. The font used for the large "M" in the centre is Clarendon giving it an old world charm and the text "Make Yourself At Home" is used to remind people to sit and chat a bit.

Results: The results have been overwhelming and the café is a huge success.

Designer: Catharine Bradbury | **Design Firm:** Bradbury Branding & Design | **Client:** Magpies Kitchen

Assignment: The goal was to design a strong, dynamic, vital and easy to differentiate logo.

Approach: We designed a flexible brand, incorporating different types of fur, feathers or scales inside a cross typically related to health services.

Results: The client was very surprised and pleased.

Designer: Alvaro Perez | **Design Firm:** El Paso, Galeria de Comunicacion | **Client:** VITAVAL Veterinary Services

Assignment: The Levis billboard illustrates the notion of "We Are All Workers" by constantly breaking down and rebuilding the typography placed on actually turning cogwheels.

Results: New Yorkers loved the concept and many had themselves photographed in front of it.

Designer: Jessica Walsh | **Design Firm:** Sagmeister, Inc. | **Creative Director:** Stefan Sagmeister | **Client:** Levi Strauss

170 LEVI'S BILLBOARD — WE ARE ALL WORKERS OUTOOR GOLD

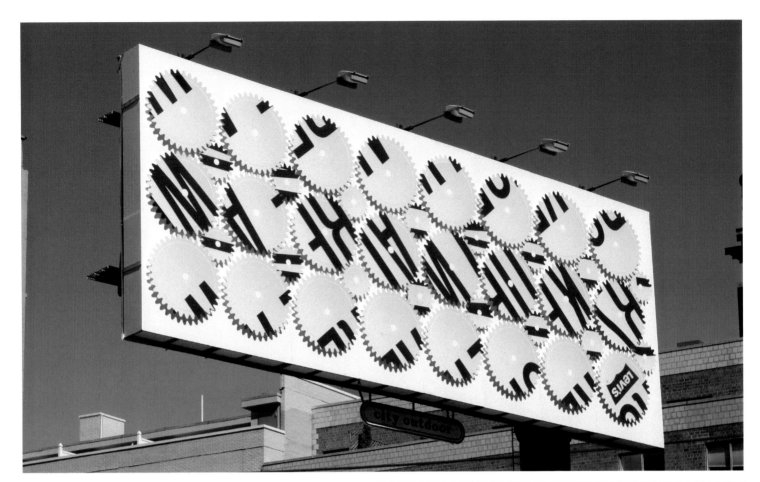
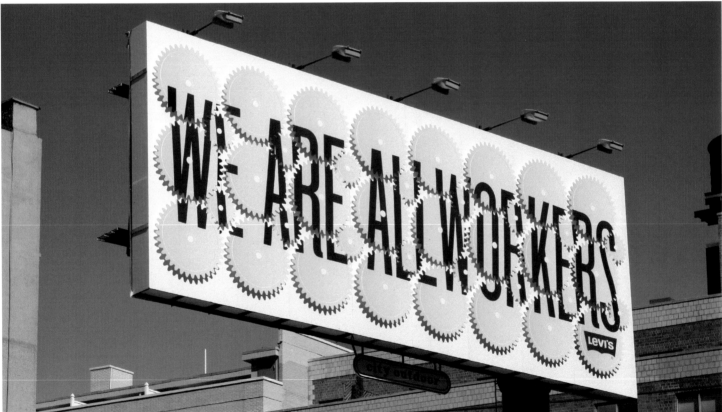

Assignment: The truck wrap was part of a campaign to drive donations and shopping at Goodwill stores throughout San Antonio.

Approach: The two-dimensional illustration is intended to look like a three-dimensional inside of the truck and attract the attention of potential

donors. The illustrator used photo examples as inspiration to develop the composition, but the entire rendering is an illustration.

Results: The client was pleased with the buzz generated by the truck around San Antonio.

Designers: Bradford Lawton, Emi Ramirez-Hunt, Stephen Durke, Tony Diamond, Josue Zapata | **Design Firm:** BradfordLawton
Client: Goodwill Industries of San Antonio

Assignment: Lourinhã (Portugal) is one of the three exclusive demarcated areas in the world for brandy production, although much less recognized than Cognac and Armagnac in France. It was here that Magistra was conceived — thanks to the friendship between José Roquette and Carlos Melo Ribeiro, the respect for the traditions of wine distillation and the desire to create a superior high-quality aged brandy spirit. With this very special product in mind, we wanted to created a frame like packaging that would enhance the bottle as if it were a collectors item. The simple and natural materials, combined with exquisite details in printing, seek to turn every tasting into a slow enjoyable ritual.

Approach: Our creative process is largely based on concept developing. We take the brief that is given to us, and try to shape it into a strong solid idea, that can ultimately result in an appealing final product. We also work in close collaboration with our clients and invariably our design projects are born out of an open dialogue between us. Most of the time the projects grow with trial and error, constantly going back and forth until we are fully satisfied. For example, this particular project used to be a paper package and slowly developed into something totally different.

Results: The final result could not have been better. We were very happy with our final work, the client was thrilled, the new Magistra bottle and package was quickly accepted by the consumers and we could clearly see the role of design in enriching the product and improving its placement on the market.

Designer: Eduardo Aires | **Design Firm:** White Studio | **Client:** Esporão

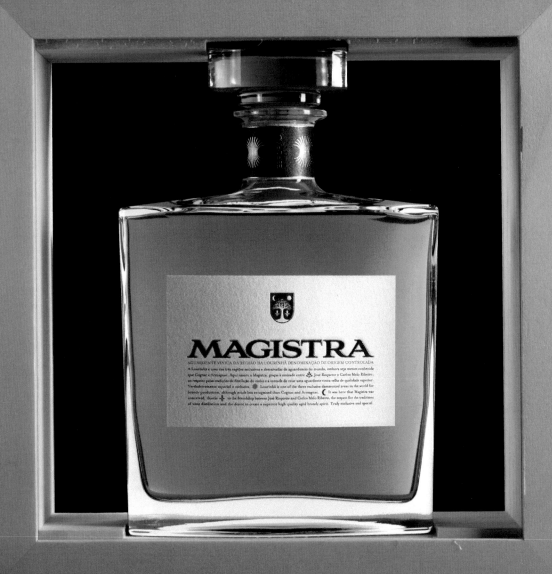

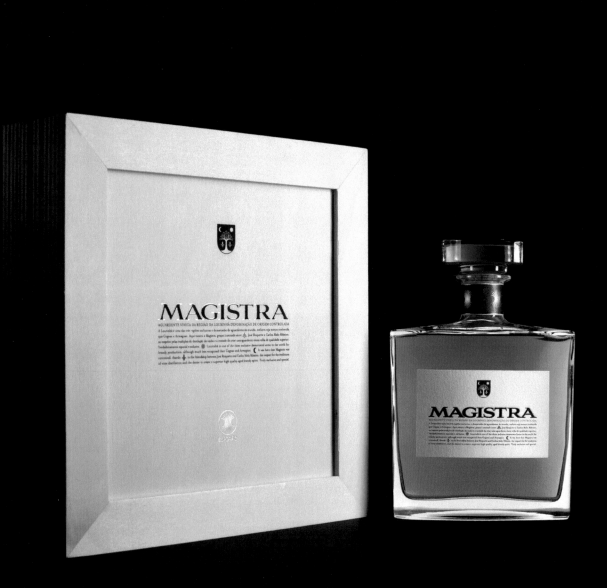

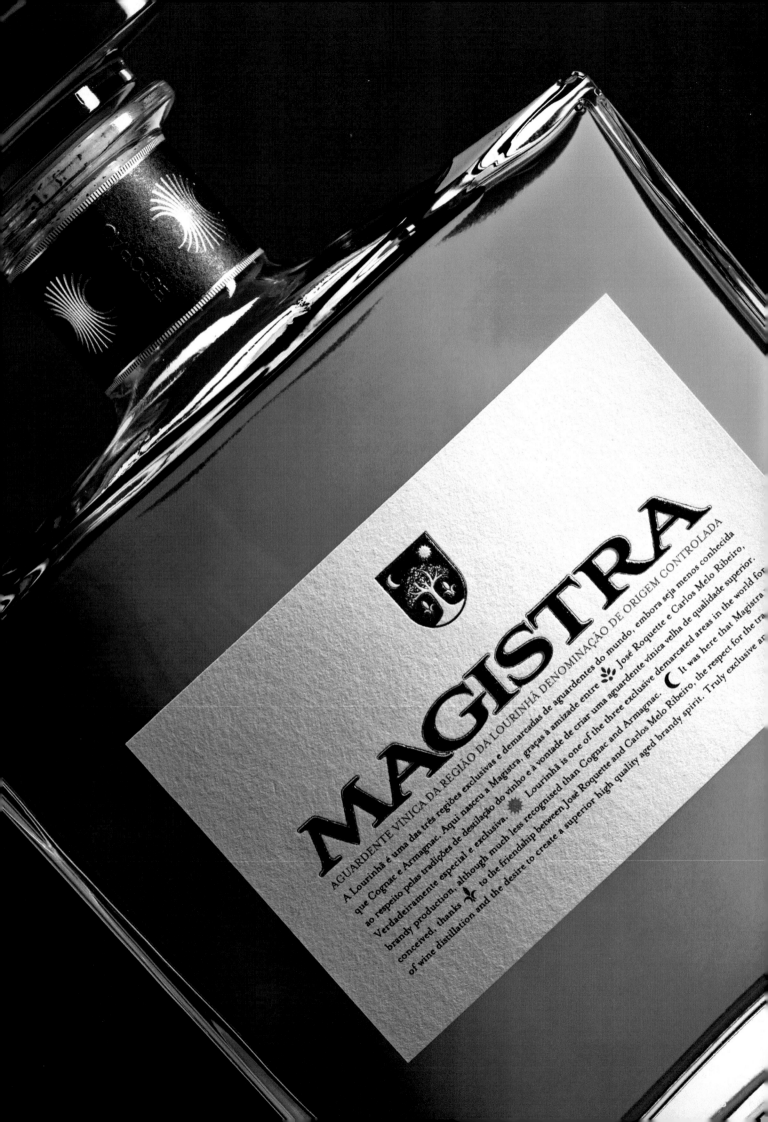

MAGISTRA

AGUARDENTE VÍNICA DA REGIÃO DA LOURINHÃ DENOMINAÇÃO DE ORIGEM CONTROLADA

A Lourinhã é uma das três regiões exclusivas e demarcadas de aguardentes do mundo, embora seja menos conhecida que Cognac e Armagnac. Aqui nasceu a Magistra, graças à amizade entre José Roquette e Carlos Melo Ribeiro, ao respeito pelas tradições de destilação do vinho e à vontade de criar uma aguardente vínica velha de qualidade superior. Verdadeiramente especial e exclusiva.

Lourinhã is one of the three exclusive demarcated areas in the world for brandy production, although much less recognised than Cognac and Armagnac. It was here that Magistra conceived, thanks to the friendship between José Roquette and Carlos Melo Ribeiro, the respect for the tra of wine distillation and the desire to create a superior high quality aged brandy spirit. Truly exclusive ar

Assignment: To create a super premium presentation to house some of the distillery's oldest and rarest single malt whiskies. The concept was to use the "elements of Islay," while making the whisky the hero.

Approach: The concept was breathtaking. Its execution was even more so. Craig Mackinlay of Breeze Creative designed the bottle shape, neck fitment and stopper. The bottle shape came from the original bottle that Mackinlay designed in 2007 for the Bowmore core range. Taking inspiration from the ancient rocks that line Islay's rugged coastline, Brodie Nairn and Nichola Burns of Glasstorm have hand-blown and painstakingly sculpted each of the 53 bottles, using molten glass and stones collected from the island's shore. Hamilton & Inches provided the finishing touch at its workshops in Edinburgh.

Results: The result was astonishing, as you can see. A credit to the craftsmen at the distillery and the creative team working together to bring the consumer the perfection Bowmore deserves.

Designer: Craig Mackinlay | **Design Firm:** Breeze Creative Design Consultants | **Client:** Morrison Bowmore Distillers

Assignment: The brief was to design and launch the new Tom Ford beauty line. It needed to communicate an extension of the Tom Ford vision, while being unique and bold within the crowded high-end beauty world. The challenge was in creating a new design vocabulary that could be scalable across an entire range of products including bottles, tubes and brushes, all in varying materials, sizes and uses.

Approach: Tom Ford has a very distinct design sensibility. Our role was to distill his vision into a unique packaging program that would align Tom Ford and Estee Lauder, the licensor. Furthermore, the process was about understanding consumers in this category so that we could deliver a design that would inspire them to purchase the product. Our experience in beauty provides a strong focus that allows us to do just that.

Results: The client is extremely happy with the end result and has continued to add additional SKU's to the initial line up. The brand has just launched. No real sales data is available yet, however reaction from both the press and retailers has been extremely positive.

Designers: Doug Lloyd, Asako Aeba | **Design Firm:** LLOYD&CO | **Client:** Tom Ford

Assignment: Coca-Cola Olympic Winter Games packaging that celebrates the joy and excitement of the Olympic games and hints to the bubbly effervescent beverage inside.

Approach: The Coca-Cola Olympic Games-themed collectible cans and FridgePacks feature silhouettes inspired by some of the most popular Olympic Winter Games sports, such as figure skating, speedskating and snowboarding. Additional packaging includes 20-ounce Coca-Cola bottles, multipacks and 2- liter bottles, with a new silhouette appearing every two to three weeks.

Results: More than 700 million cans were on store shelves throughout January and February, 2010.

Designers: Josh Michels, Tetsuya Takenomata | **Design Firm:** Turner Duckworth London & San Francisco | **Creative Directors:** Bruce Duckworth, David Turner | **Design Director:** Sarah Moffat | **Illustrator:** John Geary | **Client:** The Coca-Cola Company North America

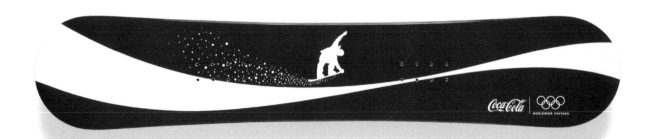

Assignment: Dell XPS 15Z is a premium performance machine showcasing leading-edge technology built inside a beautifully crafted exterior. The challenge was to develop a package that compliments the product design and focuses on a simplistic customer experience.

Approach: We started by studying the ID of the product to gain an understanding of how to build the best structure and graphics that support the design attributes. We also conducted market research on our competitors as well as other premium categories outside of the tech industry. Working closely with the ID, design and engineering teams, we collaborated on rounds of concepts before reaching the final result.

Results: Our solution showcases the product and lets it be the ultimate hero of the package. Simplistic photography defined the product angles with dynamic lighting and intense depth.

Design Firm: Cinco Design | **Art Director:** Michele Witenko | **Client:** Dell

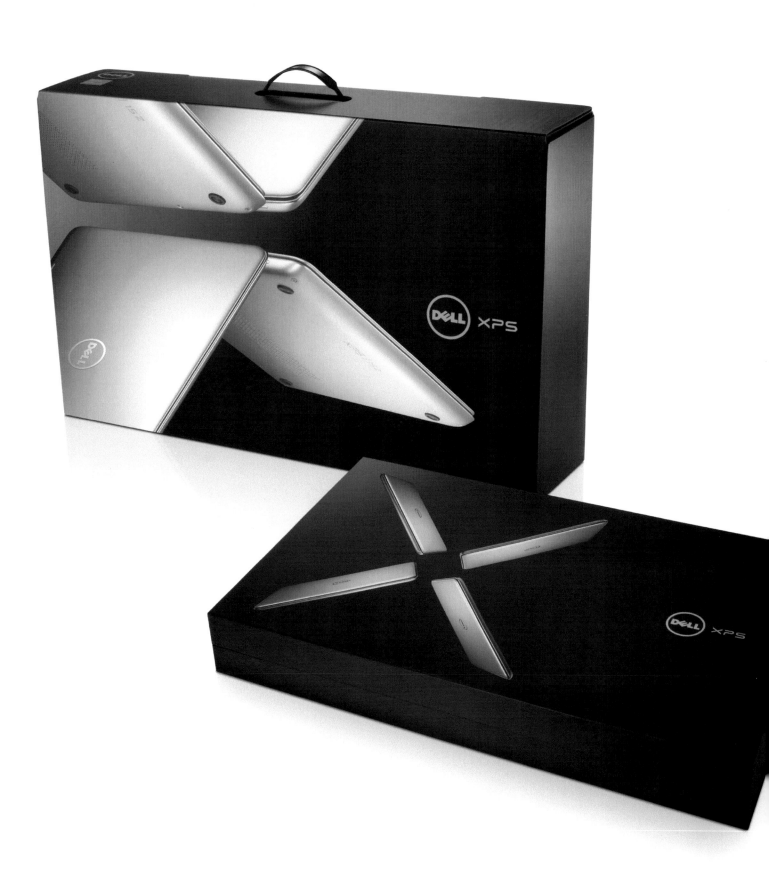

Assignment: Each year Tivoli Gardens asks a leading artist to create their annual poster. There are no limits, except it has to say TIVOLI. Over the years, truly outstanding work has been done.

Approach: A fine artist and a graphic designer working together, is for us a great way to create unexpected results — and this poster is made in that way. Erik made the painting and Søren put the type on to give it the Tivoli meaning. The typography is ZADIE made by Henrik Kubel.

Results: From press release, Erik A. Frandsen says, "My startpoint is a classic flowermotive. At first glance you se flowers in a vase, but then you see that it is the stems and the vase, and not the flowers that are the motive. In that way you feel Tivoli Gardens as a world you are seduced into, where fairytales invades realness. That is how I feel when I go to Tivoli Gardens, from one state to another."

Designers: Erik A. Frandsen, Søren Varming | **Design Firm:** Punktum Design MDD | **Typographer:** Henrik Kubel | **Client:** Tivoli Gardens

TIVOLI

erik a. frandsen 2011

Assignment: Glass Enchantment is a world-class contemporary glass show. The exhibition was likely to attract the area's glass fanatics. The show director was also looking to get attention from the general public. So we put these posters up around town to perk in interest the opening.

Approach: To give the impression that this was not a show to be missed, I wanted to make the artwork feel larger than life. The effect would hopefully give the viewer a foreshadowing of the inspiration to come.

Designer: Tim Winter | **Design Firm:** Jay Advertising | **Client:** RCT/Nazareth College Arts Center

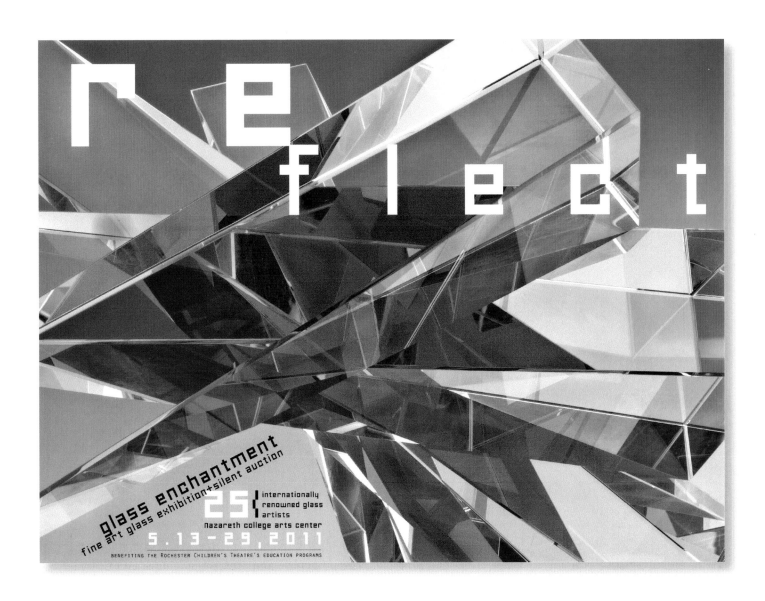

re flect

glass enchantment
fine art glass exhibition+silent auction

25{ internationally
renowned glass
artists

Nazareth college arts center
5.13-29,2011

BENEFITING THE ROCHESTER CHILDREN'S THEATRE'S EDUCATION PROGRAMS

Assignment: Saratoga Shakespeare Company is a local not-for-profit theater company committed to bringing professional performances of

Shakespeare's work to the Capital Region. As a player in the busy cultural scene of Saratoga Springs, the Company needed a distinctive,

compelling campaign for its 10th anniversary season. The producers put together a show that satisfied Shakespeare enthusiasts while giving

newcomers to his work, especially families, a fun, exciting introduction.

Approach: Palio developed imagery to reflect the production of Hamlet, Shakespeare's most famous and haunting play about madness, revenge,

and mortality. The great mystery of Hamlet lies in his trying to figure out where true morality lies. Is he mad? Should he revenge his father's

death? Should he kill himself? Is murder ever legitimate--even when the ghost of your father commands you to commit it? Hamlet's struggle

to retain his sanity and integrity in a confused, morally corrupt world speaks to us today. It is one of the reasons the play has endured through

the centuries. Palio designed all the promotional materials needed to make Saratoga Shakespeare Company a summer phenomenon engaging

residents and international visitors.

Results: More than 5,000 people of all ages attended the performances over 10 nights. The Company also received generous financial support

by local businesses and foundations. The success of this year's production guaranteed the company would be back in the park in 2011.

Designers: Guy Mastrion, Bob Rath, Tom Rothermel, Eric Sahrmann, Kim Werther | **Design Firm:** Palio | **Client:** Saratoga Shakespeare Company

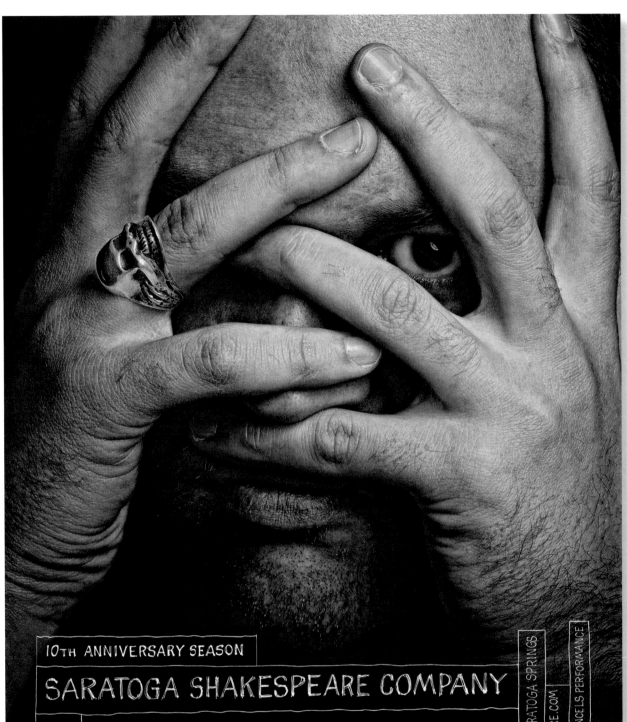

10TH ANNIVERSARY SEASON

SARATOGA SHAKESPEARE COMPANY

PRESENTS

HAMLET

CONGRESS PARK, SARATOGA SPRINGS

SARATOGASHAKESPEARE.COM

RAIN AT SHOWTIME CANCELS PERFORMANCE

DIRECTED BY WILLIAM A. FINLAY | PERFORMED **FREE** ON THE ALFRED Z. SOLOMON STAGE

JULY 13-17 AND 20-24 AT 6 PM | JULY 18 AND 25 AT 3 PM

SARATOGA ARTS
ARTS CENTER | ARTS COUNCIL

SARATOGA
SHAKESPEARE
COMPANY

NYSCA

THIS PROGRAM IS FUNDED IN PART BY THE SARATOGA PROGRAM FOR THE ARTS FUNDING (SPAF), PART OF THE DECENTRALIZATION PROGRAM, A REGRANT PROGRAM OF THE NEW YORK STATE COUNCIL ON THE ARTS (NYSCA) ADMINISTERED BY SARATOGA ARTS

MAJOR SPONSORS: ADIRONDACK TRUST COMPANY, ESPEY MANUFACTURING & ELECTRONICS CORP., HERBERT ROGOFF, JAY ROGOFF & PENNY JOLLY, MARSHALL & STERLING, SARATOGA FOUNDATION, MARTIN KLOTZ, MICHELE & RON RIGGI, STEWART'S SHOPS, *THE SARATOGIAN*, STOCK STUDIOS PHOTOGRAPHY, WRIGHT FAMILY FOUNDATION DESIGN BY PALIO, PHOTOGRAPHY DONATED BY ERIC SAHRMANN, PRINTING DONATED BY FLM GRAPHICS

Assignment: We needed a poster to promote the Pecha Kucha night. This event is free to the public and a non-profit so we were offering poster

for a donation. You don't need too many excuses to do a poster anyway.

Approach: Austin Speed Shop is a local icon so we knew we wanted to integrate this great venue. Also, Pecha Kucha originated in Japan so we

were trying to tip our hats to that culture. We scanned these car parts out of an old car manual from the 1960s.

Results: Everyone loved them. We put some up around town and people would ask how long they had to leave them up before taking them

home. It created enough talk around town for the event that we had to turn people away.

Designers: DJ Stout, Stu Taylor | **Design Firm:** Pentagram | **Illustrator:** Marc Burckhardt | **Client:** Pecha Kucha

Assignment: Poster, Program Cover, and merchandise for San Francisco Opera's Production of Wagner's Ring Cycle.

Approach: Our task was to evoke the visual drama of the Valkyries with the backdrop of their world destroyed by fire as well as the hope of new life merging from the river Rhine.

Results: Abundant poster and merchandise sales at the San Francisco War Memorial Opera House. The directors, producers and ticket holders were all thrilled.

Designer: Michael Schwab | **Design Firm:** Michael Schwab Studio | **Client:** San Francisco Opera

Assignment: After a renovation, the museum desired to make a bold impact in coming back to Zurich's cultural agenda.

Approach: Not a single but a series of posters manifests the fresh start of the established brand.

Results: The opening was a true happening. The museum was filled with friends — a who is who of Zurich's cultural elite.

Designers: Fritz Gottschalk, Michel Schmid | **Design Firm:** Gottschalk+Ash Int'l | **Client:** Coninx-Foundation, Zurich

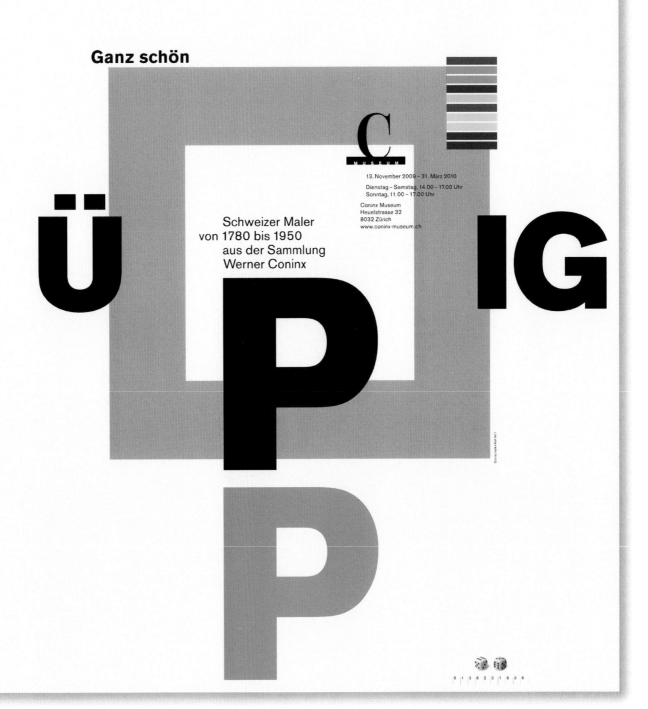

Ganz schön

ÜPPIG

C
MUSEUM

13. November 2009 – 31. März 2010

Dienstag – Samstag, 14.00 – 17.00 Uhr
Sonntag, 11.00 – 17.00 Uhr

Coninx Museum
Heuelstrasse 32
8032 Zürich
www.coninx-museum.ch

Schweizer Maler
von 1780 bis 1950
aus der Sammlung
Werner Coninx

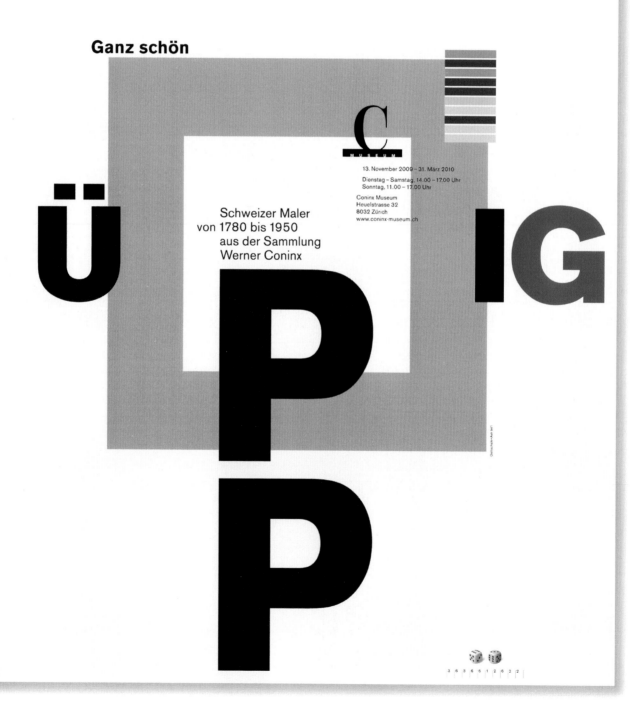

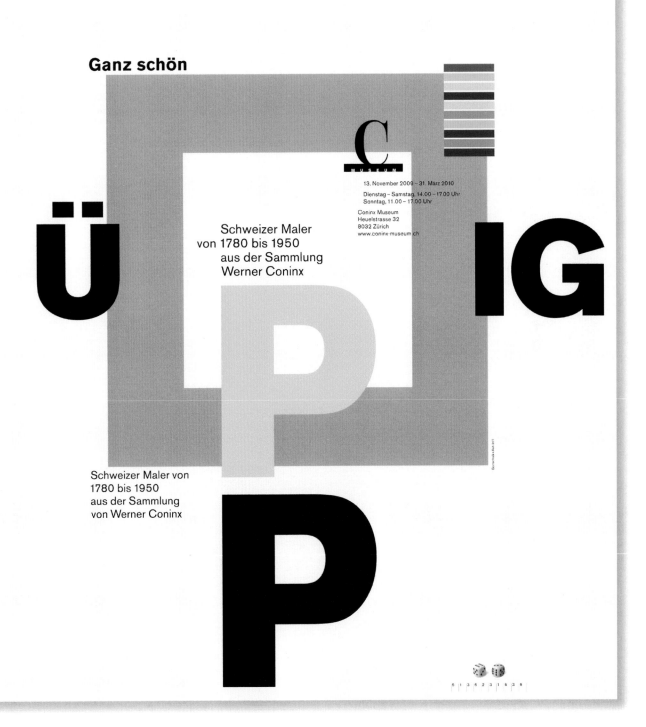

Ganz schön

Schweizer Maler
von 1780 bis 1950
aus der Sammlung
Werner Coninx

13. November 2009 – 31. März 2010

Dienstag – Samstag, 14.00 – 17.00 Uhr
Sonntag, 11.00 – 17.00 Uhr

Coninx Museum
Heuelstrasse 32
8032 Zürich
www.coninx-museum.ch

Schweizer Maler von
1780 bis 1950
aus der Sammlung
von Werner Coninx

Designers: DJ Stout, Stu Taylor | Design Firm: Pentagram | Illustrator: Marc Burckhardt | Client: AIGA San Antonio

Designers: DJ Stout, Stu Taylor | Design Firm: Pentagram | Illustrator: Marc Burckhardt | Client: AIGA San Antonio

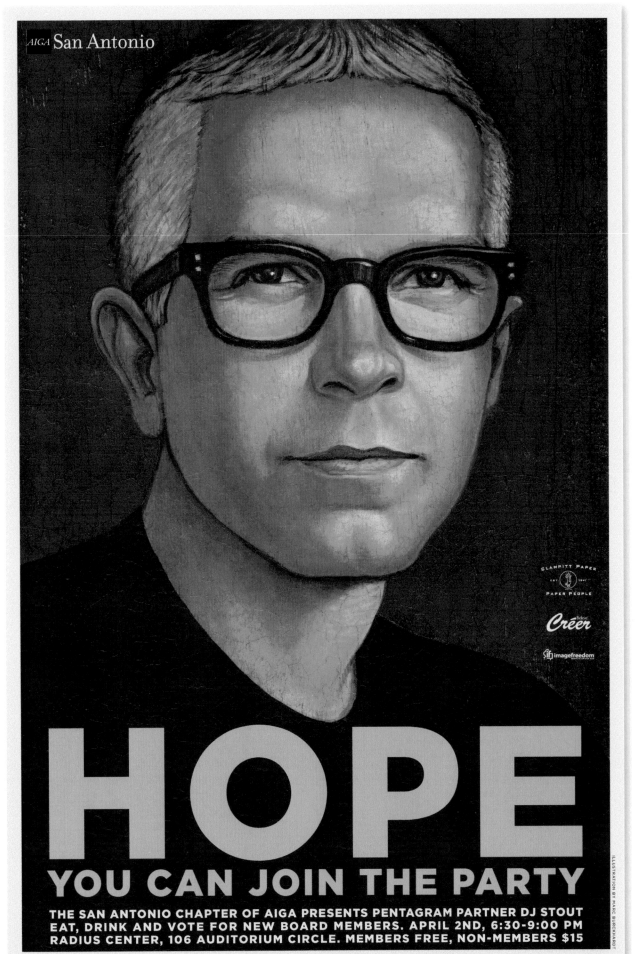

AIGA San Antonio

CLAMPITT PAPER
est 1941
PAPER PEOPLE

Créer

imagefreedom

HOPE
YOU CAN JOIN THE PARTY

THE SAN ANTONIO CHAPTER OF AIGA PRESENTS PENTAGRAM PARTNER DJ STOUT
EAT, DRINK AND VOTE FOR NEW BOARD MEMBERS. APRIL 2ND, 6:30-9:00 PM
RADIUS CENTER, 106 AUDITORIUM CIRCLE. MEMBERS FREE, NON-MEMBERS $15

PLEASE RSVP TO RSVP@AIGA-SA.ORG. OUR THANKS TO FRENCH PAPER, MURILLO DESIGN, MÖLLER DESIGN, CHIMAERA DESIGN, PICOSO CREATIVE, SWIRL,
LOWERCASE A: DESIGN STUDIO, DEFIGN CREATIVE FACTORY, JUMP COMMUNICATIONS DESIGN, RUMBLE CREATIVE GROUP, IADT SAN ANTONIO, SOUTHWEST
SCHOOL OF ART, C4 WORKSPACE, FINESILVER BUILDING. AND A SPECIAL THANK YOU TO ALL OF THE VOLUNTEERS WHO HAVE HELPED US OVER THE LAST YEAR.

ILLUSTRATION BY MARC BURCKHARDT

Assignment: When it comes to 'The Atmosphere', "C" (Carbon) endangers "O2" (Oxygen). This 3D Typography Poster with the impression of space is to arouse peoples attention to Climate Change.

Designer: Hoon-Dong Chung | **Design Firm:** Dankook University | **Client:** Self-Promotion

Keep Earth's Air Safe

C Endangers O2

Assignment: This was an open brief, which I love, to create a gig poster for Band of Horses. Gig poster briefs are typically really open and have great deadlines too so they're really fun ones to get involved with. I wanted to create a poster that really wowed them, I love the band so felt like a bit of an honour to be working on something for them.

Approach: This piece was worked slightly differently from my other work in that I had to shoot very specific bits. I drew out the type as I wanted it, refined it, drew it out again and again until I had a very good plan of what I wanted to shoot/create. Next was the painstaking part, shooting the rope bending and curling to make it follow my plan, resulting in the finished pieced, and something I'm really proud of.

Results: The result I had from this, from the band and their management through to type enthusiasts has been great! And I look forward to the next one...

Designer: Sean Freeman | **Design Firm:** THERE IS/Sean Freeman | **Client:** Another Planet Entertainment

Another Planet Entertainment *presents*

BAND OF HORSES
with Admiral Radley

September 24, 2010 • The Greek Theatre at UC Berkeley

©2010 Another Planet Entertainment_No. 97. Design by Seur Foreman

Assignment: Design two sides of skateboards.

Approach: I really enjoyed the creative process of this projects as the client gave me complete creative freedom. I chose the warm, golden

colors. The letters resemble tree branches. I was looking for a mix between ornate lettering and organic shapes that would make a hybrid image.

Designer: Alex Trochut | **Design Firm:** Alex Trochut | **Client:** FTC Skateboards

Assignment: Advertising/Promotion Campaign for Aishti, a luxury department store in Beirut. We honed in on Aishti's signature orange gift box, making it the visual centerpiece of the campaign. The box becomes a symbol for the brand, turning into an object of luxury. Campaign images were used in newspapers, magazines, and billboards in the Middle East.

Designer: Jong Woo Si I **Design Firm:** Sagmeister, Inc. I **Art Director:** Jessica Walsh I **Photographer:** Bela Borsodi
Production Company: Lutz and Schmidt I **Client:** Aishti

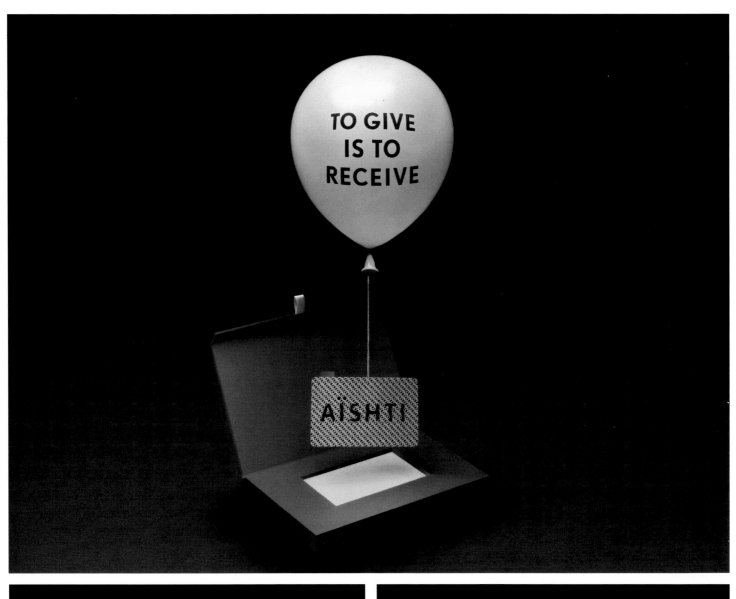

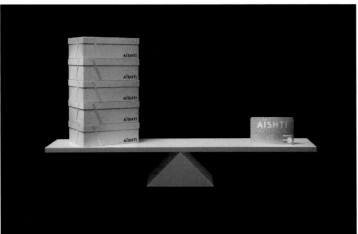

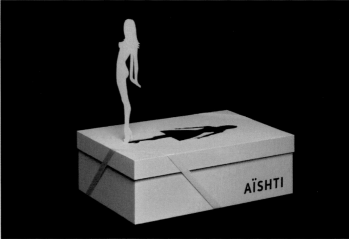

Assignment: The all-new Fiat 500 made its North American debut during a November 2010 media reveal at the Los Angeles Auto Show. The 500 was a new vehicle in the North American market and the first representation of the Fiat brand's return to the U.S. after nearly 25 years. The original 500 — Cinquecento — was introduced in 1957, and after almost 20 years and four million vehicles, it has attained iconic status as an affordable, reliable and innovative small car. The new 500 symbolized the rebirth of the brand and the vehicle in the United States and offered a fresh look at how Italian automobile design and technology had evolved. Our assignment was to communicate pertinent information about the vehicle to the media, while simultaneously increasing awareness of Fiat's return and long-term intentions.

Approach: We knew that the announcement package had to reflect several of the car's attributes: compact size with a lot of content, sleek, simple, and functional with an overall contemporary Italian design feel. We initially came up with three different packaging directions, one of which was our preferred choice. In this direction, a square shape seemed more contemporary to us, given the subject matter and content. We proposed a small cube, whose final size was dictated by the readability of the book that would be contained inside. We knew we wanted a lot of "white space" in conjunction with colorful, contrasting colors, so the original sketches featured corporate red fields on a white outer box. To represent the numerous custom configurations the car was available in, we proposed having different color versions on the outer box. The final product was a five-inch, turned-edge cube-shaped box, printed in one of the 14 new colors available on the vehicle. The cube contained a 64-page, perfect-bound book detailing the car's heritage, design approach, engineering features and specifications. Also included was a USB with electronic versions of the printed information, as well as high-resolution photography. The Fiat-branded espresso cup and saucer was also part of the package, and held the USB in a bed of multi-colored confetti. At the Los Angeles show, a few hours prior to the media event, the cubes were stacked in multi-colored rows at Chrysler's media desk, generating a lot of interest from passers-by.

Results: The client reported that response for the event and the media materials exceeded expectations and that subsequent published coverage was extremely strong. A second version of the package was utilized at the larger North American International Auto Show several weeks later.

Designer: Renée LeClair | **Design Firm:** Iconix, Inc. | **Creative Director:** Robert Evans | **Client:** Chrysler Group LLC

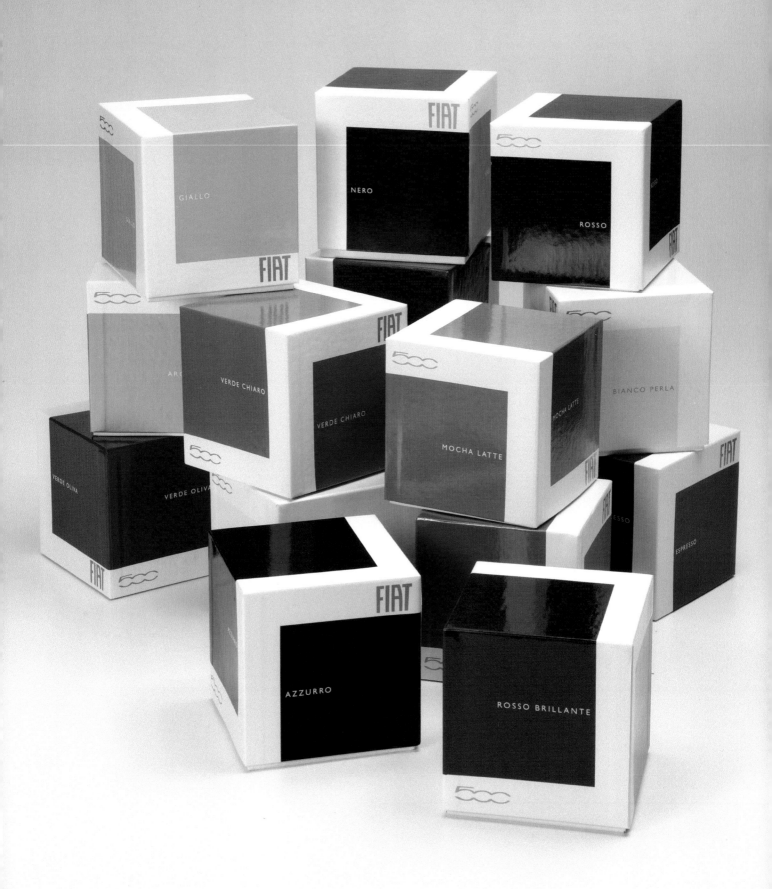

USB IN CUP

REMOVE FOAM
TO ACCESS SAUCER

PRESS RELEASES

Download Entire Press Kit *(pdf)*

DOWNLOAD PRESS RELEASES
(RTF FORMAT)

OVERVIEW

EXTERIOR DESIGN

INTERIOR DESIGN

ENGINEERING

ADAPTATIONS

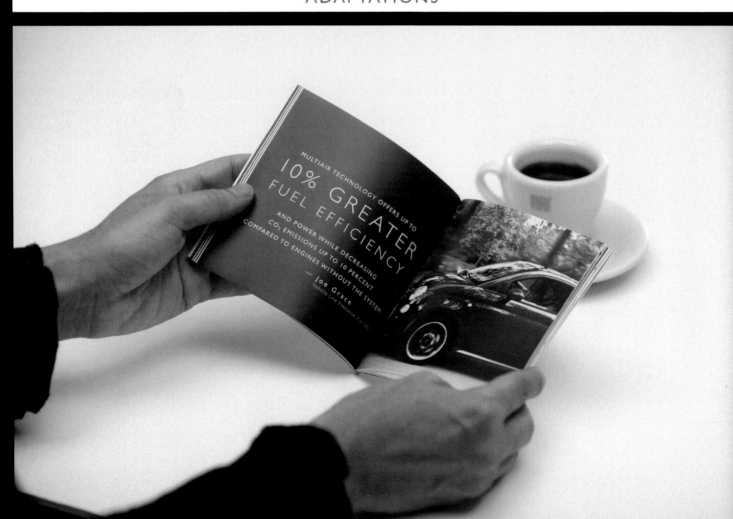

Assignment: Every two years the Whitney Museum undertakes the enormous task of giving us a survey of the contemporary art scene. 2010 marked the 75th edition of the Whitney's signature exhibition. While Biennials are always affected by the cultural, political, and social moment, this exhibition simply titled 2010 embodied a cross section of contemporary art production rather than a specific theme. To underscore the idea of time as an element of the Biennial and to demonstrate the influence of the past on 2010, familiar and less well-known artists from previous exhibitions are brought together in Collecting Biennials, an accompanying installation drawn from the Museum's collection on view on the fifth floor. Balancing different media ranging from painting and sculpture to video, photography, performance, and installation, 2010 also served as a two-way telescope through which the Whitney's past and future.

Approach: Sotheby's was asked to design a creative yet simple invitation for VIP clients and art collectors. This resulted in a ""balance of different media"" using acetate and a steel plate. As the steel invitation was removed from the acetate sleeve, it revealed a bright yellow interior with the names of all 55 artists.

Results: They loved it.

Designers: Beth Lin Garland, Sandra Burch | **Design Firm:** Sotheby's | **Client:** Sotheby's, The Whitney Museum

20 WHITNEY BIENNIAL 10

Assignment: Create a theme and invitation campaign for River City Roll — an exclusive, upscale fundraiser for the Cerebral Palsy Foundation's wheelchair program.

Approach: We needed a concept that would appeal to an upscale crowd, and also provide opportunities for the event itself. The theme, "Astronomical Possibilities," was played out with a Jules Verne and a steampunk approach that created an otherworldly, unexpected mystique around the event

Results: The event registered it's highest attendance ever and beat its fundraising goal by $25,000.

Designer, Illustrator: James Strange | **Design Firm:** Bailey Lauerman | **Art Director:** James Strange
Copywriter, Creative Director: Raleigh Drennon | **Print Producer:** Gayle Adams | **Client:** Cerebral Palsy Research Foundation

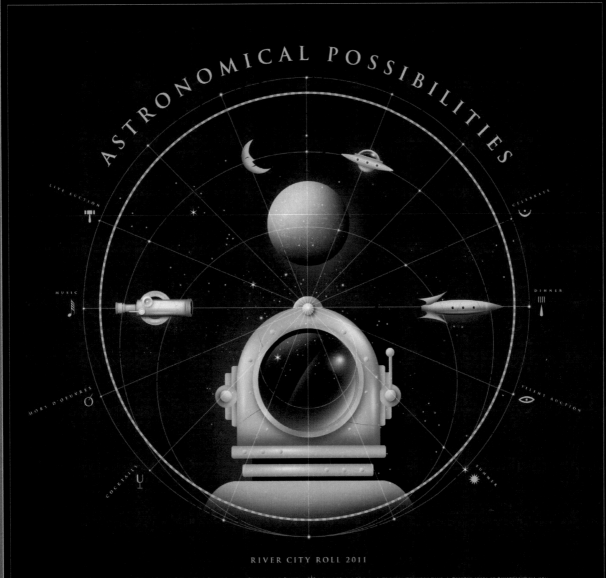

ASTRONOMICAL POSSIBILITIES

LIVE AUCTION

CELEBRATE

MUSIC

DINNER

HORS D'OEUVRES

SILENT AUCTION

COCKTAILS

SUMMER

RIVER CITY ROLL 2011

A BENEFIT FOR THE CEREBRAL PALSY RESEARCH FOUNDATION EQUIPMENT FUND ✳ JUNE 25 | 6:30 P.M. | WICHITA COUNTRY CLUB | RESERVE SEATS AT RIVERCITYROLL.ORG

Assignment: "Out of Character" is a series of limited edition prints created in response to numerous natural disasters and resulting devastation.

Based on original artwork by the Character design team, each piece is printed on archival paper and is a hand-numbered edition of 50. One

hundred percent of proceeds is donated to an international humanitarian organization providing aid in nearly 60 countries.

Approach: Each member of the Character design team was encouraged to participate and generate artwork for the limited edition prints.

Final artwork included hand drawn typography and original illustrations.

Designers: Andrew Johnson, Rishi Shourie, Ben Pham, Tish Evangelista | **Design Firm:** Character | **Client:** Self-Promotion

Out of
Character™

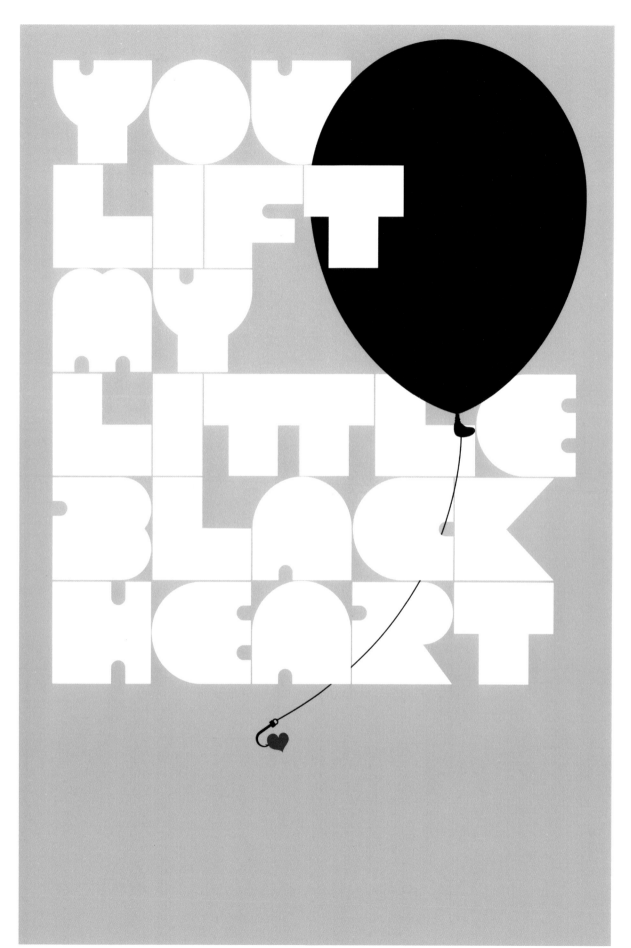

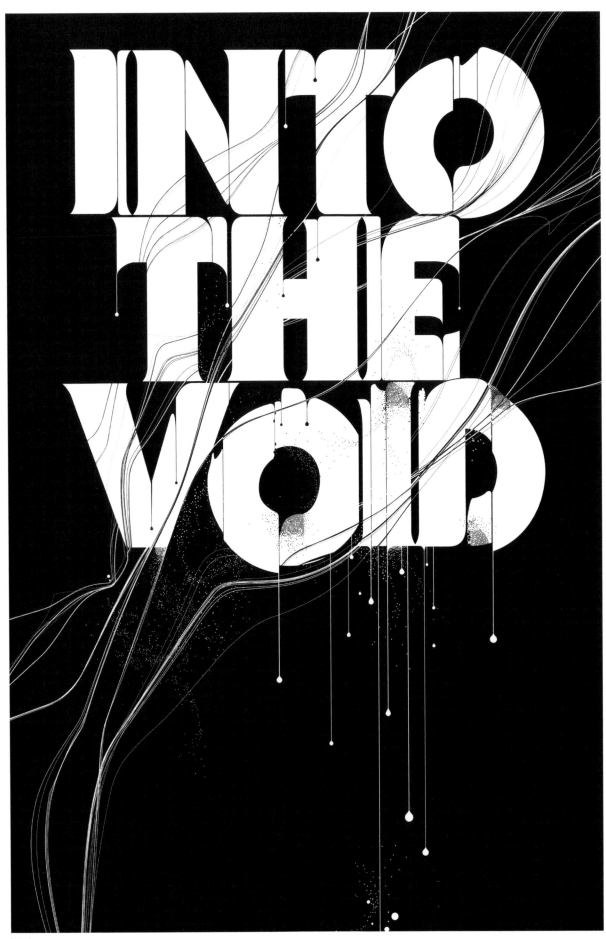

Assignment: To develop a Christmas gift for our clients and associates.

Approach: 150 full size Belgian chocolate keyboards were cast to celebrate XMAS 2010. May contain traces of nuts.

Results: 100 percent satisfied target audience because chocolate was built into the idea.

Designers: Clem Devine, Dean Poole, Tony Proffit | **Design Firm:** Alt Group | **Creative Director:** Dean Poole | **Client:** Alt Group

Assignment: The project was to design a Christmas card for photographer Dazeley which showcased his work and was memorable and appropriate for its recipients. The primary audience were advertising agencies, design companies and designers, as well as commissioning clients.

Approach: Once the image / theme was established the aim was to create a card which used typography to enhance and animate the image whilst not overwhelming it.

Results: Dazeley was delighted with the final card and it triggered a strong response from the recipients.

Designer: David Clare | **Design Firm:** Exposed Design Consultants | **Photographer:** Toaki Okano | **Client:** Dazeley

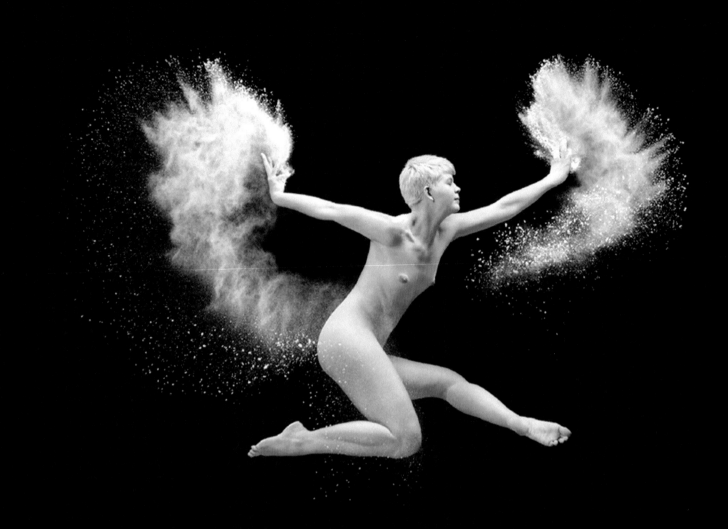

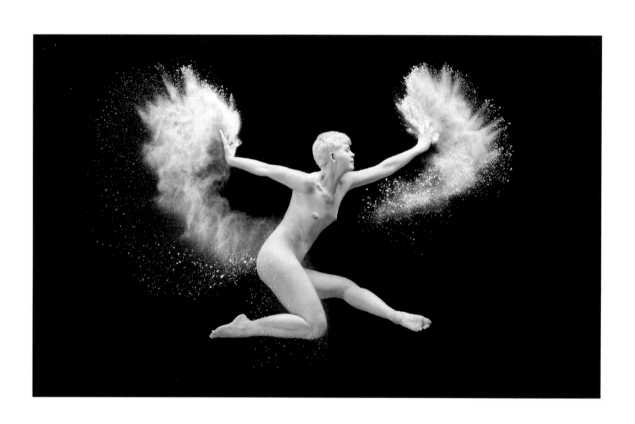

IT IS NOT KNOWN PRECISELY WHERE ANGELS DWELL - WHETHER IN THE AIR, THE VOID, OR THE PLANETS

VOLTAIRE 1694-1778

PHOTOGRAPHY: DAZELEY THE STUDIOS, 5 HEATHMANS ROAD, LONDON SW6 4TJ 020 7736 3171 STUDIO@PETERDAZELEY.COM

STYLIST : BAZ 07976 848 637 MODEL : RHIANNON RETOUCHER : ESTHER SALMON

DIGITAL ASSISTANT : ALYSSA BONI PRODUCER : JANNITH WONG

DESIGNER : DAVID CLARE 020 8202 5964

PIPPA HALL 020 7736 2999

PRINTER : LYNHURST PRESS 0845 53 999 00

REPRESENTED BY : SARAH RYDER RICHARDSON & PIPPA HALL

WISHING YOU A VERY MERRY CHRISTMAS, HAPPY HOLIDAYS & A WONDERFUL NEW YEAR

Assignment: At the end of every summer, Wallace Church throws a tuna party, where we grill fresh tuna and celebrate with friends and clients.

For this occasion, our designers are asked to come up with original ideas for our invitation.

Approach: Our 2010 invitation features a die cut tuna curled into a clear tube. As the invitation is removed from the tube, its texture and movement

are supposed to suggest a real fish. As the fish is uncurled, the flattened scales open, creating a graphic pattern of shadows around the message within.

Designers: Becca Reiter, Stan Church | **Design Firm:** Wallace Church, Inc. | **Client:** Self-Promotion

Assignment: Developed as part of a multiyear educational program, The Standard is a guide for designers to show how they can use printing techniques and processes to achieve the creative results they seek. Published by Sappi Fine Paper, The Standard also serves to demonstrate the exceptional performance of their printing papers. Earlier volumes, discussed topics such as preparing files for print, color management, and varnish and coatings.

Approach: Volume 4 of The Standard explores scoring and folding. Volume 4 takes the reader from folding basics, a glossary of terms and a listing of do's and don'ts to real examples of scoring options, actual in-use case studies and seven folding samples that readers can hold and try themselves. The book ends with a wall-size poster that shows all of the folding families at a glance. The way each section of the book is assembled and folded is a folding demonstration in itself. The piece also includes bindery steps that are an integral and essential part of any printed piece but perhaps one of the most under utilized as a creative too. Volume 4 of The Standard is produced in concert with the "Fold Factory" and allows designers to expand their knowledge through a "templated" program of unique folds. In addition, Sappi had a series of cross-country speeches, video demos and webinars to enhance the information provided in the printed documents. By Sappi's metrics, the Standard 4 was the most effective standard to date.

Results: This was gauged by the sell out crowds at the countrywide speech program, the extraordinary response to the webinars and the "over sold" paper situation that they found themselves in at the beginning of 2011. The main take away from the piece was how print can offer unique customer responses in concert with a strong digital communication program.

Designers: Kit Hinrichs, Belle Chock | **Design Firm:** Studio Hinrichs | **Client:** Sappi Fine Paper, North America

A Sappi Guide to Designing for Print:

Tips, Techniques and Methods for

Achieving Optimum Printing Results

The Standard

SCORING & FOLDING

Over 50
Folding
Examples
Inside

The Standard

4

sappi

A Sappi Guide to Designing for Print

Tips, Techniques and Methods for

Achieving Optimum Printing Results

Scoring & Folding

B B B H

TIC

E

A

A

The **Exotic** family consists
of challenging folds, including
proprietary configurations, that
may require hand folding or
the services of a specialty bindery
that can automate the process.
A twist fold is shown here.

C

C

EXO

D D D

Assignment: Unisource Canada is a major distributor of commercial printing, fine imaging papers and graphic arts supplies. The paper giant selects a design firm each year to conceive of and execute a creative concept for its annual awards competition. The national competition is directed to an audience of design firms, ad agencies and printers.

Approach: The concept "Unveiling Your Best" was developed for the campaign in order to capture the objective of the awards, which was to reveal outstanding work using paper. This theme was explored throughout the campaign, informing the design, art direction, photography and production techniques. For the call for entries poster, the title of the awards show, NUARs 2010, was cut out from grey paper and then photographed with the letters peeling back. The letters revealed a typographic pattern designed from the words "Unveiling Your Best" beneath. The annual continued the theme, featuring a dust jacket with a die cut that knocked out the awards title completely.

Results: "The design of NUARs 2010 really hit the mark by utilizing different production techniques for each progressive piece of the campaign. From the unique perforation on the call for entries envelope to the digitally printed white ink on the awards gala invitations to the die cut on the dust jacket of the annual, each subsequent piece incorporated an exciting production technique worthy of capturing the attention of a critical audience of printers, ad agencies and designers." — Susan Corbeil, Director of Specification Sales, Unisource Canada, Inc.

Designer: Fidel Peña | **Design Firm:** Underline Studio | **Client:** Unisource Canada

NUARS 2010 50

NU·ars unisource

Assignment: The Corbis 24/7/365 Calendar program was created to show the depth, breadth, diversity and quality of the Corbis image collection and remind target customers who are primarily designers, art directors, publishers, editors and filmmakers to keep Corbis at the "top of their minds".

Approach: The day-at-a-time desktop calendar featured an event that happened that day in history and linked it with an image available from Corbis. This approach allowed us to include images from all of their collections — celebrities, sports, fine art, science, architecture, cultural, outer space, historical, etc. The printed calendar was translated into several languages and sent to a select audience of active customers worldwide. The printed calendar was also converted into a digital version that anyone could access online on their computer or handheld device. Additionally, the program was launched with a 24/7/365 poster that featured a montage of all 365 images used for the calendar. This poster was printed as a self-mailer and as a giveaway, and was produced in sufficient quantity to distribute to "future" customers in design schools and other relevant segments.

Results: Since its launch at the beginning of 2011, the response has been terrific. The programs has sparked an initiative by Corbis to engage with Art Center College of Design to donate $1 from each stock image sold to fund a continual online seminar with design experts from around the globe.

Designers: Kit Hinrichs, Gloria Hiek | **Design Firm:** Studio Hinrichs | **Client:** Corbis

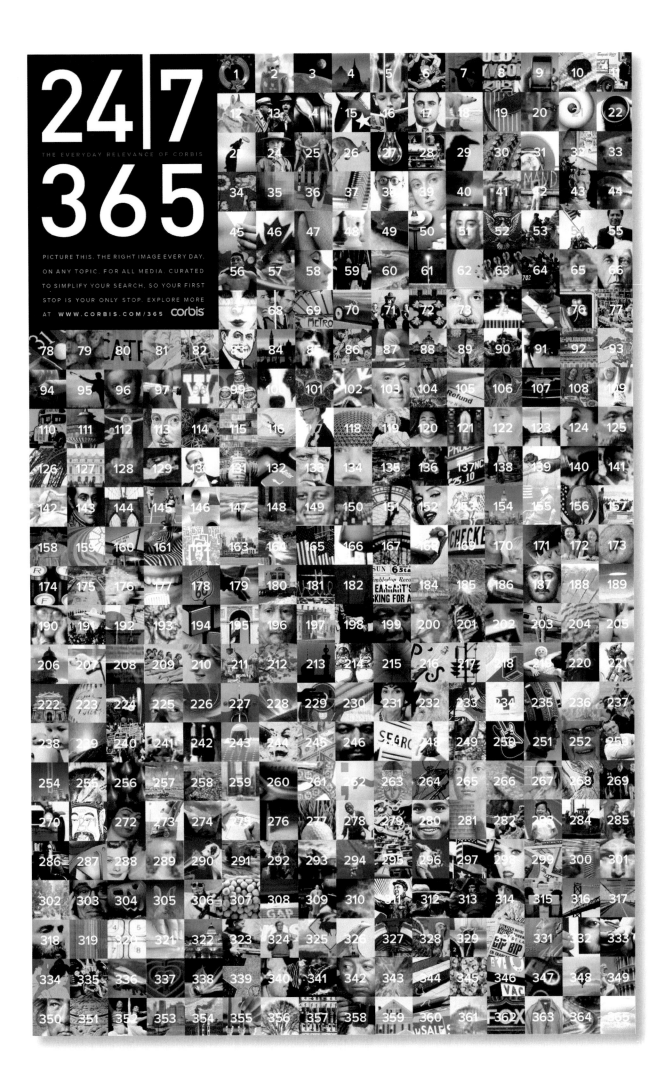

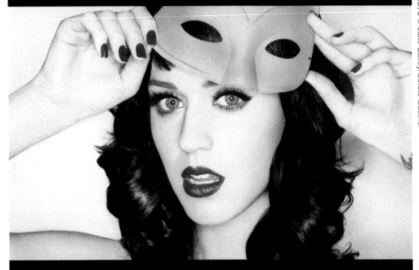

Assignment: Jason Henry, of Henry+Co, was invited to speak at a poster art show. These shows have a heavy silkscreen printing presence and Jason thought it was a great opportunity to show other poster printing techniques.

Approach: The ticket poster was Jason Henry's giveaway at the show, acting as an introduction to his company's capabilities and an invitation to hear him speak. The typography styling reinforces and promotes the new Henry+Co brand logotype and positioning line. The poster replaces the typical ticket information with some of the finishing techniques you could use on art posters, available from Henry+Co. The phone number substitutes for the ticket number and the ticket shape is a die cut, with punch outs to highlight the techniques used to produce the ticket poster. The perforating top and bottom edges were hand torn to mimic a ticket, and the bottom ticket part has a perforation with key information that would leave a ticket stub if torn off. Kraft paper was selected to further the ticket connection.

Results: Jason's talk went well at the show and the poster was taken to the HOW conference to further promote Henry+Co at their booth.

Designer: Lionel Ferreira | **Design Firm:** Ferreira Design Company | **Client:** Henry+Co

7704577228

HENRY+CO
ATLANTA

HENRYANDCO.COM

POSTER ART
PRINTER

+ THE FINISHING TOUCH +

LETTERPRESS

LITHO

EMBOSSING

FOIL STAMPING

DIE CUTTING

HENRY
AND COMPANY

ESTABLISHED 1975

PRINTER

7704577228

Assignment: The Print Counsel is a boutique offset printing company specializing in A3 and custom finishing. The brief was to create an identity and apply it to a piece of direct mail to promote a new A3 press. Rather than create a logo mark, the identity was built around the visual elements of the default plate settings that appear outside the trim area of the press sheet — Helvetica, CMYK color control bars and crop marks.

Approach: The brand idea was to start a colorful conversation by amplifying and personifying CMYK colour swatches. A piece of direct mail was developed to promote a new A3 press. A folded envelope showcasing the different inline effects was created along with a series of promotional postcards as an ongoing conversation between two colored squares. Each square was embellished with a different print technique to showcase and personify the effect humorously as well as technically.

Results: The postcards brought new opportunities to The Print Counsel by highlighting new investments in production capabilities and showing existing and prospective clients that the company can provide a unique quality solution and have fun in the process.

Designers: Dean Poole, Tony Proffit | **Design Firm:** Alt Group | **Creative Director:** Dean Poole | **Client:** The Print Counsel

I'm impressed

how are you? I'm depressed

Assignment: Part of a new product line launch (kMix Collection) to the trade audience at the 2011 International Home & Housewares Show.

Approach: We sketched out ways to bring the scale and color of the products to life on a medium that is often over-looked. The placement of one's hand on the bag served as an ideal place to showcase the product.

Design Firm: 160over90 | **Creative Chief Officer:** Darryl Cilli | **Creative Director:** Stephen Penning | **Executive Creative Director:** Jim Walls
Photographer: Thomas Ammon | **Client:** De'Longhi

DēLonghi

kMix

2011 IHA TRADESHOW

Assignment: Typescape is a project that delves into typography beyond paper. Exploring how a text may have vitality beyond the scope of paper, the aim is to facilitate new forms and meanings through all kinds of experiences within time and space. Typescape fosters a different view of letters, like those displayed on a moving railroad car or an automobile. The constellations in the night sky may likewise be read in the form of letters. Sometimes lettering in Typescape is shown in three-dimensional space.

Designer: Namoo Kim | **Design Firm:** Hankyong National University | **Client:** GT Press

Assignment: To give visual life to the GLP Creative brand.

Approach: We wanted to visually burn the GLP Creative brand mark into the viewer's retinas. Once a set template was formed with a determined ratio, a monthly goal was created to an unsaid number of executions of the GLP Creative brand mark. Once animated, the continuos random looping of those executions would create a burn effect similar to a flash bulb.

Results: Well received both externally and internally. By creating a goal of executions monthly, a sense of commodity formed internally which only progressed the creative teamwork of the group.

Designers: David Barry, Thomas Frtizsche, Gary Land, Marcus Smith | **Design Firm:** GLP Creative | **Client:** GLP Creative

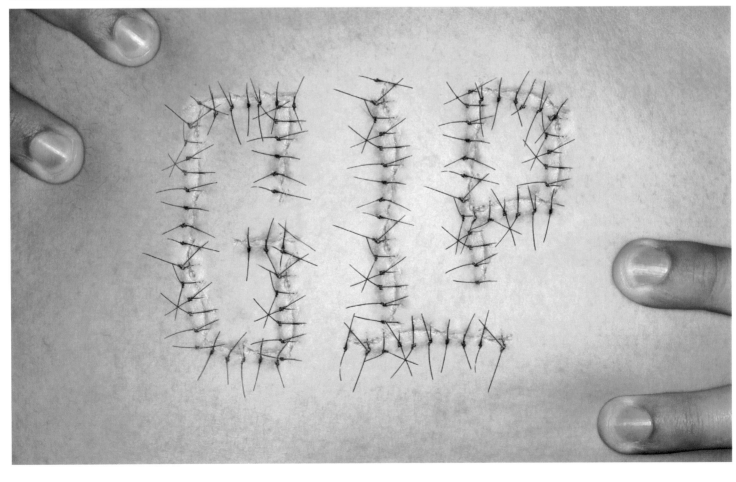

9Threads www.9Threads.com
East 15th Street, Brooklyn
NY, 11230, United States
Tel 917 326 1843

160over90 www.160over90.com
One South Broad Street, 10th Floor
Philadelphia, PA 19107, United States
Tel 215 732 3200 | Fax 215 732 1664

601 Design, Inc. www.601design.com
PO Box 771202, Steamboat Springs
CO, 80477, United States
Tel 970 819 4264

Alex Trochut www.alextrochut.com
c/Pamplona, 89, 08018 Barcelona, Spain
Tel +34 931 822 845

Alt Group www.altgroup.net
PO Box 47873, Ponsonby
Auckland, New Zealand
Tel +64 9 360 3910

American Airlines Publishing
www.aapcustom.com
4333 Amon Carter Blvd., MD 5374
Fort Worth, TX 76155, United States
Tel 817 967 1793

American Museum of Natural History
www.amnh.org
Central Park West at West 79th Street
New York, NY 10024, United States

Artemov Artel www.designartel.com
Tychiny str., 13, Ap. 346
Kiev, Ukraine 02152
Tel +38 044 592 83 07

Bailey Lauerman
www.baileylauerman.com
1248 O Street, Suite 900
Lincoln, NE 68508, United States
Tel 402 475 2800 | Fax 402 475 5115

Bradbury Branding & Design
www.bradburydesign.com
2827 McCallum Avenue, Regina
Saskatchewan S4S 0R1, Canada
Tel 306 525 4043

BradfordLawton
www.bradfordlawton.com
1020 Townsend Avenue, Suite 100
San Antonio, TX 78209
Tel 210 832 0555 | Fax 210 832 0007

Brandient www.brandient.com
4 Varsovia, 2nd Floor
Bucharest, 11807, Romania
Tel +40 720 250534 | Fax +40 212 308 174

Breeze Creative Design Consultants
www.breeze-creative.com
15 Dominie Park, Balfron, Glasgow G63 0NA
Scotland, United Kingdom
Tel +01 360 449347 | Fax +01 360 449348

Character www.charactersf.com
487 Bryant Street, 3rd Floor
San Francisco, CA 94107, United States
Tel 415 227 2100

Cinco Design
www.cincodesign.com
1700 SE 11th Street, #100
Portland, OR 97212, United States

Collins
261 Manhattan Avenue, Apt. 3
Brooklyn, NY 11211, United States
Tel 612 305 6000 | Fax 612 305 6500

Dankook University
http://203.237.226.61
126, Jukjeon-dong, Suji-gu
Dankook University, College of Arts
Dept. of Visual Communication Design
Room 317, Yongin-siGyeonggi-do
448-701, Republic of Korea
Tel +82 318 005 2114

DDB Canada/Karacters Vancouver
www.karacters.com
600-777 Hornby Street, Vancouver
BC V6Z 2T3, Canada
Tel 604 640 4374

Dolhem Design www.dolhemdesign.se
Nybrogatan 3, Stockholm, Sweden 11434
Tel +46 08 661 50 47 | Fax +46 08 661 50 48

Eduardo del Fraile www.eduardodelfraile.com
Saavedra Fajardo 7, 2c, Murcia, 30001, Spain
Tel +34 968 211 824 | Fax +34 968 218 087

El Paso, Galeria de Comunicacion
c. Sagunto, 13, Madrid, 28010, Spain
Tel +34 91 594 2248

Exposed Design Consultants
www.exposed.co.uk
PO Box 35575, London
NW44UH, United Kingdom
Tel +44 845 680 5964 | Fax +44 870 125 9115

Faceout Studio
www.faceoutstudio.com
520 SW Powerhouse Dr., #628
Bend, OR 97702, United States
Tel 541 323 3220 | Fax 541 323 3221

Ferreira Design Company
www.ferreiradesign.com
335 Stevens Creek Court
Alpharetta, GA 30005, United States
Tel 678 297 1903

Flame
41/13 Herbert Street, St. Leonards
Sydney NSW 2065, Australia
Tel +61 42 307 0100

Gee + Chung Design
www.geechungdesign.com
38 Bryant Street, Suite 100
San Francisco, CA 94105, United States
Tel 415 543 1192 | Fax 415 543 6088

Gensler www.gensler.com
2 Harrison Street, Suite 400
San Francisco, CA 94105, United States
Tel 415 836 4494

Gevir Design www.gevir.no
Thorvald Meyers, gt 15
N-0555 Oslo, Norway
Tel 21919127

GLP Creative www.glpcreative.com
21 Broad Street, Quincy
MA 02127, United States
Tel 617 328 9800

Gottschalk+Ash Int'l
www.gplusa.com, Boecklinstrasse 26
Zurich 8032, Switzerland
Tel +41 44 382 1850 | Fax +41 44 382 1858

GQ Magazine www.gq.com
4 Times Square, 9th Floor
New York, NY 10036, United States
Tel 212 286 6695

Hankyong National University
www.hankyong.ac.kr
327 Chungang-no, Anseong-si. Kyonggi-do.
456-749., Republic of Korea
Tel 82 031 670 5114 | Fax 82 031 672 2704

HKLM Group www.hklmgroup.com
4 Kikuyu Road, Sunninghill
Johannesburg, South Africa
Tel + 27 11 461 6818 | Fax +27 11 461 6819

Iconix, Inc. www.iconixinc.com
1100 Centre Road, Auburn Hills
MI 48326, United States
Tel 248 475 5800 | Fax 248 475 9970

Jay Advertising
www.jayadvertising.com
170 Linden Oaks, Rochester
NY 14625, United States
Tel 585 264 3644 | Fax 585 264 3650

João Machado Design, Lda
www.joaomachado.com
Rua Padre Xavier Coutinho,
125 Porto 4150-751, Porto, Portugal
Tel +351 226 103 772 | Fax +351 226 103 773

KMS TEAM GmbH www.kms-team.com
Tölzer Straße 2c, Munich 81379, Germany
Tel +49 89 490 411 | Fax +49 89 490 411 109

LLOYD&CO www.lloydandco.com
180 Varick Street, Suite 1018
New York, NY 10014, United States
Tel 212 414 3100 | Fax 212 414 3113

Lorenzo Ottaviani Design, Inc.
www.ottavianidesign.com
65 Hack Green Road, Pound Ridge
NY 10576, United States
Tel 212 253 9522

Michael Schwab Studio
www.michaelschwab.com
108 Tamalpais Avenue
San Anselmo, CA 94960, United States
Tel 415 257 5792 | Fax 415 257 5793

Mike Barker Design
www.mike-barker.com
12 Congdon Way
Booragoon, WA 6154, Australia
Tel +61 404 994 666

Mikey Burton
1245 Carpenter Street, Apt. 2A
Philadelphia, PA, 19147, United States
Tel 215-915-3075

Oakwood Media Group www.oakwood-mg.com
7 Park Street, Bristol, BS1 5NF United Kingdom
Tel +44 117 983 6789

Palio www.palioblog.com
260 Broadway, Saratoga Springs
NY 12866, United States
Tel 518 226 4126 | Fax 518 583 1560

Pentagram www.pentagram.com
1508 West 5th Street
Austin, TX 78703, United States
Tel 512 476 3076 | Fax 512 476 5725

Peter Kraemer
www.peterkraemer-web.de
Lindemannstr. 31,
Duesseldorf 40237, Germany
Tel + 49 211 210 80 87 | Fax +49 211 22 85 41

Punktum Design MDD
www.punktumdesign.dk
Pakhus 12, Dampfaergevej 8, 5th floor
Copenhagen, DK 2100, Denmark
Tel +45 39 63 2253

Ralph Appelbaum Associates, Inc.
www.raany.com
88 Pine Street, 29th Floor, New York
NY 10005, United States
Tel 212 334 8200 | Fax 212 334 6214

Sagmeister, Inc. www.sagmeister.com
206 West 23rd Street, 4th Floor
New York, NY 10011, United States
Tel 212 647 1789 | Fax 212 647 1788

Sonner, Vallèe u. Partner www.sonnervallee.de
Eduard-Schmid-Str. 2, Munich 81541, Germany
Tel +49 89 767768-41 | Fax +49 89 767768 45

Sotheby's www.sothebys.com/en.html
1334 York Avenue
New York, NY 10021, United States
Tel 212 894 1180

Steven Taylor & Associates
The Plaza, Unit 3.17 - 535 Kings Road
London, Chelsea SW10 0SZ, United Kingdom
Tel +44 207 351 2345

Studio Alexander www.studioalexander.co.nz
L1, 326 New North Road, Kingsland
Auckland, New Zealand
Tel +64 9 359 9947 | Fax +64 9 35 999 48

Studio Hinrichs www.studio-hinrichs.com
368 Clementina Street, San Francisco
CA 94103, United States
Tel 415 543 1776 | Fax 415 543 1775

SVIDesign www.svidesign.com
124 Westbourne Studios, 242 Acklam Road
London W10 5JJ, United Kingdom
Tel +44 20 7524 7808

Synopsis
Str. Evlia Celebi Nr.5 Ap.11
Timisoara, Timis 300226, Romania

Target www.target.com
33 South Sixth Street, CC-03
Minneapolis, MN 55402, United States
Tel 612 304 9858

THERE IS/Sean Freeman www.thereis.co.uk
c/o Levine/Leavitt
670 Broadway, Suite 304
New York, NY 10012 , United States
Tel 212 979 1200 | Fax 212 979 7388

Turner Duckworth Design
London & San Francisco
www.turnerduckworth.com
831 Montgomery Street
San Francisco, CA 4133, United States
Tel 415 675 7777

Underline Studio www.underlinestudio.com
247 Wallace Avenue, 2nd Floor
Toronto, Ontario, Canada M6H 1V5
Tel 416 341 0475 | Fax 416 341 0945

Vanderbyl Design www.vanderbyldesign.com
171 2nd Street, 2nd Floor
San Francisco, CA 94105, United States
Tel 415 543 8447 | Fax 415 543 9058

Version-X Design www.version-x.com
11023 McCormick Street, Unit B
North Hollywood, CA 91601, United States
Tel 818 308 6111

Wall-to-Wall Studios www.walltowall.com
1010 Western Avenue, Suite 302
Pittsburgh, PA 15233, United States
Tel 412 232 0880 | Fax 412 232 0906

Wallace Church, Inc. www.wallacechurch.com
330 East 48th Street, New York
NY 10017, United States
Tel 718 422 7594

Watts Design www.wattsdesign.com.au
2nd Floor, 66 Albert Road
South Melbourne, Victoria 3205, Australia
Tel +61 3 9696 4116

WAX www.wax.ca
320 333 24th Avenue SW
Calgary, Alberta T2S 3E6, Canada
Tel 403 262 9323

Webster Design Associates
www.websterdesign.com
5060 Dodge Street, Suite 2000
Omaha, NE 68132, United States
Tel 402 551 0503

Weymouth Design www.weymouthdesign.com
332 Congress Street, 6th Floor
Boston, MA 02210, United States
Tel 617 542 2647 | Fax 617-451-6233

The White Room, Inc. www.thewhiteroom.ca
191 First Avenue, Toronto
ON M4M 1X3, Canada
Tel 416 901 7736

White Studio www.whitestudio.pt
Rua da Cerca No. 5
Porto, 4150-202, Portugal
Tel +35 122 616 9080

Xose Teiga Studio www.xoseteiga.com
Rua Nova de Abaixo, 5 bajo
Pontevedra 36002, Spain
Tel +34 60 715 5211

Zync www.zync.ca
282 Richmond Street East, Suite 200
Toronto, Ontario M5P 1P4, Canada
Tel 416 322 2865

DESIGNERS

ART DIRECTORS

DESIGN FIRMS

CLIENTS

CREATIVE DIRECTORS

ILLUSTRATORS

PHOTOGRAPHERS

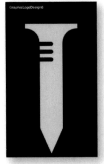
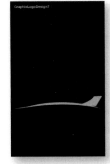
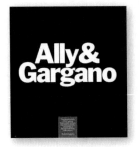
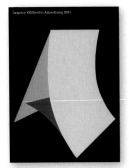
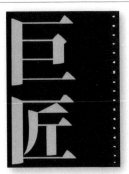
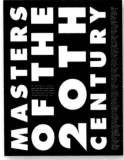

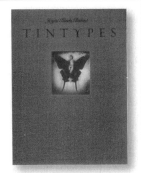
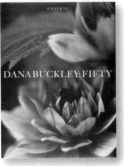

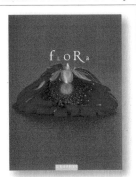